# Flesh Trade

## Tales from the UK Sexual Underground

## By Bruce Barnard

*Critical Vision ... An imprint of Headpress*

**A Critical Vision Book**
Published in 2005
by Headpress

Headpress/Critical Vision
PO Box 26
Manchester
M26 1PQ
United Kingdom

[**tel**] +44 (0)161 796 1935
[**fax**] +44 (0)161 796 9703
[**email**] info@headpress.com
[**web**] www.headpress.com

**FLESH TRADE**
**Tales from the UK Sexual Underground**
Text copyright © Bruce Barnard
This volume copyright © 2005 Headpress
Design: Walt Meaties
Layout & editing: Miss Nailer
Cover photo: Andrew Parker & Vanessa White
[**w**] www.xvoidx.com [**e**] andrew@xvoidx.com

World Rights Reserved

**British Library Cataloguing in Publication Data**
A catalogue record for this book is available from the British Library

**ISBN 1-900486-43-1**
EAN 9781900486439

# www.headpress.com

**The world don't move to the beat of just one drum, What might be right for you, may not be right for some.** *Theme tune from Diff'rent Strokes TV Show*

## ACKNOWLEDGMENTS

WITHOUT THE HELP of the following people this book could never have been written. I'd like to thank them for their good humour, trust, honesty and heroic commitment to challenging the status quo: Sandie Caine, Terry Stephens, Christian Marshall, Video Alex, Dave, George, Sally, Angela, Jay, Patricia, Michael, Mark, Anton, Kenny, Ben and Luke. I would also like to extend my sincere thanks to everyone else who agreed to talk to me over the last year. For reasons that may soon become apparent, the majority of them chose to remain anonymous.

Without the support of Marie I would still be staring blankly into space and holding the large number of rejection letters that have landed on the doorstep over the years. Thanks also to the following people, who have all contributed something positive to the creation of this book as well as improving the quality of my life on a daily basis: John Edwards, Matthew Fletcher Jones, Mark Barnard, Cath and Simon Frayne, Geraint Jones, Anton Frumeli, Gerard Conlan, Dax Dyer, Terrie Henderson, David Kerekes, Lomsang Rampa, Ian Powell and all my brethren in the 'Port.

For all their support in helping me pick up the pieces over the last year I'd like to send my love to Helen Foster, Annette Rickard and Paula Seagar.

Special thanks to Matthew Boyden and Laura Kenton Weeks, for their commitment, patience and valued friendship. Without the enthusiasm, support and practical assistance of my two most vocal critics this book could never have been written.

Finally, I'd like to extend my sincere apologies to Susan. Maybe one day I'll feel compelled to write about a subject she feels comfortable telling her friends about.

I'm sorry to tell you, mam, but *Flesh Trade* is not that book.

# Introduction

## We made our excuses and left

**If an attitude of permissiveness were to be adopted regarding pornography and sexual promiscuity, it would contribute to an atmosphere condoning anarchy in every other field, and would increase the threat to our social order as well as our moral principles.** *Richard Nixon*

**Ohh... you are awful!** *Dick Emery*

GROWING UP IN THE PROVINCES IN THE SEVENTIES, SEX was something that happened elsewhere. There may well have been people 'doing it' in a variety of new and interesting ways in bohemian Soho, but the sexual revolution never seemed to export successfully to the small South Wales town where I spent my formative years.

Ignore the fashion revisionists who claim the seventies were all about paisley shirts, quaaludes, afros and disco fever. The stark reality was in a world of strikes, power cuts and the dead going unburied, most people were too depressed to even think about jumping the free love bandwagon.

In the uniformly grey culture of seventies Britain where even the TV channels were forced to stop transmitting at midnight, the *Tomorrow's World* vision of a multi-channel digital age seemed as far fetched as the plot of a 1950s science fiction novel.

As a youth I honestly believed that I'd live to see flying cars and three course meals in capsule form before I was lucky enough to witness a pair of jiggling knockers on the television. Mary Whitehouse may have spoken about the 'constant filth' she was subjected to

every time she switched on the idiot box, but if you'd taken the time to ask the opinion of any focus group made up exclusively of teenage boys, they'd have vocally informed you that there was nothing in the schedules that could be described as decent wank fodder.

Given the Antarctic sexual climate of the age, options for visual titillation for the hormonal teenager were severely limited. You could either develop a vivid imagination, follow the trail of torn pages from porn magazines that littered the local woods, or commit to memory the Barbara Windsor bra popping scene from *Carry on Camping*.

To rub salt into the wound, Johnny Foreigner had recently been struck by a tsunami of filth, just at the point where we were queuing round the block to watch the pantomime slap and tickle of the *Confessions* series at the local Odeon. Our European partners were busy liberalising all laws dealing with the freedom to fuck. They started to view sex as a fundamental human right, rather than something that should never be spoken about in polite company. Laws relating to homosexuality, pornography and prostitution were being relaxed all over the continent following the radical steps taken by the Danish government in 1967[1]. Sexual practices forbidden by law for decades soon came creeping from the darkest shadows to infiltrate mainstream society, as adult shops and businesses devoted to selling sex sprung up in most European provincial towns.

Instead of being repulsed, as the guardians of the nation's morals had predicted, the general public were flocking to them in their droves, eagerly handing over cash to see hirsute hippie chicks get boned on 8mm film, paying for a furtive hand job or stocking up on dildos and erection creams. Despite the many vocal prophets of doom, such lurid displays of deviancy didn't appear to stop the world spinning on its axis.

Britain however, remained immune to this seismic cultural shift, and it would be decades before this ungodly liberal thinking ever made it through customs at Dover.

Things were destined to only get worse during the 1980s.

Just as I finally approached the age where inane fumbling with girls was finally on the agenda, there were prophetic warnings of a horrific new disease scattering itself across the globe. Terrifyingly enough, for smug members of the public who had never experimented further than the missionary position, experts were claiming that it would soon be spreading to straight folk, rather

than focusing exclusively on intravenous heroin users and the nervous patrons of San Francisco bathhouses.

In my understanding the Thatcher government were saying that any teenager foolhardy enough to risk fingering a girl as they danced to Careless Whisper at the school disco, would face an uncertain future haunted by the spectre of a long, lingering death. Like many others I made the link between sex and death without having to plough through a moribund poem or watching art house cinema, and for this at least I can be grateful.

This period of enforced celibacy suited the political landscape of the time. The conservative government may have talked of freedom, but these new rights never crossed over to the sexual arena, applying only to the ruthless quest of making money.

Like Homer Simpson says: "Making teenagers depressed is like shooting fish in a barrel." But even bearing this statement in mind, the fear and misinformation which surrounded HIV infection may well validate my generation's shared bout of teenage angst. If you were born after 1965 your entire philosophy on human sexual relationships will have been coloured by the theoretical risk of contracting DEATH following a drunken knee trembler in a pub car park. Such a threat, even if the government were guilty of embellishment, meant I, like many others of a similar age, have always had a tendency to live my sexual life vicariously through the promiscuity of others.

## LUCKILY PEOPLE WERE STILL HAVING SEX

DESPITE THE RISK of humiliation, disease, peer mockery and social stigma the sexual urge is just too strong to resist. There will always be a brave minority who demand the right to indulge in relentless, soulless fucking with faceless strangers. Free of guilt. Free of commitment. Free of the conditioning that dictates sex is bad unless it involves a stable relationship. Free in fact, of all the subconscious baggage that conspires to make sex less fun than it should be.

In swingers clubs, peep shows, massage parlours, 'members only' cinema clubs, saunas and steam rooms, people were indulging in the kind of periapic sexual activity the world hasn't seen since the days of Caligula.

It seems they'd always been doing it. Even when I was listening to Blondie as a teenager, thinking that the decade that taste forgot

had stripped society of its sex drive and led the UK to a frustrated mindset of angry impotence. The biological, sociological, physical and psychological need to connect on a sexual level, along with a strong need to show off and scream at your fellow man "I'm a pervert and proud of it" had always been bubbling under the surface, despite the many barriers that were erected to stop it spilling out into the public domain and soiling polite society. The reason *I* never knew was because no one was telling me.

Apart from the odd scare story written by a lazy tabloid sub-editor on a slow news day, there were no investigative journalists on the trail. No Bernstein or Woodwood delving into the sordid sexual goings on of our once proud nation. The British tabloid press have always been defined by their hypocrisy, and the puritanical approach they choose to take on matters sexual represents one of the best examples. The recent tabloid campaign of 'naming and shaming' paedophiles may in your opinion be justified when it relates to the sexual exploitation of children, but bear in mind that even consensual sexual behaviour among adults has fallen foul of their rigid moral standards in the past.

Where British journalists should have been travelling to group sex events, orgies, S&M clubs and porn film sets to document the changing face of our nation's sexuality, they were instead undertaking clichéd exposés of massage parlours, "*making their excuses and leaving*" at the point where things got interesting. If anyone did record the rich tapestry of British sexuality, the culture of the time meant they had to sit in judgement instead of making a straightforward historical record of events. The media were blinded by a flawed moral agenda, making any honest investigation into the sexual behaviour of our peers a definite no go area. Even the increasing number of top shelf magazine titles that sprung up in the seventies, tended to shy away from documenting the sexual fringes. Their brief was always titillation, not anthropology.

The UK experience stands in stark contrast to the United States, where the post sixties hippie rush to destroy conformity led to hundreds of magazines and underground newspapers covering the more blatant Stateside sexual revolution in increasingly lurid detail. You couldn't organise an orgy or a swingers event without having a reporter pointing a microphone into the face of the participants. Every bump and grind was captured in print and than devoured by a sex hungry domestic audience.

Al Goldstein's famous *Screw* magazine sold thousands of copies every week, despite the police busting any newsagent with the balls

to keep it on public display[2]. In between the badly printed nude photos, contact ads and swingers confessions there was some brave and exceptional journalism. Profound in one simple way at least: you could legitimately claim that you were reading the magazine for the articles.

The journalists covering the sex industry at the time often offered an insight into a secret cultural history, one that has long since passed and is unlikely ever to return. Goldstein, who takes great pride in his self proclaimed title as public enemy number one, puts it in simpler terms: "There was a reality out there, a reality that consisted of married men paying for sex, masturbation, peep shows, porn and homosexuality. None of that was represented. I started *Screw* to fill a vacuum, to reflect the sexual reality. I democratised sex."[3]

The British mindset always saw the sexual revolution as something sordid. A sign of moral standards slipping ever further into the abyss. The only way you could even write about unusual sexual behaviour was to adopt a stern voice that warned the reader of the physical symptoms of decay they would experience if they dared enter the squalid world of fucking without guilt. This has always told us more about the confused nature of our society than it does the dangers of wanton promiscuity.

As a nation we stood like King Canute, frantically trying to stem the sweeping tide of this dangerous new morality. This may have been the dawning of the Age of Aquarius, but in the UK at least any discussion of fucking for fucking's own sake was persona non gratis.

At the present time, we still have some of the most draconian laws covering sexual behaviour of any developed democracy. Britain also has the highest rates of teenage pregnancy in any western country and we top the European league table for sexually transmitted infections. Despite these areas of serious concern, the majority of the nation still seems unable to engage in any conversation relating to sex without turning into giggling school children or taking the chance to blindly condemn. It's easy to draw the conclusion that there is something in the British psyche that finds sex deeply strange and confusing.

Recently, Britain has found it increasingly difficult to continue its coy virgin act, pleading "don't touch me there" is unworkable as a response to the new sexual dynamic. Over the last decade things have changed in a way I'd wouldn't have believed if you'd told me as a teenager.

Restrictions imposed on sexually explicit material have been quietly dropped, the Internet provides a gateway to millions of sexual images, sex workers are taking the first steps to unionisation and porn stars regularly appear on day time talk shows.

Despite this transformation, people working in the sex industry are still only given media attention within rigidly defined parameters, often being viewed by the media and public as the modern day equivalent of Siamese twins in the freak show big top. Our combined urge to judge, label and maintain moral superiority, means we rarely hear the real voices of people working at the fringes of our society.

The ever increasing mass of programmes devoted to the sex industry that clog up the TV schedules, do little to increase our understanding of those who seek employment in the flesh trade. The aim usually is to expose the maximum amount of naked flesh, in order to draw in the post pub demographic, rather than offer any genuine insight into peoples' motives for fucking for a living. I wanted to get behind the PR campaign and tear apart the UK sex industry like a bucket of fried chicken, until all that was left was a pile of bones, connective tissue and gristle.

## I' VE GOT EYES, I LIKE TO SEE THINGS

WHEN NORMAN MAILER decided to devote his considerable talent to writing about boxing, no one raised an eyebrow, despite the low brow profile the sport had always maintained among US intellectuals. Literary critics praised his work for tackling the big themes in life: race, money and the quest for the American dream. If two men battering each other senseless for prize money can act as a metaphor for the human condition, imagine what wisdom can be gained from watching a group of thirty people blindly poking any available orifice at a swingers party?

*Flesh Trade* is an attempt to make amends for previous mistakes, to fill the gaps in the documentation of our small island's diverse sexual history. The aim of this book is simple: I'm not making my excuses and leaving when the action kicks off, I'm reaching for my notebook and asking *why*?

part
1

# Boys with the Wood

## Introducing One Eyed Jack

*T*he chief enemy of creativity is good taste
*Pablo Picasso*

## I

ALTHOUGH TOURIST GUIDES NEVER RECOMMEND IT, you can gain a good insight into the culture of a society purely by watching the pornography it produces. As a litmus test of a nation's morals, traditions and social values, it's more effective than walking through an art gallery, reading a newspaper or speaking to the locals.

Take France for example, where the adult films that are made tend to have high production values, scripted dialogue, soft focus camera work and female leads that wouldn't look out of place on a high fashion catwalk. The French sex industry likes to think it's a cut above, operating in an artistic sphere far removed from the sleazy approach of its European neighbours. Xenophobes could claim that the superior attitude of France's native adult entertainment industry is representative of its culture as a whole. People who have seen an overweight Bordeaux housewife answer *"oui"* to the question *"vous voulez sodomy?"* in a bottom of the range French sex film will have however formed their own opinion.

German folk may not have a sense of humour, but they do have a healthy appetite for watching fleshy Aryan chicks getting sodomised to a soundtrack of Teutonic yelps and oompah bands. The Hun also has no qualms about including water sports, S&M and

**13**

fisting sequences in otherwise vanilla sex productions, confirming the deep rooted suspicions of us Brits that there is still something about them that's not to be trusted.

The Danes tend to produce work best described as 'novelty items'. Scat, bestiality and 'extreme insertions' comprise the bulk of its domestic porn. Graphic animal sex may be profoundly repulsive, but Denmark is a large rural country so you can at least respect them for making the best use of the limited resources available. When William Shakespeare wrote "there is something rotten in the state of Denmark", he could quite easily have been talking about the lurid titles lining the shelves of their sex shops.

Despite their reputation as a nation of super freaks, the Dutch don't make many sex films. Amsterdam acts as a popular shooting location and has always been party central for foreign filmmakers, but its role as a distribution centre is much more important than the small number of films it produces. A trawl through the peep booths contained in most Amsterdam sex shops can however offer a surreal insight into a paraphillic selection of obscure sexual peccadilloes, some of which are so extreme they can even motivate committed atheists like myself to pray for the souls of my fellow man. This easily confirmed by anyone who has force fed guilders into a peep show cash box, to bear witness to a twenty minute loop, filmed in static close up of a man anally penetrating a goat.

Greece seems to have a national obsession with pairing off different generations of performers, with twenty something starlets performing with men old enough to be drawing their pension. Greek tourist supermarkets often keep hardcore pornography on open display, in case you need to pick up a fuck film when doing the shopping. This can represent a profound culture shock, when you're on holiday in Corfu and your children start expressing an interest in the strange video boxes.

Italy[4] is a world unto itself. In a culture where porn stars have been elected to parliament anything goes. It's no surprise that many of their films feature nuns as an object of sexual desire, and they have historically produced big budget period costume sex romps for the export market. Eastern Europe has seen a massive rise in feature film production since the Iron Curtain fell. Hundreds of films are shot in Hungary and Czechoslovakia per annum, most of them by companies who quickly realised that the stunning talent pool of female performers will work for buttons. This along with the picturesque scenery and low cost of living has started something of a porn gold rush in the region.

## AND THAN THERE IS US

CRIPPLED BY A NATIONAL sense of self doubt, defined by an inability to engage in any profound debate about sexuality — but still showing a keen taste for our filth — the majority of UK sex industry product is best described as 'Sweeny Porn', in tribute to the gritty, no frills style of the 1970s detective series. Years of strict censorship law meant the domestic trade had to develop on the fringes of legality, producing hours of video footage that was exported around the globe but rarely seen by a native audience[5].

Since the recent liberalisation of the restricted 18 category, very little has changed. Production values remain the same as they did throughout the dark days of the British Board of Film Classification iron fist. As there was never a chance of gaining classification or mainstream distribution for hardcore films, producers were unwilling to invest in a high budget. The net result was that the domestic industry produced films that were low on gloss, but high on sex. The majority of the public watched the finished product on bootleg videotape, so the profits never filtered down to the producers, which meant they were understandably reluctant to increase costs and improve quality.

Paradoxically this low budget, grainy aesthetic is now a unique selling point for our films both at home and abroad. Despite being decades behind the rest of the world, UK based smut vendors have managed to carve themselves a niche in a market overloaded with product, attracting large numbers of consumers as a result of their reality driven approach to sex. British top shelf magazines have always adopted a similar approach. Americans had *Playboy* interviews with Malcolm X.[6] We had the 'Razzle Stack', a complicated centrefold shot that featured five or six models piled on top of each other in order to increase the labia count.

In an increasingly dull pornography scene dominated by the major US and European studios, our rough and ready approach is something of a unique selling point. Filming locations are often budget flats, pubs, parks, bedsits, railway stations and chintzy suburban living rooms rather than a well dressed Hollywood soundstage. The female talent is often said to possess a girl next door quality rather than a conventional glamour girl aesthetic, although at the lower end of the market this would only be applicable if you lived next door to an inner city crack den. If a UK porn director says he is travelling to a shoot, his journey will probably involve a bus trip to Hackney rather than a flight to the Mediterranean.

This is confirmed if you watch any episode of *Fuck Truck*, a long running series by director Jim Deans (aka Phil McCavity). Filmed in the back of his cramped motor home as it travels through different British towns, the series itself comes across like a charmless hardcore reinterpretation of *On the Buses*. The theme music however sums up all that is great about British porn, incorporating the comedy 'duck quacking sound' which highlighted every lame gag in seventies British sex comedies.

Most UK porn doesn't attempt to create anything as pretentious as fantasy. Its aim is simple: to capture real people fucking, often complete with stretch marks, acne, love handles, floppy knockers and black ash furniture. Rather than watch a *Hustler* centrefold signed to an exclusive US studio contract, the average UK punter wants to see housewives take a triple plugging on a pastel coloured leather sofa, surrounded by Athena framed prints and ceramic ornaments of dogs.

Before Ugly George[7] or John Stagliano coined the phrase 'gonzo' to describe their lone man with a camcorder approach, the Brits were 'gonzo' out of financial necessity. In many ways our porn industry is not dissimilar to our mainstream cinema culture. Ken Loach and Mike Leigh may be well respected as aueters, having been showered with awards and critical acclaim, but they show no desire to dramatically increase budgets or spend vast amounts on attracting known Hollywood faces to a project. They are more comfortable telling simple human stories, without using flashy visuals, explosions, elaborate car chases and CGI imagery.

Likewise the major players in the UK sex film trade have never been tempted to invest millions in filming the first cum shot in zero gravity[8], or spend hundreds of thousands on elaborate historical sets. Why bother when this level of cinematic embellishment only distracts the viewer from enjoying a Tesco cashier from Penge take a double penetration in a pay and display car park?

## II

AS THE BMW comes screeching around the corner of High Barnet train station I guess straight away that my lift has arrived. This is confirmed as soon as I spot the driver, the unmistakable Terry Stephens, better known to connoisseurs of homegrown smut under his alias of One Eyed Jack.

Terry shoots his own gonzo line, acts as director for hire for

the girl/girl *Lubed* series and maintains an interest in a number of UK websites. After spending a few hours in his company, I get a strong sense that if people are fucking anywhere in the UK, he would happily turn up with his camera and lighting rig to capture the action.

Terry's smut is as British as it gets. Ask him to describe the approach he adopts when filming and he will tell you the following: "Raw, real and spontaneous. None of my shoots are scripted and I've never spoon fed performers cheesy lines. I'll admit I tried it a couple of times but it was too tacky for me. Not many people can act when they are fucking."

In *Hard Days at the Orifice*, one of his past releases, Terry shot a three way sex scene in the back of a taxi as it crawls through central London. As confused pedestrians do a double take when they glance inside the cab, Terry focuses his camera as much on Buckingham Palace, Piccadilly Circus and Trafalgar Square as he does the frantic sex. The only way he could make his films more evocative of Blighty, would be to dress his male performers in Beefeater costumes and insist the girls sing the National Anthem whilst taking a rigorous anal pounding.

As a nation we may not be able to produce a world cup winning football squad, but we do seem to have a natural ability to make smut which manages the difficult balancing act of raising a smile, as well as an erection.

Terry also has a reputation for shooting in public places, something that endears him to the fans, but is unlikely to impress the British Board of Film Classification, who take a firm line on outdoor sex. In one sequence from the same film, Jirina, the female lead, starts sucking cock in the first class carriage of a train pulling into Charing Cross station. A perplexed commuter sits in silence on the next seat, a wry smile indicating that he's not the sort of guy to take offence at displays of public indecency.

In his One Eyed Jack line, Terry Stephens provides ample evidence of the missing link between modern day UK hardcore and nostalgic teenage memories of watching Robin Askwith shag negligee wearing housewives in the *Confessions* series. Although it is always full on, the sex is never taken that seriously. A grope of tit is incomplete without a thumbs up, giggling or a broad grin and the people taking part, both male and female, always look like they are having a great time. In a global porn scene often dominated by a sterile, conveyer belt approach to sex, it's refreshing to finally see people enjoying themselves. Even the most humourless critic

of smut would be hard pressed not to see the funny side. Terry is not keen to trade on his nice guy image, but he is undisputedly a nice guy. Open, intelligent, honest and committed, he seems like he'd be a great bloke to work for.

After a short car journey through suburban North London we arrive at Terry's pad. A house situated in a quiet residential street, which looks like it sees its fair share of curtain twitching. Inside the house is Lindi (aka Mr Slurpy), the star of a number of Terry's releases. He's watching Quincy with the volume turned down when I arrive. "You can keep your blow jobs, I'm all about the pussy," he tells me in his thick Jamaican accent.

I'm struck by a powerful sense of déjà vu when I walk into the room, which soon passes when I realise that the sofa I'm sat on has appeared in a number of Terry's films. If furniture could communicate a sexual history, this one would come with a 'Parental Advisory: Explicit Lyrics' sticker attached, given that it has played host to many penetrated smut starlets over the years. The place in general screams bachelor pad, and not just because there's a vast library of pornography on the shelves, although it's a sign of the filth related embarrassment of riches that I'm given a porn DVD to use as a mug coaster. Terry is obviously a techie, the curse of the thirty something male with a disposable income, which explains the video duplication set up, two televisions, PlayStation and wafer thin computer.

People seem to think that a career in smut is a recipe for making a million overnight, but after meeting a number of producers, this is definitely not the case. Terry is at heart a self employed businessman, subject to the same day to day cash flow hassles as a newsagent, baker or publican. "As far as money goes, it's either a feast or a famine," he tells me. Whilst long established players like David Sullivan may have the income to build vast mansions, own a stable of racehorses and set up poor quality newspapers, the majority of people making a living in the smut business will earn a much smaller salary, although the fringe benefit of regular sex probably helps to soften the blow.

Like many people in the gash business I have met, Terry's a big fan of gadgets, especially cameras. He's been playing with them since he was a kid, so a move into pornography was probably always written in his stars. Terry got his start in the flesh trade in 1996, distributing filth door to door, after running off pirate copies of porn movies and advertising them in *Loot*, the small ads paper. The move into production came shortly afterwards. "I was asked

by a regular customer to make a video of him and another woman. Another customer who was interested agreed to let me use his girlfriend to make up a threesome. My most enduring memory of that shoot was seeing this guy's dick popping out of this woman's pussy while the other guy put it back in for him. I've never been that accommodating."

Over time Terry started investing cash in hiring professional models for video shoots. Making the move from cameraman to performing for one simple reason: "I didn't want to pay the guys. It was more about the film, than getting a leg over. Unless you've done it, you'll never realise how much hard work it is. If it was just about the sex, I wouldn't bother with the camera."

Terry sent his debut video to Your Choice, the British owned, Amsterdam based company who provided a beacon of light to native masturbators throughout the dark days of sexual prohibition in the UK. They distribute a line called *Viewers Wives*, encouraging their customers to set up a tripod in the bedroom and submit the results for a cash fee, along with the erotic frisson of knowing that their sex lives will be eagerly viewed by a large one handed audience. They liked Terry's work, and as a result he received his first pay cheque as a producer of filth in a business partnership that exists to this day.

Being a dick for hire in the sex industry may be perceived as a dream job, but the reality of a porn set is much harsher. Just ask the hundreds of wannabe studs who turn up for their debut shoots, only to be humiliated when they end up standing in front of their female lead, desperately pulling at their elastic penises in a vain attempt to get wood. Lindsay Honey (aka Ben Dover), the highest profile domestic pornographer is on record as saying that British men are incapable of fucking on camera, the sole reason he imports his dick flesh from Europe.

It takes an Olympian talent to get hard and ejaculate on film, especially when you take into account that Terry is often holding the camera at the same time he's thrusting into his co-star. Viagra would seem to offer the perfect solution, but Terry is keen to point out that his performances are always clean and serene, achieved without the assistance of performance enhancers. "People use it, but tend to keep it quiet. I worked with one guy on a shoot whose dick started bleeding after taking it. I don't believe in that, as far as I'm concerned you should always go on natural sex drive."

People who don't watch pornography, probably still labour under the illusion that all you have to do to make sex films, is

set up a camcorder on a tripod and ask your cast to start fucking. This takes no account of the fact that some pornographers take great pride in the technical aspects of their work, some displaying a skill for direction, lighting and editing on a par with their mainstream comrades. Every comedy spoof on pornography you watch still subscribes to the idea that sex films exist in a world of moustaches, flares and jumpy 16mm film stock. This is ironic when you take into account that porn producers have always been first in the queue to adapt new technology to the production of wank fodder. The crystal clear clarity of digital video was being utilised by smut directors, long before straight film directors like Spike Lee and Mike Figgis started shooting critically acclaimed, low budget features on the format.

A dawn knock at the door is a widely accepted occupational hazard for UK pornographers, especially in the dark days before the prohibition on sexually explicit material was relaxed in 2000. "I made videos for people on the agreement I could sell them on through my delivery and mail order business," Terry tells me.

"My services came to the attention of the constabulary and I was raided by eight policemen from the Clubs and Vice unit of Charing Cross Police, charged for selling obscene materials for gain and subjected to a two year court battle." Terry tells me the police were polite throughout, a recurring theme of smut raids, which indicates that the dirty squad don't necessarily see the war on porn as a high priority. "When the case came to trial, the court recorder had to read out a list of all the seized titles. She could hardly keep a straight face. When she got to *Hungry Cunts* you could see the jury looking at the floor to stop themselves laughing." Terry escaped court with a fine and community service sentence and hasn't looked back since.

Like most people in the adult entertainment business, Terry is acutely aware of the way society tends to judge people involved in the sex trade, although deep down I'm guessing that he doesn't really give a fuck.

"No one wants to hear about a girl with a high sex drive who gets into the business solely to become famous for the love of her chosen craft and become successful from it. The media finds it more interesting to see us producers as lecherous, money grabbing, baby eating monsters that exploit pretty young girls and corrupt them. I suppose if a vigilante came in and wiped us all out Charles Bronson style that would be an acceptable ending."

Despite this understanding of the negative way the general pub-

lic chooses to view his career, you only have to spend a few minutes in the company of Terry to realise that this is a man who loves his work. "Some women are really into pornography," Terry tells me. "I had a girlfriend who had nothing to do with this industry and she'd always be asking for me to put pornography on."

I ask Terry if fucking for a living has desensitised him to sex.

"There's too many performers with a workman like attitude," Terry tells me. "The sex ends up passionless and robotic in most films. I take for granted all the hardcore stuff like anal now, so I guess I am desensitised to a point. I find it easy to detach myself from the sex. A while back I was filming a girl/girl scene and one of the performers asked me if I was turned on. I get turned on by the idea that the video will come out well, but if I get a hard on when filming I get distracted and the camera ends up shaking."

Terry looks different to the majority of the other male performers you see fucking on film. In the sense that he doesn't seem to share the gym obsession evident in some of his porno peers. He's a big guy, not fat by any stretch of the imagination, but starting to show the first signs of the weight gain that tends to curse men as they celebrate their thirtieth birthday. His lack of a six pack and defined pectorals does however seem to give him a positive advantage, making it easier for the punters to imagine themselves in the same position when he's boning the ladies.

What he lacks in toned physique however, he makes up in cock. Playing host to a thick, purple headed monster of a dick that conforms to all the clichés of black guys being well hung.

Race is generally an inflammatory topic, and never more so than when it applies to black dicks in white chicks. Careers have been made by people subjecting the sex industry to extended spells under the microscope, trawling for any hint of abuse, exploitation or coercion among performers, so critics are myopic when it comes to seeing any good points. Despite this, Terry's work, along with other high profile black British producers like Omar Williams, proves that for all its faults UK pornography is at least an apartheid free zone. Something you could never say about the sex industry across the Atlantic.

Memories of slavery, lynching and bloody civil rights battles add a bitter dimension to the race dynamic in the States, that has never been evident in British society. Lexington Steele, a high profile American performer and previous winner of three AVN[9] awards, has expressed dismay at the large number of female performers who have refused to work with him during his career, although

the reason they give tends to be based on economics rather than racism. If a female performer has shot black on white scenes, she can find bookings for feature dancing gigs tend to disappear in some of the more conservative US states. The dance circuit is a major money spinner for women in the American sex industry, and many refuse to risk reducing their earnings to improve ethnic diversity on planet porn. Watching black US performers like Mr Marcus or Lexington Steele plough into immaculate blond pussy, brings to the surface barely suppressed racist stereotypes that still have the power to offend bigoted audiences in the Southern states or the American midwest.

The frenzied negro. Sex crazed niggers, bug eyed, aggressive, hung like a donkey and ready to 'rape dem white bitches' at the drop of a watermelon. A perception of afro American ethnicity has led to many documented miscarriages of justice, especially when a black man found himself in front of an all white jury for mixing with forbidden snow white flesh.

Although, you'd tend to think that people of different colours fucking, would cease to be a problem in this enlightened age, you would be very wrong. It's not just racist US white folk who are responsible for this state of affairs, taboos about inter-racial sex are as strongly held in Caribbean and Asian communities as they are on predominantly white UK council estates.

Luckily in the relaxed world of British porn, it's all about the fucking, so people tend to be colour blind. Race is never an issue as long as there is wall to wall sex on offer and Terry is a man with a reputation for delivering the goods time and time again. "It's funny, because there's a lot of racism in the states, but inter-racial material is one of the biggest sellers. I can't figure it out. Racism just isn't as prevalent in this country. There are more mixed race relationships going on. Pornography is about fantasy, so the idea of watching a girl get fucked by a big black dick is not a problem," Terry tells me.

"Yeah, on video," Lindi replies laughing. "There's a big difference between the US and the UK. In Britain there isn't the culture of Christian fundamentalism, which is partly the reason why inter-racial material doesn't work in the American south. Britain is grey, there isn't so much distance between black and white," he adds.

It seems that despite its general perception as a disagreeable business motivated by greed and misogyny, British pornography actively embraces the concept of the melting pot. Because the

majority tend to condemn pornography as a matter of routine, it has as a result become a genuine sexual democracy, unafraid of breaking all taboos. Race may be a topic deemed persona non gratis in straight society, but given that British pornography operates at the margins in a world untouched by social conditioning, it is capable of teaching mainstream society much about the concept of tolerance, unity and the act of getting it on with our coffee coloured brethren. If you're still not convinced that pornography is taking the lead, try and name a recent Hollywood blockbuster where the romantic subplot involved a mixed race relationship.

Critics could claim that asking a pornographer if everything is healthy in the sex business is similar to getting a psychic reading from a gypsy fortune teller, only to be told that you can never have enough pegs.

Despite this, like everyone I meet, I ask if there is any truth in the widely held belief that women in the sex industry always come from difficult backgrounds. "I'd say about forty per cent of women in the industry come with a certain amount of baggage, but the majority just want to fuck," Lindi responds. "The general consensus on most of the girls is they do it equally to have fun and to make some money," Terry adds.

"We put an advert in a magazine and you would not believe the response we got from women. Just calling up and saying 'we want to do this'. We used to operate a casting couch, not in the sense of them stripping off or anything, more sitting down having a conversation. We would ask 'why do you want to do this?'. You know, tell them that there is no guarantee that it won't be seen by people in this country, we'd go through all these little things with them. That's why I know there's a change in attitudes in this country. People do it now for excitement, something to do for a year or so of their lives. Others do it for the money side of things, and obviously a lot of people do it because they like to get paid to have sex," Lindi adds.

Speaking of money, I tell Terry why everyone I have spoken to so far has been reluctant to discuss the money women earn in the smut game. Terry doesn't share their sensitivity. "There is a general industry standard of £250–£300 per scene, £350 for anal and double penetration. I always tend to pay anal money. I want people to feel comfortable and empowered to perform on their own terms. I never subject anyone to any kind of force or blackmail. I'm easy going, it's up to the performer to draw the line," he tells me.

If Terry has a trademark, apart from his reputation for shooting

gritty, no frills sex in public locations, it would be his unbounded enthusiasm for anal sex. Including taking the opportunity to include 'gapers' whenever the opportunity arises. Any casual punter searching the titles in a sex shop will be well aware of this, if only because a title like *Every Hole's a Goal* gives little scope for consumer confusion.

A long established tradition in US fuck films at the rain coater end of the market, a 'gaper' is a close up shot of the starlet's dilated anus, cheeks spread apart, following penetration. Terry seems happy to accept a degree of blame, or indeed credit (depending on your aesthetic viewpoint) for putting gapers on the UK map. "You can't win on this subject of anal. It's down to everyone's subjective tastes. I hold my hands up to some questionable envelope pushing shoots," Terry said, when the proliferation of over graphic anal sex in Brit porn was raised recently on an Internet forum.

"No one ever says anything about the models. There are some who have a taste for the extreme. I could name drop several that personally like to push the boundaries a bit further than their peers would like. Let's face it, if you have a girl who comes to you on the day and tells you she can fist her own arse, what do you do? If it were a more extreme demand I would say no, even if the model wanted to do it. Fact is I have shot many a scene with and many a scene without anal. I only work with consenting models that I have a chat with beforehand about how far they would like to go. To quote one well known model who shall remain nameless, "The kind of video I would like to make, no one could shoot because everyone would get arrested and no one would be man enough to do it. Female sexuality can sometimes be scary."

Whilst some folk give praise to God for slutty women, others tend to take the moral high ground. Female sexuality is a topic that has only been afforded any serious discussion over the last few decades and a number of people would like it to stay that way. Before the permissive sixties, any suggestion that the female of the species had sexual horizons that extended beyond a three minute fuck in the missionary position, would have been met by contemptuous laughter. Over the last few decades however, the complex nature of female sexuality has slowly begun to emerge. Not only do women enjoy sex, but they are quite capable of dreaming up sexual fantasies more perverse, imaginative and twisted than men. Women have battled hard to benefit from the same human rights enjoyed by men, and I am sure some of them hoped that these would extend to the sexual arena. Sadly, female performers in the sex industry

still find themselves in a difficult situation. Accepting that they love sex, and as a result choosing to make a living mixing business with pleasure, means they are often subject to outraged voices claiming they are little more than shameless sluts. The loudest of these voices are not coming from the traditional enemy, but from within their own ranks. Despite an understanding that their freedom of expression has historically been suppressed, concealed and censored by men, some feminists choose to ignore the fact that this is exactly what they are doing themselves when they criticise women who make an informed decision to fuck on film. Ironic, when you take into account that it is always men who are accused of upholding double standards when it comes to sex.

Film director John Waters is quoted as saying "there is good bad taste and there is bad bad taste". After watching Terry's work most people would end up drawing the conclusion that he falls into the first category. Some people may believe that he shoots mindless filth that is deeply offensive, but the protagonists always look like they are having such a good time the end result is almost wholesome.

The vast chasm between the industry at home and the sex trade Stateside becomes obvious, when you take into account that Terry's One Eyed Jack line was for a number of years distributed in the US by the notorious Extreme Associates production company. Owned by Robert Zichari (aka Rob Black), director of films like *Cellar Dweller, Extreme Teen, Fuck my Dirty Shithole* and *Don't Tell Mom, But the Baby Sitter Fucked Me.* Zichari's titles have been vilified by his many critics, with some of the loudest voices of protest coming from within the sex industry itself. Zichari stands accused of pretty much everything, from transgressing acceptable boundaries of bad taste to serious concerns related to the pathological levels of misogyny he tends to adopt in his movies. This ultimately reached its conclusion when the film *Forced Entry*, a hardcore title dealing with rape and murder, recently came to the attention of the FBI. They raided the company's LA office in June 2003, seizing five titles and bringing obscenity charges against Extreme Associates that may well result in a lengthy custodial sentence when the case comes to trial.

"We come from a background of having strong women in our families. My mum knows how I make my living; she's cool about it, accepting of what I do. She makes jokes about it from time to time," Terry tells me.

"I don't subscribe to that derogatory, misogynistic title thing

you see in the states. Producers calling their films 'Ass Whores' or 'Cum Drinking Sluts', if I was buying them as a punter I'd be embarrassed to be honest," he adds.

In response to my question about what he would do if his son or daughter vocalised an interest in entering the business (a contractual obligation for any journalist covering the flesh trade), Terry replies, "I'd ask her why. If it was about the money we could sort that out. If she still wanted to do it, I'd make sure she knew the producers to avoid and tell her about the good ones."

Terry is the same age as me, so he's had a very similar experience of the multitude of scams historically adopted by British pornographers, who have always been happy to exploit the rigid UK obscenity laws to extract more cash from horny punters. "You still go into sex shops and find pictures of models on the cover of video releases who have never done hardcore. The approach among some people in the industry, as it relates to the consumer still seems to be 'you suckers!'"

In direct contrast, Terry's business manifesto is transparent. Namely to produce quality muck at a reasonable price. One of the reasons why he doesn't currently seek BBFC certification for his One Eyed Jack releases, choosing instead to distribute them on an unclassified basis through Your Choice.

The current fee payable, if you'd like the Board to examine your film, is £11 a minute (excluding VAT). This is a set fee, regardless of the content, genre or budget of the work submitted. It means producers seeking a certificate for a British sex film with a budget of £4,000 pay exactly the same amount as a Hollywood studio seeking the go ahead to release a $50,000,000 Jim Carrey blockbuster. Smut peddlers often complain they have to spend twenty-five per cent of their total budget costs on the classification process, meaning when it comes to retailing their product to the one handed consumer, they have to sell hundreds of additional copies just to cover the BBFC fees. "The restricted 18 certificate has a number of flaws," Terry tells me. "You can walk into any newsagent and pick up a hardcore magazine from the top shelf that shows explicit sex, but the controls on video are still incredibly tight."

As the interview winds down, I bid farewell to Lindi, and Terry drops me back at the train station. Before I leave I ask him if he thinks it is possible to watch too much porn. I have a vision in my mind of some of the people I've spoken to over the last few months, who happily vocalise that they spend more on porn each month than rent.

"If someone is reluctant to engage with reality as a result of watching porn, than yes. But I also think that if there is enough passion in the finished product, pornography can come close to art," Terry says as I leave the car.

Regardless of your feelings on the ready availability of sexually explicit material, the work of Terry Stephens serves one vital purpose. It destroys the long held perception that as a nation we are sexually repressed, whilst also denying the myth that we are still suffering from a sexual hangover passed on by our puritan Victorian grandfathers. There is a generation of both men and women in the UK, who don't necessarily subscribe to the widely accepted dogma which states that pornography is inherently bad for society. In a world where everything is for sale why do people express outrage when sex becomes just another commodity?

Even better, next time you take your dog for a walk in North London, keep your eyes peeled for a smiling guy with dreads holding a camcorder. If you ask nicely I'm sure Terry would be happy to give you a cameo role in one of his home grown fuck epics.

# Love Spreads

## The Curious World of the British Sex Party
### Part I

**I have seen women with cum on their faces in pornography so often, that's how they all look now**
*Peter Sotos*[10]

### I

ANY JOURNEY INTO UNCHARTED SEXUAL WATER WILL manage to throw up bizarre practices for journalistic voyeurs to feign disgust. Take for example the new bukkake[11] craze, which has recently swept the British adult entertainment industry like typhoid.

It's a new variation on an age old theme, which arrives in the UK after being filtered through the brutal blender of Japanese and American porno culture. As always, the British tend to adopt a low key approach to our sexual peccadilloes in direct contrast to our brasher US cousins. This means that despite a thriving domestic scene, UK bukkake has so far remained a strictly underground activity.

One that is hidden from the judgmental eye of the mainstream, existing purely on a word of mouth, need to know basis. I'll avoid the urge to use the term 'shadowy' because this would imply people's motives are in some way sinister.

Draw your own conclusions, but do so after you take into account this important fact. Like the native sex industry as a whole, bukkake is based strongly on the principle of informed consent. It may in some people's opinion be strange, deviant, peculiar, even

**28**

profoundly repulsive, but there are people out there keen to give it a go, both male and female. With this in mind let's be adult, and adopt a 'different strokes for different folks' approach before we call for any of the participants to be tied to a stake. Enough of the lengthy disclaimer, what is this bukkake thing?

In short, bukkake drags the sex industry's obsession with the visible facial cum shot screaming to the furthest extreme. Our female starlet Victoria (*name changed*) will arrive in the back room of the venue, usually the upstairs of a pub, a private house or a hired room in a motorway travel tavern. As the camera crew set up their equipment, our performer will go into her 'dressing room' (most likely the toilet) in order to change into the regulation slut uniform that she's chosen for the main event. This will be a variation on the long established heterosexual fantasy of a nurse, schoolgirl, French maid or policewoman. Sometimes she will just strip and work naked if her fee doesn't include a costume budget.

As she applies the last layer of foundation and touches up her lip gloss, she will take a deep breath and walk out to face her public. As they whoop and cheer at her arrival, straining to get a better look, she'll kneel down on the dance floor, maybe flashing her breasts or spreading her labia as an entrée. The baying mob will form an orderly queue, beady eyes focused on their object of desire, acutely aware that after the long wait kick off time has finally arrived.

Slowly, patiently, one by one, over the course of the afternoon, the men in the room will take it in turns to wank furiously under the halogen glare of the video lights. Every stroke captured on film for prosperity. Safe in the knowledge that the crew taping the event will carefully avoid picking out any distinguishing features, such as close ups on faces, tattoos or unique jewellery that could give away the male performers' identity to friends or family who may watch the tape in the future.

Struggling to retain wood, as they sweat under the hot lights, worrying throughout that their impatient peers may well be mumbling that they are taking too long, the male cast will try and put the camera out of their mind as they concentrate on the job in hand. This curious ritual will continue, until each and every man finally manages to shoot his muck. Cough their filthy yoghurt. Deliver the 'money shot'.

Every time a man emits a low groan indicating that their urethra is about to go into spasm, Victoria will move closer towards the man's groin, directing her face towards the trajectory of his

seminal arc. Over the course of the afternoon, as line after line of men trawl through the building to take part, Victoria's face will slowly begin to resemble melting sugar icing on a cake left out in the sun on a balmy August day.

## II

SUCH A PERVERSE PRACTICE could only have been dreamt up recently, right?

Strangely enough this statement doesn't tell the full story, because as much as the contemporary sex industry likes to think it has a monopoly on inventing new lapses in taste and decency, there are a number of historical precedents for this very modern behaviour. You could easily imagine that fertility rites in pagan Britain could follow a similar template to the modern day bukkake party. Semen was seen as a panacea to cure all ills, thought to fight disease, act as a healer for wounds and protect those receiving it from misfortune and evil influence. Given the sheer number of men taking part in modern day bukkake parties, Victoria can at least be confident that she's not going to get her car clamped in the near future.

Whilst an entire village of pagans spanking the monkey around a stone circle may seem a little far fetched, freaky or indeed disturbing, just think about the widespread sacrifice of children at the time and ancient bukkake events start to seem vanilla in comparison.

There's no prize for guessing that bukkake's spiritual home is based in the Land of the Rising Sun. The Japanese sex industry has always shown a frenzied taste for female degradation[12], which remains defiantly mainstream, rather than hidden in the darkest corner of the small ads as it is in the West. Their domestic smut industry has long had the power to offend even the most liberal Western sensibilities, something they are themselves acutely aware of. Entry to the red light district in any Japanese city remains forbidden for the Western male. Tourists are often politely turned away at the door of sex shows, porn cinemas and brothels and encouraged to seek titillation at establishments more rooted in mainstream Western pleasures. Porn distribution companies mostly refuse to ship video or DVD to the US or Europe, so, much like Japanese culture as a whole, the native sex industry retains an air of mystique purely because it is impossible to access.

The current orthodoxy states that modern day bukkake is an

updating of an ancient Japanese rural punishment. Adulterous women were tied to a pole in the village square, or buried in sand, leaving just their faces exposed, whilst the honourable men folk took it in turns to torment them by waving their dicks in her face and serving up a punishment cum bath. For a culture where any perceived loss of dignity remains the worst possible case scenario, many of the fallen strumpets were said to have fled the village immediately after their punishment. Sometimes they would kill themselves rather than continuing to live with the constant re-minders of the humiliation they had suffered at the hands (or more literally, dicks) of their peers.

In reality however, bukkake results from a modern, practical tradition rather than any historical precedent. Japanese pornog-raphy has always used post-production mosaics on images that fall foul of native taste and decency law. For example, the display of pubic hair has always been strictly forbidden, watch any Japanese pornography and the female groin will always be pixilated. This means that the consumer never sees close up shots of penetra-tion. To prove that the sex is not stimulated, great importance has always been placed on ejaculation in Japanese sex cinema, a cultural peculiarity that gives a strong clue to the genuine roots of bukkake.

Given the history, you'd think it would be impossible not to claim that modern day bukkake is by its very nature a ritualised process of female degradation. But as you often learn when you take a close look at the motivations of people involved in the sex industry, some things just aren't that black and white. Not only are the male participants queuing around the block to take part, there seems to be a never ending line of women willing to offer themselves up as spunk covered Goddesses, objects of adoration and worship to the hardcore bukkake fanatic.

## III

THERE ARE FREQUENT adverts in a number of sex related publications, along with many Internet forums asking for male bukkake participants. When I contact the advertised mobile number and outline my journalistic interest however, I receive a rigid 'no comment' from the majority of the protagonists. This reluctance to talk openly is easy to understand, given that the law as it stands is very hazy.

The general perception is that organising parties may put the female performers involved at risk of an arrest for soliciting. Recording the event and selling copies to the punters, without first paying a fee to the British Board of Film Classification for a certificate is however strictly illegal. As videos tend to provide the major income stream, I guess people may have thought that I was a maverick Trading Standards officer with a keen eye for the promotion opportunity.

After weeks spent trying, someone involved in the recruitment of male participants for parties finally agrees to talk to me, but only after a series of cryptic emails and phone calls, which make me feel like I'm organising the sale of depleted uranium to a terrorist group rather than trying to work out why so many men want to line up to cum in the face of a complete stranger.

Eventually I speak to Dave (*name changed*) a self confessed newcomer to the scene whose interest is both professional and personal. As well as organising the venue, girls, recording equipment and refreshments, he's always first in line to start proceedings. The fringe benefit of being a bukkake Mr Big is you get to unleash the pre-emptive strike which signals the shower of fuck butter landing on the female star's face. As soon as I talk to Dave I realise that this is a man who is very happy in his work. He shows a lot of passion when he discusses his parties, a good move given that my career adviser always said it was wise to do a job that you saw more as your hobby.

Dave has been making a living on the fringes of the flesh trade for a decade now, booking strippers, organising 'gentlemen's afternoons' and recently devoting all his free time to his new found bukkake obsession. He loves the scene because it gives him a healthy wedge on top of the day job. Despite my repeated requests he's unwilling to disclose just exactly what the day job is. Given his treacle thick East End accent, I'm guessing he'd be perfectly suited to selling dodgy meat over the scratchy PA of a butchers market stall.

Dave tells me that in the past month he's organised 'The UK Ultimate Bukkake Party' in a London boozer, which broke the record for the number of men in attendance at a British event. For the hard working deviant, Dave had organised both an evening and a matinee performance, the aim being to draw in the horny office lunchtime crowd.

Three women had taken part, with a male cast of twenty-eight and to quote Dave's excited voice directly: "They were caked in

jizz after ten minutes!" Like many people I speak to over the time I've been writing this book, I realise that Dave tends to embellish things a little. I ask him if he can send me a VHS or DVD copy of the event for 'research' purposes (a literary defence now very much out of favour following the Pete Townsend case). He agrees, but only after suggesting that I pay the full £25 charge. I batter him down to a fiver to cover postage. He promises to stay in touch and we say our reluctant goodbyes.

## IV

THE TAPE ARRIVES just days later and that very evening I press play, ready to bear witness to the mythical act of bukkake, as shot on a bottom of the range Dixon camcorder. As soon as the first visual comes flickering to life, I realise that this is not by any stretch of the imagination a legit porno production. Straight away you realise that it has more in common with home video footage of my nan getting pissed up last Christmas, than it does Jenna Jameson getting rear ended in a US high end fuck film.

There's a vibe to it that is equal parts squalid, exciting and profound.

The setting is a down on its luck pub. The last event held in this nicotine coloured function room was most likely a wedding between two recent divorcees, or an eighteenth birthday drug party and piss up. There's a small dance floor, missing the decks and funky rope lighting of the resident DJ, a small bar (with the shutters closed) and a motley selection of chairs covered in crimson vinyl scattered around the room. A trestle table holds a cash box, model release forms and a thick stack of pornographic magazines. This is where the male participants register for the event[13].

Soft rock plays on the soundtrack and small groups of embarrassed men mill about smoking fags and drinking cans of lager. To signal the main event the lights are dimmed, although throughout the film the action takes place in the full glare of the overhead fluorescents, giving the cast an eerie whiteness, hinting that they might well live underground and only risk daylight when the chance to soil a complete stranger presents itself.

Our starlet enters stage left. She looks happy enough. Comfortable with the task in hand. She shows no concerns that her role today is purely to act as a flesh canvas that will be sprayed with wads of spunk until her face resembles a Jackson Pollock abstract.

Removing her dressing gown and resting her knees on a pillow, there's a vague mumbling among the men folk as they eye up the prize. Given the nature of the event our star doesn't give the impression of being as far down the porno performer food chain as I expected. She's cute: nice hair, works out at the gym and has a well performed breast augmentation that doesn't display horrific scarring like some of her colleagues.

If you take away any moral concerns you have regarding sex workers, you quickly realise that this is a woman punching the clock. Like all of us who have undertaken the nine to five grind, she's counting down the hours until she can go home, turn up the stereo and have the first of many glasses of wine. The malaise you get as a result of performing at bukkake events is probably no different to the frustration I used to feel when I arrived for an eight hour shift lifting cereal packets in a warehouse.

I've never really understood the feminist argument, that there is no such thing as 'informed consent' if women feel pressured to fuck on film out of socio-economic necessity. If that is the case, than surely it's capitalism rather than sleazy men that should take the blame for the predicament some sisters find themselves in? I've known men that have been fucked over their entire working lives, retiring early to find that their lungs have become clogged with dust from heavy industry, but I don't see women who wear comfortable shoes forming movements to bitch about it.

*Return to video:*

A whippet thin man sporting shades and a baseball hat approaches Victoria, he drops his jeans and frantically starts tugging at his putty like dick in a vain attempt to bring it to life. As he starts cranking other men move forward, crowding round like a pride of lions tearing into a freshly caught zebra. In the midst of this blurred wank frenzy, Victoria offers vocal support and on occasion touches the odd cock in a bid to speed up the milking process[14]. Given the poor stock of men taking part, I'd happily forgive her if she decided to treat the swollen dick flesh on offer in the same way Superman handles kryptonite.

Five minutes in and we get our first money shot. You get a psychic sense of when this is about to happen because all the other participants move suddenly to avoid getting any spunk on their leisurewear. God forbid that they too get soiled by the secretions of their fellow bukkake ninjas. As soon as one man has delivered his filthy package, another slob will rush forward to fill the gap.

The enthusiasm from the male cast is terrifying. As soon as they spot their chance they rush forward like Meat Loaf attacking a buffet table. On occasion there is good natured giggling when one of their deviant peers reaches nirvana before them, and they are forced back to wait in the line, their faces radiating the same sense of disappointment as a toddler refused sweets at a supermarket checkout.

Over the next two hours (yup, you heard right, *two hours*) fifteen men pass through the line. Some wear masks in a bid to avoid being identified. Leading to a number of surreal moments as I witness Tony Blair bashing the bishop on two separate occasions, an overweight Elvis struggling to retain an erection, and a terrifying bloke who wears a rape balaclava who hasn't had the decency to remove his socks.

Sometimes you get answers to the big questions in life in the most inappropriate settings. If you were looking for a single visual image that sums up the futility of all human existence, then sit mouth agape, hypnotised by the sight of a morbidly obese man wanking for fifteen minutes without a single camera change and you will start to question everything you ever believed in.

There's more existential angst in watching this hirsute fatty cracking one off than the contents of the Sartre back catalogue. Brave enough to perform unmasked, his contorted face suggests a hearty portion of shame, served with a side dish of loneliness, suffering and self loathing. He probably wants nothing more than to form a relationship with a nice woman. Dinner, theatre, trips to the zoo and romantic cuddles. Sadly the only human contact he can maintain appears to involve ejaculating into the face of a stranger. If he had any friends or family surely he'd have had the decency to wear a mask like his peers, preventing me bearing witness to his jiggling, undulating, fleshy jowls as he struggles like a trooper with his disobedient cock. After an eternity he finally lets loose, a stringy splash of spunk hitting the bull's eye, sitting like a lifeless albino slug on the cheek of our starlet. As he zips up he stares down to admire his work and in a croaky voice says: "Thanks." Being a true gent, he'd probably lean forward to kiss the back of her hand but he's noticed that it's coated in a thick protein stew from the day's periapic activities, so to a round of applause he leaves the dance floor grinning like a cheshire cat.

I watch the rest of the tape on fast forward, realising that Benny Hill was bang on the money: there really is nothing funnier than watching sexual activity speeded up for comedy effect.

## V

A FEW WEEKS LATER, Dave rings me, barely concealed agitation in his voice. It seems that he's having problems getting a full quota of men for his next event: 'Ultimate UK Bukkake II' (taking place in picturesque Croyden), which for the first time is being streamed online so armchair voyeurs can join in the action at home. I joke that 'Ultimate UK Bukkake II' sounds like natural territory for a Sky Digital pay per view event and it's a sign of Dave's desperation that he takes me seriously and asks how I'd pitch the idea to a television producer. Dave tells me that there are so many bandwagon jumpers, the market is rapidly becoming saturated with parties over the next few months. From its humble beginnings at the furthest margins, bukkake appears to be becoming a viable money spinner for the adult entertainment industry. Dave is a small fish in a big pond and his operation is rapidly becoming sidelined by big business, so now he finds himself involved in a Dave versus Goliath battle.

Dave has decided to follow the lowest common denominator and focus his attention on the gang bang and watersport genres. With rising excitement in his voice he asks for a copy of the finished article and says he will get in touch when his first 'Fifty Man Gang Bang Extravaganza' gets underway.

Dave never does get in touch again, disappearing from the flesh trade soon after. A number of emails and phone calls yield no positive result and like many people who work in the sex industry he disappears without trace overnight. Given the quality evident in Dave's video productions, I'm starting to think he was never really a player; a keen amateur rather than a business motivated by the pay cheque. I take solace in the fact that karma means we are destined to hook up again, probably when I hear him pitching 'ten sausages for a pound' when I'm next walking through Bethnal Green market.

Bukkake offends women for the same reason *Daily Mail* readers are outraged by asylum seekers: FEAR. They see bukkake as degrading and inhuman, a pernicious manifesto devoted to their ritual humiliation.

Although this reaction is understandable, it fails to take any account of Dave's love of women. When we chat on the phone he talks about the girls taking part in his parties in the sensitive, hushed tone of a man blinded by love. To him the women are not just empty vessels whose sole purpose in life is to act as a sponge

to male body fluids, they are the living embodiment of women as Goddess. If bukkake was just about sex than it would be much easier to talk about, he tells me over the phone.

Pushing him to expand, Dave starts to tell me how he sees the parties as an almost spiritual experience. A cathartic display of the esteem and love he has for the fairer sex. This is about respect he tells me, rather than an attempt to humiliate an entire gender for the crimes of one of their sisters who had refused Dave a dance at a school disco.

This was not something I was expecting. The impulse for men to indulge in sleazy sexual activity, especially when together in a group is easily understandable. The idea that bukkake represents something more profound than the chance to indulge in gross indecency is a much more difficult concept to swallow.

For example, don't labour under the illusion that the men blindly purge their muck into the female's face without thinking about what they are doing. Much like Kung Fu there are a number of specific moves you must master before you can achieve the status of bukkake samurai. There's the 'crossing of the swan' (aiming for both eyebrows), 'breaking the ox' (a direct hit on the cheek), along with a number of fiendishly complicated variations that sound very similar to the moves taught by Mr Miyagi in *Karate Kid*. Male performers often deny themselves the pleasures of self stimuli for days before a party, in order to get their man slime as thick as wallpaper paste for the main event. Like Olympic athletes they are reluctant to risk their performance on the day by submitting to any sexual urges during training.

Someone who does see bukkake as a pay cheque, rather than an act of worship on a par with Holy Communion is Dawn (*name changed*), a regular performer at parties who kindly agreed to discuss the scene with me.

Dawn has a squeaky, girlish voice that is powerful enough to raise a stalk on a dead man. She's keen to vocalise that she makes her own decisions in life, and takes great offence at what she describes as 'people telling me I'm letting the side down'.

She started accepting invitations for parties after working as a stripper and shooting films for a satellite fuck channel. She decided this was a much less stressful way to earn a buck.

"I've done anal scenes with three men at a time and the money doesn't get anywhere near what I can expect to earn at a bukkake event. It's well paid and I don't even have to touch a dick if I don't want to," she tells me.

Acutely aware that I'm talking about anal sex with a bona fide porn star whilst watching my son draw with a crayon on the kitchen table, I lower my voice a notch and press on.

What about the health risks? Semen can represent an incredibly rich bacterial stew that may well be loaded with as much aggressive virus as the donner meat in my local kebab house. Dawn tells me that bukkake, like all sexual activity does come with a degree of risk, but this can be dramatically reduced by ensuring she doesn't get sperm in her eyes, mouth or nasal cavities. Given that her colleague in the video I saw appeared to have needed a snorkel to breathe through the spurting dick assault, I ask her how this is possible. She tells me the vast majority of men who take part in the events display heart warming levels of respect and purposely direct their flow away from these high risk areas.

Than there's the regular trips to the GUM (Genito-Urinary Medicine) clinic that operates a drop in centre for adult performers. Vaccination can prevent Hepatitis B, but sadly HIV[15] transmission remains a genuine threat. This isn't just applicable to bukkake however — until planet porn gets over its reluctance to rubber up performers will always face the risk of a viral hangover when they leave their g-strings and enema packets for a life in suburbia.

"Look, I would never want my daughter to do this, but it's worked out well for me," Dawn says.

I mumble vague agreement, but before I get the chance to invite Dawn for dinner and sweep her away from the evils of the smut business, she tells me she has to pick her kids up from school so we are forced to bid each other farewell. Dawn seems sparky, funny, intelligent and doesn't fit any popular cliché about women who work in the sex industry. She may be a slut but I like her.

## VI

SO RATHER THAN JUST A MALE bonding ritual motivated by an urge to disrespect the bitches, bukkake is an act defined by love, mutual respect and acknowledgment of the fact that all women are to be worshipped. Tame your cynicism and avoid thinking of that fat bloke spending an eternity wanking off and this could almost be true. My main concern with bukkake is in no way related to that hoary old cliché of female exploitation, but has everything to do with aesthetics. There is something inherently ugly about it, a common criticism of all pornography, but especially applicable

to bukkake when taken in isolation. This may well be because it doesn't display the production values we've become used to in smut, or maybe even because there's no attempt at narrative. Just a never ending queue of purple headed dicks battering the viewer into a state of numbness. As Jim Goad once wrote: "a hard cock is a blunt instrument."[16] You quickly realise the blinding truth of this statement when you have spent an hour watching one penis after another relentlessly pound into the face of the female bukkake performer.

Bukkake is just too *real*, that's the frightening thing about it. Sex on film, much like everything else in our society, has become homogenised over the last few decades. It tends to conform to a rigid set of unspoken rules. Take the endless product spewing from the LA smut production line, a soulless parade of blond, robotic, badly augmented fuck machines sucking cock with all the enthusiasm I reserve for the drive to work on a Monday morning.

A good example of how the industry is in complete denial of reality, can be gained from its crippling pubic hair phobia. Something as natural as a vast hairy snatch is seen as an unbreakable taboo, it's just too real, too indicative of the flaws that us humans display. It's less dangerous to insist the performing talent sports the smooth labia of a six year old child, then the punters can live in denial that these women are in any way like you or me. Reality and pornography are two words that you just can't fuse together, a glaring oxymoron on a par with the supermarket term 'fresh frozen'.

That's why bukkake is so radical; it wears its 'ugly' status like a badge of pride. To paraphrase the Millwall football chant: no one likes us we don't care. Bukkake may well be difficult to watch, but in some ways its honesty makes it less dangerous than the misplaced clinical detachment you get whilst watching high brow pornography, a plastic world of unreality where women seem to 'want it' 24-7 and no one sweats, cries or bleeds. Regardless of what you think one fact can be taken for granted: it's here to stay, so arguing about its relative merits is a waste of time.

More importantly, when you look at the wider picture, bukkake also highlights some of the gross hypocrisy apparent in our society, especially as this relates to our sometimes twisted view of the human sexual impulse. When Karen Findlay, the famous New York performance artist was touring her one woman show, she'd encore with a spoken word piece about her childhood. This for some strange reason involved her placing yams and bananas into

her snatch, whilst croaking some inane sixth form poetry over a soundtrack of industrial noise. The Armani suited gallery crowd would give a standing ovation after every performance and critics rushed from the venue to shower her with praise. They claimed it was a 'deeply impressive work', a performance that 'questioned sexual taboos in the most fundamental manner possible'. She was even lucky enough to receive taxpayer's money to fund her menstrual squawking[17].

There is a simple reason for this double standard. Findlay's motivation was art not sex. If she was performing the show at an Amsterdam sex club or a London strip pub it would be classed as obscene. Take the exact same behaviour and place it in a sterile gallery setting, and any suggestion of the show appealing to prurient interests can be rejected. It's about the 'context'. Society respects free sexual expression when it's perceived as having artistic merit, but is quick to condemn when the motivation is purely dick led. This unchallenged hypocrisy is for me, much more disturbing than watching an overweight man take twenty minutes to masturbate himself to orgasm on grainy VHS tape.

I finally make the decision that if I'm ever going to gain any real insight into the psychology and motivation of the players on the bukkake scene, I need to feel the radioactive heat of the video lights, hear the lecherous roar of the crowd and smell the combined stench of thirty cocks in a stuffy room without air conditioning. So I spend the next four weeks shamefully touting for a part invitation.

# Straight to Hell

## On Set with Christian Marshall

From: bruce@phatbeats.freeserve.co.uk
To: ***@godhatesfags.com
Subject: Will I Burn in Hell?

Dear Rev Phelps,

I recently spent three days in France watching men having sex.

You can imagine how horrified I was on reading your website, to discover that there appears to be a risk of me burning in hell for this?

I'd be very grateful if you could clarify the situation please.

Kind Regards

Bruce

From: ***@godhatesfags.com
To: bruce@phatbeats.freeserve.co.uk
Subject: Re: Will I Burn in Hell?

Dear Fag,

REPENT OR PERISH!

```
(1) Any nation that condones, promotes or pro-
tects homosexuality will be destroyed by God
(2) All nations must immediately pass laws that
make sodomy a crime punishable by death (3) All
media acting as fag enablers who fail to chal-
lenge the perversion of homosexuality should
realise that they too will be destroyed.

As a sodomy enabler you will be judged by a un-
forgiving Lord!

You and your faggot friends will burn in hell
for eternity. You will all gnaw your tongues in
agony, flames of God's wrath will engulf you,
filling your heads, bowels and limbs with never-
ending agony!
```

# I

I'M DRINKING *café au lait* and eating *pain au chocolat* in the kitchen of a large house in southwest France, looking out over the hundred acres of emerald green pasture land that surround the picturesque medieval hamlet of Chalus. To my left there is a decaying church which dates from the thirteenth century. Although it is no longer a place of worship, locals still leave fresh flowers at the alter as a mark of respect to their ancestors. To my right there is a scattering of picture post card cottages populated by clichéd folk who wear berets, smoke Gauloise and enthusiastically shout 'Bonjour' to everyone who passes by. The village is filled with the brackish smell of wood smoke, and apart from the faint hum of a faraway tractor you struggle to hear any traffic noise. It is a place so profoundly peaceful when compared to the British world of supermarkets, sink estates, fast food franchises and discount tyre centres, the six hour drive to get here feels like travelling back in time.

Our closest European neighbours may have many faults — a pathological obsession with force feeding poultry, contempt for the English language and an embarrassing willingness to surrender under fascist occupation being the first three that spring to mind — but their way of life quickly becomes infectious. Who can resist the Gallic world of freshly baked bread, three hour lunches, friendly

neighbours, well funded health services and butcher shops which display vast slabs of BSE free, blood red fillet steak which retails for the price of a broadsheet newspaper?

Chalus is a dream location for any tourist wanting to paint landscapes, an inspiring setting for any novelist aiming to work in complete isolation, and young couples in the first flush of love could spend many happy hours walking hand in hand through the walnut forests in the region.

I, however, have come to this rural utopia for a different reason. Namely, to watch four men fuck each other in the attic room of my best friend's holiday home.

This explains the naked Scandinavian with a body more suited to a renaissance sculpture who is sat directly opposite me at the breakfast table, sipping a mug of tea as he works out where to position his bishop on the chess board.

Anton (fluent in five languages, ballet dancer, now in his fourth year of an architecture degree at a London university) can spot a poor chess player a mile away. The reason for his broad grin as he destroys my game within seven moves.

"Did my cock put you off?" he asks as I shake his hand to accept defeat.

I'm here to cover the shooting of *Boyz on the Side*, the new release from gay smut auteur Christian Marshall[18]. After spending months trying to find a gay pornographer willing to speak on the record, Christian turns out to be the only person who responds to my pitch. I'd previously taken him for lunch in London when he was publicising his debut feature *Hard Games*. Given that he has a day job and aims to keep a low profile, I have no idea what Christian looks like, so he kindly agrees to wear a t-shirt advertising his film so I can pick him out of the crowd. Luckily I recognise him straight away, given that I feel a lot like John Voight in *Midnight Cowboy*, nervously standing outside the crowded entrance to Islington tube station chain smoking cigarettes.

Christian is a youthful looking thirty-nine. Dressed in jeans, baggy jumper and trainers, he looks more like a student than a peddler of filth. In fact peddling filth isn't his day job, it's merely something he decided would be good fun. Retiring to a nearby bar, we spend an afternoon discussing Christian's new job as a pornographer and from what I remember he speaks with humour, insight and charm about his career in the sex industry.

Sadly, a mixture of inept professionalism and heavy drinking

means I arrive back at the place I'm staying after a four hour interview, only to discover that I hadn't pressed record on my cassette player.

By a strange quirk of fate however, I did mention that I had a liberal minded friend who owned a large house in France during our conversation. After a number of phone calls and letters over the next six months, Christian has arranged to travel to France to film a number of sex scenes for *Boyz on the Side* which is being funded by the Playboy owned Spice channel.

The main reason Christian has had to transplant production to this tiny hamlet isn't just the beautiful setting, there is a practical and very British reason why he has been forced into spending a large chunk of his budget bringing over his cast and crew.

UK law currently forbids more than two men from having sex in the same room, a couple involved in a one on one fuck frenzy is acceptable, but bring a third sodomite into the mix and consensual sex quickly becomes gross indecency. Among gay folk the expression 'two's company, three's a crowd' moves beyond the realms of cliché into the world of prison sentences. The 'gay gang bang' law is due to change shortly, but until the new Sexual Offences Act passes through Parliament, the BBFC refuses to classify any material which puts them at risk of an obscenity bust for breaking British law. Given that Christian wants to release his film in the UK marketplace, he has had to travel to a more tolerant sexual climate to capture the man on man action.

The adult entertainment industry may be a guaranteed ratings winner for any documentary filmmaker suffering from a bankruptcy of original programme ideas, but this interest has never extended to the gay business. I've watched hours of moribund starlet interviews and behind the scenes footage from players in the straight sex industry, but never any media coverage where men are filmed boning each other to the sound of a mocking, ironic voiceover.

To understand this low media profile, you need to take into account the flood of complaints that greet any attempt to deal with gay sexuality on UK television. A 2003 episode of the BBC hospital drama *Holby City*, which featured two of the male cast kissing, attracted over 300 viewer phone calls from outraged members of the public. Although this number of complaints in no way represents a large per centage of the seven million who watched the show, it still stands as a BBC record.

This is not an isolated case, given that any attempt to demystify gay culture within the mainstream has always met with vocal oppo-

sition. Take the notorious 'East Benders!' front page headline that splashed onto the *Sun* under the editorship of Kelvin McKenzie[19] after it was announced that a gay character would be joining the soap in the eighties. This outraged reaction at the sight of gay men daring to touch each other on television, seems to indicate that the great British public are unlikely to be enthused at the prospect of reading newspaper articles or watching documentaries about buffed up muscle boys plunging into each other on digital video.

British folk have always liked their TV queers to be non-threatening. Whilst it may be acceptable for gay performers to ooze pantomime camp and sustain entire careers based on their ability to make the most filthy expressions sound mundanely comical ('back passage' and 'tradesman's entrance' being two terms which have paid Julian Clary's mortgage for the last two decades), any suggestion that these housewive's favourites may actually indulge in sordid acts of sodomy quickly leads to tabloid vilification. A quick scan through the press coverage that greeted Michael Barrymore's coming out (many years before the legendary sex and drugs party which resulted in a drowned corpse), should provide even the most hardened cynic with ample evidence.

Black performers are starting to understand the rules of engagement as it relates to gaining mainstream acceptance. One of the reasons why one well known, ebony celebrity chief can sustain a successful TV career based on bug eyed 'cooning', whilst talented Afro Caribbean sitcom writers will never make a decent living in the British media. Likewise, whilst an openly gay performer may currently hold the position of the UK's highest paid entertainer, let's not pretend that his gay Uncle Tom act bears any relation to mainstream gay sexuality. If you're a confused teenager thinking of coming out in a Yorkshire pit village, you'd have to search long and hard for gay role models who don't subscribe to 'camp' as *the* entry point into the British TV industry.

Of course, Sapphic couplings have never been subject to the same levels of hysteria. In fact, you could make a strong argument that the subject of lesbianism has been actively perused by mainstream broadcasters, because it guarantees a large one handed audience and plenty of free publicity.

Girl on girl action has also been the backbone of the UK sex industry for decades. Given the strict laws historically imposed on the display of male genitalia, shooting gap lapping footage meant directors didn't need to spend hours in the editing suite removing all signs of an erect cock to pacify the censor. Some female

performers have worked their entire careers exclusively filming girl/girl footage, never having to deal with dick on screen despite being big fans away from the camera.

In the US, gay porn went legit in the early seventies, around the same time as the straight world. Feature length, narrative driven, lavender fuck fests were shown in their full 35mm glory in adult only gay theatres across the country, although it is likely that some patrons had more interest in cruising the bathroom glory holes[20] looking for action than watching the movie.

Given that the UK is decades behind the rest of the world as it applies to porn in general, the native gay porn scene is still very much in its infancy, a situation that is rapidly changing as an increasing amount of home grown material is being now being produced. Smut has long been a part of life in British gay culture, although punters historically tended to watch a flood of US and European imports. This changed in 2000, when the Restricted 18 classification was relaxed and the British Board of Film Classification specifically wrote into their new guidelines that the freedom to purchase and distribute sexually explicit material, applied equally to both homosexual and heterosexual smut.

As a general rule the gay and straight pornography scenes never mix. On the contrary there are many examples of bisexual male performers being blacklisted from girl/boy porn sets because they have performed in films that feature an all male cast. Even straight studs who appear in 'solo' films (video shorts that feature male performers masturbating targeted at a gay audience) have been subject to vilification from their hetero peers. Despite this a number of high profile US male performers, Peter North and the late John Holmes among them, did at some stage in their working lives embrace the mantra of 'gay for pay'. Both vocally denied any suggestion they had performed with other men despite video evidence to the contrary. When the truth eventually came out they both defended their youthful indiscretion by stating that they always 'topped never bottomed' and under no circumstances did they ever suck cock.

The career destruction which occurs when a straight stud is discovered to have appeared in gay product is not just related to homophobia, but is often based on misguided fears surrounding disease transmission. This is ironic, given that gay smut producers have never shared the straight industry's reluctance to insist the talent 'rubber up before getting down'. The HIV pandemic had a profound effect on the US and European gay porn scene,

especially in the eighties when performers found themselves developing strange purple lesions that couldn't be hidden by make up, became prone to opportunistic infections and started to lose dramatic amounts of weight. At the time a large number of performers on the gay scene died from AIDS related symptoms, and in a culture where it is still rare to find a gay man who hasn't been personally affected by the death of a friend or partner from the disease, the gay sex industry had no choice but to take dramatic action. As a direct result penetrative sex in gay product has been mostly condom based for decades[21].

In the US, where the straight sex industry operates on a much greater scale than the gay scene, there have been a small number of high profile cases of HIV transmission among straight performers, but nothing on the scale of its gay counterpart.

Actress Brooke Ashley believes she contracted the virus during the filming of a gang bang video, an event which sent shock waves through an industry that had always been complacent about the risks to heterosexual performers.

Mark Wallace, a veteran US stud, was subject to industry rumours that he worked with a false negative test and in the process infected a number of his co-stars in 1998. One women infected was Tricia Devereaux, the wife of John 'Buttman' Stagliano (himself diagnosed as HIV positive in 2000). Their relationship spawned *Buttman's Toy Stories*, the first ever example of a straight video release that features a scene made up exclusively of heterosexual HIV positive performers.

Given that straight porn producers could easily be described as living on the sexual margins, you'd think they would have a sense of solidarity for their gay comrades making a buck in the same trade. Sadly, this is not always the case. Despite vocally defending their own right to film people fucking, a number of straight producers see no hypocrisy in vocalising that they find gay porn deeply offensive. There are no current examples of any general video series that feature gay scenes in productions aimed at the general straight market. Although the Bi Curious line of films, which sell under the charming video tag line of '*she loves cum, they like it up the bum!*' are obviously fighting their corner.

To even hint at an element of gay sexuality in a hetero fuck fest would generally isolate the core demographic of wankers. Straight porn consumers already complain that smut directors spend too long focusing the camera on the face of the male performer. To most punters buying straight product, the on screen stud is noth-

ing more than a pixelated circulatory system, carrying oxygenated blood to the extremities, purely to support a flesh stick onto which we can all project our own fantasies.

## II

WHEN WRITING A BOOK about filth, male friends tend to take a keen interest, often because they realise that at some stage they will receive a box of review tapes when the project is complete. When you tell people you're visiting a porn set the usual response is "can I tag along?", swiftly followed by "no *really*, can I tag along?"

Before I leave for France I'm having a drink with some male friends, telling them about my plan to spend a week drinking wine, smoking weed, eating seven course lunches and watching people make fuck films. As you can imagine I had a number of pleading requests to accompany me on my working holiday, although these soon disappeared into the ether when I clarified my schedule with the statement: "It's an all male cast."

One person who doesn't share this view on life is Matthew, my best friend, music critic, occasional co-writer of radio comedy drama, and the owner of the house in France. Despite possessing one of the most painfully upper class accents I've yet to hear, and spending his teenage years translating Shakespeare into German at his boarding school (whilst I experimented with solvents and stole cars), our shared sense of humour quickly destroyed any class differences we may have had. As soon as I mentioned that Christian had expressed an interest in filming sodomy in his French retreat, he jumped at the chance to take part. Like myself he believes strongly that to understand sex is to understand humanity but even better he thought it would be a bit of a laugh.

Because of Matthew's love of opera, ballet, cooking, modern dance and other activities not necessarily deemed macho by society, most people tend to think Matthew is gay anyway.

If I'm being honest, at some stages over the weekend, a passer by walking into the house to be faced with the sight of Matthew baking a quiche, whilst I did the washing up, would have been hard pressed to identify any straight men on the shoot.

Matthew's watched a few porn films with me since I started writing this book, but he claims he's no big fan. We've watched three films together in total, all of them vanilla filth, devoid of any overt misogyny. Despite this, Matthew's typical reaction to a

cum swapping scene in a Ben Dover flick is to cover his eyes and express disgust whilst loudly demanding that under no circumstances should I fast forward.

## DAY ONE
## THE PINK EAGLE HAS LANDED

CHRISTIAN, COMPLETE with stills photographer and cast of four, arrives late Saturday night after flying into nearby Limoges airport. For a few hours after the group arrive, I have to fight the strange sense that I'm taking part in a new reality TV show. *Straight Eye for the Queer Guy* maybe, where two painfully heterosexual men are placed into an isolated world of gayness, the viewers ringing a premium rate phone line to evict the most uncomfortable housemate. It's worth remembering that the cast have only just met each other as well, so there's an element of social embarrassment at play across the board. This probably isn't helped by the first rhetorical question I aim at the group just minutes after they arrive:

"You've only just met each other and you'll all have to fuck tomorrow?"

Luckily, the group turn out to be great fun and an evening of male bonding ensues. The 'meet and greet' dinner party soon morphs into a drinking session, resulting in a number of unfortunate incidents later in the evening, when one drunk cast member undertakes a late night trawl through all six of the house's bedrooms looking for cock, keeping his co-stars awake until the early morning in the process.

I'm willing to accept a degree of blame for this, given that I end up comatose, sleeping on a wood floor and had been actively encouraging my door knocking comrade to drink bottle after bottle of red wine.

At one stage I vaguely remember denying the existence of God in the medieval church opposite Matthew's house, whilst drunkenly egging on a repulsed Christian to get out his camera to film one of his cast getting sodomised over the altar for an experimental art film I'm planning.

This sort of behaviour is the reason why I tend to leave the term 'diplomacy' off my CV lately. Not for the first time in recent months I start to think I should knock the drinking and recreational drug use on the head.

The net result is the cast are cranky, exhausted, hung over and have decided to sleep in past midday. Given the director only has thirty-seven hours to capture all the action he needs it's not the most promising of starts.

Christian doesn't conform to the established pornographer template I've seen so often in the straight business. He's sensitive and compassionate for starters, not a quality I've found in many other smut directors. When we met in London he was keen to vocalise that in gay culture pornography is mainstream, generally not being viewed with the same level of distaste as it is by some straight folk. Despite this Christian still chooses to use a pseudonym, although he tells me this is motivated by a need to avoid any clash between the porn world and his day job, rather than any sense of shame about how he makes a second living. He is also painfully polite, not the sort of man you'd imagine would be comfortable asking virtual strangers to undress, drop to their knees and start sucking cock.

Eventually the cast start waking up and gathering around the kitchen table in preparation for the days shoot. Kenny (6 ft 3 in, podium dancer and veteran porn performer) seems keen to apologise for keeping people awake the previous night. When he finally appears he sheepishly asks "Who exactly did I try it on with last night?" only to be met with the sight of the entire table raising their hands.

Christian's plan is to film a two way scene with Kenny and Anton today, and a four way orgy sequence with all the cast tomorrow, as well as the still photography and dialogue sequences he also needs to capture in this tight schedule.

Anyone who labours under the illusion that porn sets are glamorous needs to spend a few days watching the painfully laborious process from start to finish. Christian has a background in legitimate film, so tends to adopt mainstream practices when making wank fodder. One of the reasons why he's spent over two hours lighting the vast expanse of space inside the barn where he's shooting today.

For Christian this professional, methodical approach has been an unqualified success. He may only have one fuck film on his CV, but *Hard Games* is a genuine award winner, coming out on top in the best 100 per cent sex scene at the Gay Heat awards at the Barcelona Erotic Film Festival.

This disclosure prompts Matthew to ask, "Was there an award for best seventy two per cent sex scene as well?"

It's early February, and the temperature is only nudging slightly

above freezing inside the unheated barn. I can testify to this, because I sat in the barn wearing only my boxer shorts a few days earlier, mostly so I could mock Christian's cast if they displayed diva like tendencies and refused to get their kit off. Any man that can achieve wood in these atmospheric conditions deserves a medal for valour beyond the call of duty. Luckily Christian knows just the guy for the job, and an unperturbed Anton walks bare chested into the room ready for action. It must be his robust Scandinavian roots that make him immune to the biting chill, as he doesn't even appear to be shivering as Christian films him chopping wood.

*Boyz on the Side* is that rarest of beasts, a smut film which gives some concession to plot. Although I'm sure the director will forgive my cynicism if I state for the record that the narrative could have been easily jotted down on the back of a cigarette packet.

Kenny enters stage left, a perplexed look on his face on discovering his object of sexual desire dressed only in jeans, chopping wood in the middle of the night. My suspension of disbelief may have already dissolved, but it's worth bearing in mind that the majority of Christian's audience will be so blinded by the idea of the forthcoming fuck fest, they are unlikely to be in possession of their full critical faculties.

After some improvised dialogue comes the sex, shot in both a hardcore version for DVD release and a softcore version for cable distribution. Gay porn tends to follow a definite pattern, just like its hetero counterpart. There will be some general fiddling about, mutual blowjobs, rimming and than anal penetration. It does display a few peculiar quirks I've yet to see in the straight world, armpit licking for example, but it's difficult to work out if that's representative of the genre as a whole or merely a sexual peccadillo of the director.

Regardless of your feelings regarding sodomy, no one could fail to be impressed by the performers' professionalism. I'm thinking of moving to the house where I can sit in front of the fire, given that I'm shivering and can clearly see my breath each time I exhale. Anton however doesn't complain once, despite being butt naked and covered in goose bumps as he leans over a woodpile to take a vigorous anal battering.

At this point I should probably answer the question that greeted me so often on my arrival home, usually when I explained to friends, family and work colleagues why I'd been in France: "You *actually* watched men have sex?"

After you've spent a year watching people fuck, it all tends to

mutate in a distorted, pink blur of flaying limbs, erect dicks and gaping pink orifices. What's interesting is that the revulsion some folk have for the concept of boy/boy love is shared equally among the genders, as many women as men expressed disgust at the concept of me watching men bone each other. This is difficult to understand, given that the men in Christian's film look so fantastic. As a general rule, if you suffer from low self esteem avoid ever visiting a gay porn set. Everyone performing has highly toned, muscular bodies which shame heterosexual men of the same age. I have yet to see a cock which can be described as 'average' length, and when you ask people if they work out, everyone tells you: "I can eat all kinds of shit, but I never put on any weight."

For this thirty something writer, currently suffering from a rapid thickening around the waist and booze fed man tits, it's a revelation to discover that people of a similar age can look so good. I may remain immune to the pleasures of gay sex, but rather than feel nauseous when watching the cast fuck each other, I start thinking for the first time in my life that I should join a gym.

The action finally moves inside the house. Anton and Kenny gymnastically fucking on the stairs as I peel potatoes. As Glenn the second cameraman moves closer to the action, and Christian directs the sex in his softly spoken voice, I'm joined by Ben and Luke, the real life couple who take the central roles in the film.

Ben has an air of the artful dodger about him. On first impression he gives off the vibe of a guy who sells knock off car stereos on an Essex sink estate. With his short spiky hair, gold chain, Adidas trainers and branded leisurewear he looks like he once failed an audition for East 17; no great surprise when you take into account that boy bands are a musical genre predominantly overseen by middle aged, predominantly gay record executives. Ben looks nervous as we watch the action, when I ask why he replies with brutal honesty.

"In my personal life I never bottom, I'm more a mutual masturbation kind of guy."

Suddenly things start to make sense. Ben is due to film a group scene tomorrow and he tells me that when the cast pair off for sex he is likely to hook up with Kenny. The fear in Ben's eyes is entirely founded in reality, given that you only need to glance across at the stairs to see that Kenny is hung like Donkey Kong.

I went to make a cup of tea earlier that morning and found a naked Kenny sat at the kitchen table. As he stood up, and I was faced with his expansive dick, I couldn't think of anything else to

say but, "I don't want to make you feel uncomfortable, but you really have do have a monster cock."

When I suggest to Ben that a porn set should be a giggle rather than a chore, he deadpans: "Maybe for you Bruce, but you don't have to take a massive dick up your arse tomorrow. I'll need a fucking wheelchair to get through Stansted."

Luke is eighteen and achingly pretty. I'd imagine that every time he steps foot in a gay pick up joint he has to beat off predatory older queers with a big stick. He speaks in a quiet, gentle voice that makes him appear vulnerable and naïve, although over the course of the weekend he displays maturity admirable in a man of his tender years. He also boasts an impressive skill, namely an encyclopaedic knowledge of the recording career of Kylie Minogue. Randomly shout a song title from her extensive back catalogue and Luke can name the final chart position, release date, weeks it spent in the top forty and the total number of copies sold.

Ben and Luke have made a total of five films together, after making the decision to perform on porn sets to earn a deposit for a house. Neither of them are big fans of the sex; it's all about the pay cheque. This is the last project they are taking part in, as soon as the group sex scene is complete tomorrow it will mark their official retirement from porn.

Since they have been in the business the majority of their experiences have been overwhelmingly positive, although they both laugh when they tell me about a 'screen test' they did once for a notorious rain coater. He paid them £40 each to masturbate in his spare room, although afterwards they were both left with the suspicion that his camcorder didn't actually have any film in it.

Working for Christian is different, not least because he is the only pornographer I've ever met who offers his performers a slice of the film's profits. Kenny confirms that this is a rarity and he's well qualified to hold an opinion, as he recently spent an extended working holiday in Miami, "getting fucked by blokes wearing sex masks."

His US jaunt ended in high drama, when he returned home to discover that someone had tipped off his long suffering mother about his new choice of career. She tirelessly trawled the net until she found the website that featured her son in a pseudo rape scenario, leaving Kenny with a lot of explaining to do when his plane landed on UK soil.

Meanwhile on the kitchen stairs the scene is coming to an end, signalled by the mutual groaning of Kenny and Anton, who are both

masturbating as the cameras move closer to capture the money shot. Pearly white globs of jizz are sprayed (the performers displaying a rare talent for timing when they ejaculate in unison) as the audience gathered in the kitchen give the performers a warm round of applause. Anton stands up and takes a theatrical bow, whilst Kenny reaches for some kitchen roll to wipe away the paste that is slowly dripping down his chin.

## DAY TWO
## BLUE MONDAY

THE CAST ARE WALKING down a dirt track which runs through the village alongside the church. Christian is a few yards ahead, secretly filming whilst trying to hide his camera as they stroll towards the woods at the back of Matthew's house.

If any locals happen to watching, they could easily be forgiven for thinking that their rural retreat has been struck by a tsunami of 'gay'. You get a sense that the last time eyebrows were as likely to have been as raised as this, was when a platoon of Nazi storm troopers goose stepped into the village during WWII.

Last night was a more civilised affair, memorable for one line of dialogue spoken over the table that to my mind highlights the occasional confusion heterosexuals feel about the gay lifestyle. As Matthew serves up slices of rare beef, blood oozing from its centre, Ben politely vocalises that he'd prefer his meat cooked medium. My comrade replying: "You'll suck cock, but you won't eat rare beef, how does that work?"

Christian has a hectic schedule today, but luckily the cast got up early, so he's already got all the stills he needs for the DVD box cover. At one stage in the proceedings I hear the voice of Ben calling down the stairs: "I might need a fluffer, is Bruce around?"

Since the group arrived there hasn't been a missed opportunity to take the piss on all sides. At one point I'm sat with Christian watching footage from yesterday's shoot, Anton wanders past and in his dramatic Swedish accent loudly says: "You seem to enjoy looking at the film of the men fucking, Bruce. Maybe a little too much?"

Ironically, in some ways I feel more comfortable on a gay porn set than the straight shoots I've visited. I'm always paranoid that female performers tend to think people on set are leering at them, especially when you take into account that some women in the

sex industry don't hold the male gender in the highest of esteem. Regardless of this, who wouldn't be reluctant to be watched by a journalist whilst shagging?

Luckily, this hasn't happened at any point during this weekend, although ironically enough Kenny did ask for everyone to leave when he was preparing to get anally violated yesterday. Anton for starters is a shameless exhibitionist, taking every opportunity to parade around the house with his kit off. Whilst Ben, who according to Luke has "a major obsession with straight blokes", specifically asks Matthew and myself to be in the room whilst his scene is filmed.

"I'll find it easier to get it up if I know that two heterosexuals are watching."

When we arrive at the woods, Christian shoots some softcore footage of the cast touching each other up in the great outdoors, despite some vocal protests from Kenny as he struggles to break through the undergrowth. "I don't *do* woods," he tells the director, "It plays havoc with my Prada."

Matthew and myself act as look outs, keeping our eyes peeled for Matthew's seventy eight year old neighbour. The location may be isolated, but you just never know when a local farmer will walk around the corner on a gourmet mission to force feed geese. This part of France is not the most cosmopolitan place on earth. As a result it's easy to imagine the locals descending onto the house, carrying burning torches in a scene reminiscent of a 1930s Universal horror film, if they ever discover just exactly what the 'boys weekend' taking place in the biggest house in the village involves.

The outdoor footage in the can we quickly return to the house. Ben walks back very slowly, looking like a condemned man being led to the electric chair at the prospect of his upcoming appointment with Kenny's well proportioned cock. For the rest of the day, it's Matthew's attic room that will be at the centre of the action.

Everyone retires upstairs. Myself and Matthew giving them some peace and quiet, aware that there is a risk Christian's microphone will pick up our childish giggling as soon as people start fucking. The director has gently chastised me on a number of occasions, mostly for breaking into laughter every time Ben or Luke are forced to improvise creaky porn dialogue.

After a few hours Glenn, the charming second cameraman, gives us the nod to move upstairs, the majority of the sex is in the can but Anton has requested that the straights hang around the set for the mass money shot.

Our host is very concerned that his Egyptian cotton pillows may be subjected to a stray jizz splash when we enter the room, although I'm so hypnotised by the surreal sight of four highly toned gay men frantically masturbating in the glare of the halogen lamps, I haven't even thought about dry cleaning bills. Luke is at the centre of the circle jerk. Christian quietly says, "I may sound like a right pervert but can everyone cum on his chest."

Amid the carnival of boy/boy wank, Anton's eyes remain firmly fixed on the two straights rather than Luke's dream boy physique. Despite feeling slightly uncomfortable I'm not in a position to take the moral high ground, especially given the amount of times I've tried to apply the sight of a scantily clad chick to that part of the subconscious mind best termed the 'wank bank'.

In some ways I'm flattered. If I ever twist out into gayness I'd really like to think I could pull geezers like Anton. Sadly my straightness is the sole reason I'm being used as visual wank fodder by a man who looks like a monochrome vision from a late sixties Warhol movie. When Anton talks of his liberal Scandinavian upbringing, you start to realise that if he had been born thirty years earlier, he genuinely would have been dancing on stage with the Velvet Underground in '68 NYC. He reeks of bohemia and 'intelligent fuck', a dream prospect in a sexual partner be you gay or straight.

I've never seen a genuine couple perform in a fuck film before, and over the short time I've spent with them it's become obvious that Ben and Luke really do love each other. Watching Ben gently caressing his boyfriend — as he lies on the wooden floor waiting for a protein dick load from his new found fuck buddies — takes on a warming tone which is probably highly inappropriate given the circumstances.

Not for the first time whilst writing this book, I bear witness to the sight of translucent spunk flying from a number of separate man sources. Kenny in particular is milking his gargantuan member like a miserly pensioner squeezing the last dregs from a tube of toothpaste. At this stage I start to feel glad that the shoot is taking place in winter, if this were July or August the smell of cock, sweat and spunk would be unbearable.

I also notice that the large number of windows in the attic room offer an excellent homoerotic viewing opportunity for the local farming community, but decide it best not to vocalise my concerns to my buddy. Matthew's gorged on 'hot fuck action' over the last few days. He may not be writing a book about filth but he does

have an enquiring mind. I'm starting to suspect however, that rather than providing the intellectual stimulation he has been searching, the gay fuck fest is starting to make him worry about what the neighbours might think. Luckily, in a few hours he will pocket his £500 location fee and can travel back to England safe in the knowledge that he'll have a lurid story he can dine out on for years.

As the cast start to dress and wander downstairs, I take the opportunity to grab a few words with Ben, who doesn't appear on first sight to require the attention of a French medic after his meeting with Kenny.

"I've got a right gaper," he tells me, "but I don't think there is any lasting damage."

I like Christian, and I like his cast. Apart from the filmed sodomy, the weekend has been no different to the many occasions I've spent drinking, eating and talking late into the night with my own rigidly heterosexual peer group. The protagonists may be big fans of sucking cock, but they are great fun and there's even been a rush to help with the washing up after each meal, which has never happened when my straight male friends call round my house to watch a sporting event.

The remaining few hours of the group's visit is taken up with frantic packing in order to make the return flight home. During our final meal, I ask Ben and Luke to tell me about how they came out of the closet, an epoch defining moment for gay men.

Ben came out in his twenties and almost overnight friends he'd had since infant school refused to answer his phone calls, even walking across the street when they saw him coming. For Luke things were dramatically different, probably a result of the ten year age gap between the couple. His friends had been brought up with gay contestants on *Big Brother* or had watched dramas like *Queer as Folk*, so they had no problem with Luke's disclosure. This is refreshing, given that during our meeting in London, I remember Christian talking movingly of the bullying he'd experienced at school. A result of growing up at a time when the only way a gay man was allowed into our homes via the medium of television, was to conform to every mincing, camping, destructive stereotype. Perhaps Christian's move into making smut is a big 'fuck you' to his childhood critics, perhaps it's a chance to make cash whilst providing the fringe benefit of watching attractive men go down on each other? Regardless of his motivation, he's very good at it and this straight male is happy to recommend his classy video releases

to any horny queer, or indeed curious straight bloke browsing the shelves of a Soho sex shop. After all, gay, straight, bisexual or transsexual: *sex is just sex, right*?

## POST SCRIPT

THE EMAIL AT THE START of this chapter is taken from my correspondence with the Reverend Fred Phelps, patriarch of the infamous Westborough Baptist Church. Since its foundation in 1952 it has represented the most extreme example of the many US based homophobic hate groups. This is best illustrated by its notorious website godhatesfags.com. Here you can see pictures of its church members picketing the funerals of people who have died of AIDS, download a chilling MP3 of the tortured voice of Matthew Sheppard screaming (Matthew was a sixteen year old boy who was brutally murdered in a homophobic attack) or alternatively read why all gay men are paedophilic predators who should face the death penalty for sodomy.

# All Included, No Back Answers

## The Curious World of the British Sex Party
### Part II

THE DELIGHTFUL SANDIE CAINE IS CURRENTLY QUEEN of the bukkake and gang bang party scene. Organising every aspect of proceedings, she scouts for male performers, books the venue, oversees the signing of model release forms, shoots, edits and sells the video of the event. This is one sister who could comfortably be described as 'doing it for herself'. She's also a veteran performer, appearing in over seventy films since she started selling snatch for a living, including *Pump Friction, Jessica's Birthday Surprise, Cunt Hunt 3* and the alluringly titled *Piss'n'Mix 7*. Until recently, she used to be the main attraction at her group sex events, but has now chosen to direct the action rather than play the leading role.

Sandie is well loved by fans, fellow performers and many others who take an interest in the sexual margins. When we speak on the phone to arrange an interview, she tells me that she recently had a Channel Four film crew attending a party as research for a documentary[22]. This willingness to maintain a high profile and defend her choice of career is to be respected, given that she runs a number of legal risks organising parties. Despite not charging her male performers a fee, in order to avoid the risk of committing a soliciting offence, she could still face legal problems relating to 'living off immoral earnings', although you'd imagine that this would not be a major police priority in a capital awash with street robbery, gun crime and corporate fraud.

She's also very vocal when it comes to naming and shaming

her smut vending peers who have a reputation for ripping off the general public. An outlook on life that has got her in trouble with some major players in the past. She was recently sacked from Tantalise TV, a softcore satellite channel, after verbally abusing the station's proprietor live on air. In a sex industry as small as that of the UK, it could be seen as career suicide to vocalise a dissenting opinion about someone as powerful as David Gold, the owner of a stable of top shelf magazines along with a fifty per cent share in the *Sunday Sport* newspaper. Sandie however just doesn't seem to give a fuck. She is a woman working on her own terms, and provides a robust defence to the feminist argument that all women in the sex industry are nothing more than sex puppets of the clichéd fat bloke smoking a cigar, who controls the vile trade in exploitation and suffering.

We have arranged to meet in a South London pub on a summer afternoon and as always I arrive early. Spending the lengthy wait sipping coke, pretending to read a newspaper and scanning the room to spot people who fit the profile of party guests, although so far none of my fellow drinkers fulfils my clichéd image of orgy participants. At the arranged meeting time, the doors open and our host breezes into the room.

I recognise Sandie straight away. She's blond, petite, pretty and projects an aura of a woman organising an event. Despite the lack of a clipboard, she could still easily be mistaken for a twenty something holiday rep at a Spanish airport, ticking off names on a list, whilst projecting both warmth and professionalism. On today's performance I'm surprised that she's never been headhunted to work in PR.

I wait until all the male participants have massed around the table, ten in total, before introducing myself as "Bruce... the guy writing the book?" — a line rapidly becoming something of a catch phrase. Fully clothed, the male cast performing today are a pretty average bunch: a mix of suited middle aged guys with a twinkle in their eye, and casually dressed younger men who will probably regale their friends with tales of today's sex-a-thon over a few pints. They are polite, clean, punctual and shockingly normal; to the bar staff it must look like a nearby office has decided to get together for lunch. The only people in the group who you'd give a second look if they passed you in the street are Kerry and Kiwi.

Kerry is today's star turn — 6ft 2in in bare feet, she strikes an even more imposing figure when she's wearing platforms. She's nineteen, pale skinned, brunette, attractive and is wearing cute

glasses that give her the appearance of a bad ass secretary, rather than a conventional glamour model. Kiwi looks like a character from a 1960s Ken Kesey novel. His combats, tattoos, long hair, vest and leather cowboy hat complete with aviator goggles, means you can't fail to notice him, even before you see his wheel chair.

The vibe around the table is practical and business like. There's no sexual tension in the air and I fail to catch any of the men leering or touching themselves inappropriately. Sandie obviously has her fair share of regulars, given that some people already know each other, although today has also attracted a number of new faces. What is a genuine surprise is the lack of a heavily built security presence lurking in the shadows. Despite this afternoon being an exercise in filming group sex, the atmosphere could almost be described as wholesome.

As Sandie leaves to set up, the five minute walk to the house provides the ideal opportunity to assess the motives of the male cast, and rather than treating me with suspicion as I expected, most of the group are open, friendly and eager to talk. Nathan (*name changed*) is middle aged, well educated and dressed in an expensive suit. Proving the most vocal in outlying the reasons he's here today: "I just love sex, it's that simple."

He thinks he may suffer from sex addiction, a conclusion he reached during a recent discussion with his psychiatrist. In a bid to address the problem, he's just completed a lengthy period of cold turkey, fighting his urge to attend group sex events to prove to himself that he can resist temptation. He hints that he's here today for a reason he "would never discuss with a journalist", but I get the strong suspicion that he is just trying to appear mysterious in order to justify the urge to dip his wick.

Of all the male participants I speak to, Nathan has the most obvious spring in his step as we struggle to find the party location. He tells me that what's taking place today represents the future of sex: in a few years we will no longer see monogamy as an important issue. Marriage will evolve, and as a society we will all join the queue to attend gang bangs and bukkake events as an informal sexual release, rather than take the more traditional route of wining and dining potentional sexual partners. He repeats his mantra on three separate occasions, "What you see today will soon become the norm."

Damien (*name changed*), a balding Middle Eastern guy in his thirties, nods his head in agreement, but is not as positive about the future as Nathan. He's acutely aware that the majority of people

would tend to define his behaviour today as 'deviant' but is keen to point out the many positive aspects of a group of men queuing for sloppy seconds. "The women seem to enjoy the sex, although in truth they may just be good actresses. Everyone is respectful and ultimately no one is getting hurt." He's very concerned with what is happening to the US scene, after returning from a business trip to Boston. "Bush is determined to destroy free sexual expression. They are busting pornographers and jailing people for organising bukkake events. It's only a matter of time before it starts happening here[23]."

The venue is a large, three floor house in a leafy suburban street, a short walk from the high street. The interior is vast, tastefully decorated and the house in general is spotless, the kitchen and toilet positively gleaming.

Ringo (*name changed*) who owns the house is a keen participant in the sex, a fringe benefit of allowing your home to be used as a location. We file into a large, empty room to wait for Kerry to put her face on. There's some small talk, a lengthy discussion of previous events and a roaring trade in the swapping of porn videos.

It strikes me that today is all *sex* and no *party*. There's no booze being consumed and I can't spot any buffet plates covered in cling film. Surely a prerequisite for any swinging social gathering? One of Sandie's elderly regulars stopped off on the way here to buy her cherries and a bottle of wine, but it doesn't look like it's going to be opened. None of the men are carrying plastic bags containing a pre performance alcoholic snifter, and I get the strong sense that I'm the only person in the room who would kill for a drink.

Or indeed a cigarette. The smoking room is a fair distance from the action, and I'm loathe to go for a bifter in case I miss something. I never imagined sex parties would be no smoking affairs.

Recording the event poses a problem for some of the participants, despite Sandie's reassurance that all their faces will be blanked before the footage is distributed. Model release forms are distributed for signing, and this leads to an outbreak of minor paranoia among some of the frontline fuck troops. There's the job, wife, family and friends to protect, and nothing is guaranteed to destroy a career or marriage quicker than your spouse, kids or boss seeing you on DVD eagerly joining a queue to fuck a total stranger. It's a sign of the high esteem our director is held among the group, that no one refuses to take part, after a firm promise that she will ensure their anonymity. See, it is possible to use the words 'pornographer' and 'integrity' in the same sentence.

The sight of a naked Ringo in the hallway officially declares the sex festival open. Everyone undressing and neatly folding their clothes into numbered Sainsburys carrier bags. Within seconds the room is full of hirsute flesh, smiling faces, loud laughter and a giddy excitement at the prospect of fresh girl meat. It's a pornographic *Mr Ben*, an explicit version of the old seventies cartoon, where a bowler hatted city gent would enter a dressing room, only to emerge in an alternative universe. In today's case Planet Fuck.

Wherever I look I just can't avoid the cornucopia of cock. Long dicks, thin dicks, small dicks, fat dicks, monster dicks, white dicks, Asian dicks and one strange looking phallus, complete with a vivid purple, mushroom shaped head that appears more suited to a medical textbook than a pornographic video. Sitting down and trying to retain an air of creative detachment, people from the group come to chat, the majority preparing themselves for the main event by standing and masturbating inches away from my face.

As the men gather in the rumpus room, Kerry makes an appearance by slowly walking down the stairs, stalked by our director carrying an expensive looking camcorder. She looks fantastic. Red bra and thong, white stockings and a pair of terrifying crimson spiked platforms, which look like they belonged to the KISS costume department in a previous life. She enters the room to find our cast lined up, butt naked in an orderly row, most of them already erect before she's laid a hand on them. Moving along the line, she kneels down and sucks each of them off in turn, to the sound of low groaning, occasional applause and gentle verbal encouragement.

After a pause for still photography, the gang bang proper kicks into action. One of the group goes down on Kerry, whilst others form an orderly queue to tweak her recently exposed flesh buttons. She shows a rare skill for juggling dick between her mouth and hands, and I quickly realise that the glasses are not just a prop, Kerry really does need them to see where the next dick is coming from.

Choosing to lie down on the carpet, rather than kneeling and trying to balance precariously on her stilettos, the action becomes focused on penetration.

## THE MEN DIVIDE THE BUFFET

ONE GUY WILL fuck Kerry, whilst she dextrously entertains two dicks at eye level. The others stroke thigh, rub back, lube themselves or exchange casual conversation about the weather,

whilst pulling on their dicks until the tide parts and they gain access to vagina.

Very soon, one of the men mumbles that he's ready to pop. "Did I hear the magic word?" says Sandie, moving in close to capture the first of today's many protein deposits. Our vaginal conqueror pulls out his dick, and whips off his condom to deposit a thick load onto Kerry's pert knockers, leaning back to admire his handiwork with a broad grin.

Some men wear condoms, others don't. If they can provide a recent test indicating that they have had a negative HIV diagnosis, they can ride bareback; otherwise it's a strictly sheathed affair for vaginal penetration.

There is a fair amount of cock jousting, as the male cast attempt to reach mouth or vagina, only to find it blocked by their comrades. During the course of the afternoon, some of the men taking part tell me in whispered voices that one of the group is guilty of breaking the first commandment of gang bang:

*Thou Shalt Divide The Meat Equally.*

Unwilling to wait his turn, he's pushing himself into any available orifice without giving a second thought to the needs of his peers. I guess straight away that they are talking about Nathan. He's been at the centre of the action throughout and seems very reluctant to give up his prime position probing Kerry's face. Strangely enough however, he doesn't volunteer to provide his dick for the double vaginal penetration Kerry requests at one stage. In fact there's a shared reluctance among the group to risk rubbing dicks with their gang bang colleagues. After a lengthy pause, sheepish looks and some pleading from the leading lady, two brave souls agree to press the flesh and shoe horn themselves into the required position, so the speciality act can be captured on tape without any problems.

Our host constantly paces the room with her video camera, not so much directing the action as grappling her way through soft tissue to capture her close up. Today has more in common with documentary filmmaking than direction in any traditional sense. Sandie doesn't try and manipulate the performers or request different sexual positions, she's happy to let them improvise to prevent losing the natural energy in the room. The men taking part have watched enough porn to know what's expected of them, and they adopt the stock sexual positions without any prompting.

As Sandie is quite small, she constantly has to move to frame her shot, standing on chairs to film from a higher angle, or risking

taking a direct spunk hit on her lens when moving in close to the action. To be fair she's got an easier job than Kiwi. Shooting stills for Kerry's website, he's got to carefully manoeuvre himself near the action without trapping any flesh under his wheels.

As the men queue politely, a number of participants come over and chat. Tim (*name changed*) is a friendly, affable IT consultant who has been swinging for the past three years. He tells me he was up all last night entertaining an Asda cashier from Chelmsford. Despite being physically exhausted, the opportunity to get his paws on Kerry was too tempting a proposition. As he starts outlining his detailed manifesto of sexual freedom, his eyes fall on Kerry, who is now positioned on all fours on the futon. "Sorry mate, but look at that arse. I'm having some of that," he mumbles before skipping back to the fray.

Sandie displays a commendable sassy tone with the male performers throughout. When the group kneel over the prone face of Kerry, trying to muster a mass facial cumshot, she gives them twenty minutes of pulling at their exhausted dicks, before stating bluntly: "It's rude to keep a lady waiting." After a painfully lengthy episode, they finally manage a group cum shot, Kerry rising from the man mound with a face like a plasterer's radio. Her glasses appear to have taken the brunt of the assault, and as she removes them, she licks off the molasses thick sperm to awed gasps of amazement.

Kerry mentions that she has a grand finale planned, and the men retreat from the coal face and stand in a semi circle. Lying flat, with her vagina raised in the air, Kerry starts furiously masturbating. One of the group lies directly below her, hiding his face, but still managing to crank his man flesh as he awaits a baptism of vaginal fluid. We are about to witness female ejaculation or 'gushing'. A pornographic side show trick that still divides medical opinion regarding its validity. Many experts claim that women are unable to produce ejaculate, believing that gushing is nothing more than the involuntary loss of urine during orgasm. Many women disagree, claiming that they have always been capable of producing vaginal emissions. To my untrained eye, the arch of fluid that escapes from Kerry looks suspiciously like piss, but regardless of this it still manages to draw the positive attention of the man kneeling below our starlet. He directs his face towards the flow, lapping at the golden stream like a thirsty kitten offered a bowl of cold milk.

As an encore Kerry reaches for the lube and inserts her entire fist into her vagina, maintaining the position whilst Sandie and

Kiwi shoot stills and everyone, including myself, move closer to get a better look. It's likely that this sequence will never make the final cut, as both UK and US distributors are reluctant to include fisting in their films for fear that they will fall foul of local obscenity law.

After this, the party starts to wind down. Many of the men get dressed, ready to drive back to work and families, shaking hands with their new found friends and giving Kerry a warm round of applause as a thank you.

Ever the perfect gentleman, Kiwi sponges the jizz off Kerry with a baby wipe. You'd think that she would be exhausted after the gymnastic display she's undertaken for the last few hours, but apparently she's not finished yet. When 'Ms Caine' offers her the use of the shower, she's very keen, but only on the condition that the director joins her for some simulated Sapphic coupling. They disappear for a few minutes, Kiwi capturing the girl/girl action on his stills camera.

After Sandie has bid farewell to Kerry and Kiwi, we are left alone. Ringo hoovering downstairs, stressing about how he can remove the urine stains from his front room carpet. Ecstatic that I can finally spark up a cigarette, we retire upstairs for the interview.

**BRUCE** That was really filthy... in a good way of course. How easy is it to find women willing to take on that many men for a shoot?

**SANDIE** I tend to know a lot of people, so I've been really lucky.

**BRUCE** Do you think it helps being a woman?

**SANDIE** Yeah. I have been there and I've done it, so I can say to the girls it's not that bad. I always make it known to them that they can set their own limits, so they know I'm looking out for them at the end of the day. You occasionally get one or two guys who try and push the limits and do something without asking. If I can see the girl is getting uncomfortable I'll say something, but I try and get them to speak up for themselves, at the end of the day it's their body.

**BRUCE** It looks like really hard work!

**SANDIE** Compared to a professional porn shoot and having done as many as I've done, I'd say it's easier. If I've had enough I can say

so. I'm in control. It's a casual environment, a party. Yes I need to get my angles, but you have to work around them. It's much more laid back. Whereas when you do a one to one sex shoot it's more demanding, you have to make sure you've got your face on all the time and the camera is always focused on you.

**BRUCE** I'll confess to feeling slightly ashamed. There were guys here this afternoon double my age, who appeared to be a better shag than I am.

**SANDIE** (laughing) Yeah, some of them are not that bad. A lot of the guys are regulars. Some of the new guys who come let their nerves get the better of them and back out; obviously they need to be comfortable in a group environment. They all did very well today.

**BRUCE** You're moving into the production side at the moment. Given the limited shelf life of female performers, why aren't more women making this leap?

**SANDIE** A lot of people have tried. I'm lucky that I've got a good reputation. Time keeping, being punctual, being a good worker, doing the shit jobs as well as the good ones...

**BRUCE** Which reminds me, how did you land on planet smut?

**SANDIE** I was in a long term relationship with a very messy split up. For lots of different reasons I decided I was going to go out and do something completely different. I initially thought of doing it for fun, a bit of extra cash, an ego boost, a temporary thing. It helped me get over my relationship. Because I was getting sex frequently it acted as a substitute, although it doesn't now. I carried on doing my full time job as a fashion buyer, just working evenings and weekends, but I was getting calls all the time and I couldn't keep taking days off work. I added up one week how much work I'd turned down and realised that it would normally take a month to earn the same amount. That was when I realised I could make a full time career out of this. I thought do I go for it or not? Do I live the rest of my life not knowing if I don't try? In the end I thought bollocks, I'm going to go for it.

**BRUCE** How long have you been working?

**SANDIE** Just over two years, but I've crammed a lot into the time.

**BRUCE** How old are you?

**SANDIE** Twenty-four, twenty-five next month.

**BRUCE** What was your first shoot like?

**SANDIE** The guy came to where I was living at the time and we booked a hotel. I got a bit pissed up, Dutch courage. It was quite easy actually. He gave me a bit of guidance, but I had a rough idea of what was going on. Afterwards I thought, is that it? It was cool. I got a kick out of it, I was on a high for a couple of days afterwards. It was nice having the attention. The majority of the people you work with make you feel like a queen, especially in this country; America is different. As time goes on it wears off a bit. But at that point I wanted to get attention, feel wanted and I did, very much so.

**BRUCE** According to many anti-porn campaigners I've spoken to, this is a business defined by exploitation, trauma and lost souls. Any negative experiences so far?

**SANDIE** Not especially. The only thing that really sticks in my mind, which probably happens to most girls, was pretty early on. I phoned one guy when I was still working at my day job. He said come around for a test shoot, which when you are new is the norm. When you get more experience you realise that test shoots shouldn't take more than half an hour. This one took hours, I even signed a model release form. After a week I realised what I'd done, he was going to sell all the pictures. All I really cared about was that they were nice pictures, they would have been excellent for my portfolio. Yes, I'd lost out on the money because I'd been thick and stupid. I tried ringing but they wouldn't speak to me. It's about the worst experience I've ever had!

**BRUCE** That's interesting, given that I've always been led to believe that this is an industry rotten to the core with sleazy business practices. Anyway, the UK porn business is still in its infancy, how do you see things developing?

**SANDIE** I don't watch a lot of the extreme material that comes from Germany and places like that. I know it's about, but I'm not interested. Most of the material that comes from America, France and Spain is no different to the Restricted 18 stuff we get here. You can show penetration, double this, double that, there are only a few things you still can't show.

**BRUCE** I've always been a vocal critic of the rising tide of misogynistic pornography coming from certain quarters in the States. Especially the pseudo rape themes in the material produced by Extreme Associates. Given that you've worked in the States, what's your view?

**SANDIE** At the end of the day, the majority of people have values on what is right and wrong and we know where our own boundaries are. No one wants to see a girl, or a guy, getting degraded in any way, but at the end of the day, porn is a fantasy. What we have in our heads is not necessarily right or wrong, so I can understand why there is a market for that kind of misogynistic sex. I've done plenty of extreme stuff but I hate working in America, I find working out there very degrading, it's all slapping the girl around.

**BRUCE** Many performers still see working in the States as the Holy Grail.

**SANDIE** In Britain it's just more fun. You know everyone, it's about having real sex. Over there it's very choreographed, they know exactly what they want as soon as you walk through the door. The guy is the star of the show, rather than the girl, which I think is backward. There's too much choking — yeah, a degree of hair pulling and spitting is nice, but I think it goes on too frequently. I had a chat with someone recently and he explained a few things to me. A lot of US guys are working two scenes a day, and when you get to a certain level, you let your values go a bit, you get bored of tits, fanny and arse and want to move on to other things. I'm a bit like that because I've discovered I've got a slight foot fetish, because once again I'm bored of cock and you start thinking "Wow, feet!"

**BRUCE** The spiked platforms Kerry was wearing were cool.

**SANDIE** It's really startled me to find I'm looking for something else. That's why the US guys are into choking, they've seen every-

thing, they're bored, and they're trying to take it to the next level. I can understand why the guys like doing that, and why the guys filming it enjoy it, but there are so many young, naïve girls that are happy to go along with it without saying anything, and that's the side of it I don't like. There are a handful of girls prepared to stick up for themselves, but the majority don't. I need the money, I need the job, I can't be seen to be a moaning cow. You have to know when to tell people they are taking the piss. Whenever you speak up, you are always going to get a reputation.

**BRUCE** Let's talk about your friends and family. Do they know, and what do they think?

**SANDIE** All of my friends know what I do and everyone's cool. My family think I do nude modelling. I suspect that my mum knows I do more than that. She knows I earn a lot of money (laughing), so she probably thinks I'm some kind of high class hooker. The day will come when I tell her what I do, and she won't disown me, it's just not in her nature.

**BRUCE** It is a strange choice of career. Is it about rebellion?

**SANDIE** It's a strange choice of career for someone who hasn't got a very high sex drive (laughs). When I started out I was sick of the rat race. You work, come home at five, go to the pub, watch a video, the same old routine. Yeah, you may go out clubbing on the weekend, but nothing really exciting ever happens. I thought that this was different, I was always the quiet girl sat in the corner, this was going to shock everyone; in some ways I wanted people to find out.

**BRUCE** So what's your entry on the Friends Reunited website?

**SANDIE** I'm a porn star (laughs). Although I don't think a lot of people will believe it! Seeing the quiet girl getting all her bits out may shock some people.

**BRUCE** What do you think of the US culture for breast augmentation and plastic surgery, something that thankfully isn't that prevalent in Blighty?

**SANDIE** It's an odd thing, I find people can be quite hypocritical.

I've got small boobs, and when I came into the industry lots of people told me 'don't get a boob job', although I've still had photographers who won't shoot me. I think we are much more accepting of real women in this country. At the end of the day you are a product, you may as well be wrapped in plastic, but porn isn't forever. Is it really worth cutting yourself up into pieces for a career? It might be nice to have bigger tits, but I'm not going to waste £3,500 on them. I've got better things to spend my money on.

**BRUCE** What about relationships? They must be difficult?

**SANDIE** I would prefer a relationship with someone outside of the industry, a lot of my friends are people in the business and sometimes you want to go home and not talk about sex.

**BRUCE** Do you ever think you will settle down for a life in suburbia?

**SANDIE** I suppose I have thoughts in the back of my mind about what I'd like to do, but at the moment I'm happy to just wait and see what happens.

# Door To Door

## Car Booting with Video Alex

THERE WAS ONCE A PERIOD IN MY LIFE WHEN THE ONLY time I'd be up at 6 am on a weekend was during a twitchy comedown from a night of heavy stimulant abuse. This is the reason why it strikes me as strange that I'm driving through the picturesque valleys of South Wales at dawn on a Sunday morning without any assistance from class A drugs. I'm heading for the home of local legend Video Alex *(name changed)*, who has for the last three decades made a living on the fringes of legality, renting and selling porno to the grateful inhabitants of his ex-mining community.

Video Alex's double garage, situated next to his immaculate home on a new built housing estate is the heart of his business empire. It's a business that obviously makes good money given the size of the property — although Alex is understandably reluctant to go into too much detail, as he isn't a big fan of paying tax. The garage is part office, part museum of the video age, as he has sacrificed most of the floor space to his large collection of vintage Betamax, Video 2000 and laser disc players, which he has collected obsessively since the formats died a death in the fiercely competitive home entertainment marketplace of the eighties. He has always promised himself that when he finds the time he will get all of them up and running before donating them to a worthy cause.

For a nostalgia junkie like myself it's an Aladdin's Cave, especially when I spot a suitcase sized VHS monstrosity hidden among the spares. It's exactly the same model that sat in my childhood home.

The shelves are also groaning with the weight of his extensive film collection, thousands of horror, music, action and comedy films he has collected over the years. He tells me he's been lucky, searching out video hire shops on the brink of bankruptcy and clearing them of their entire stock for cash before the mortgage company

**72**

repossessed and seized the assets. For business purposes he has a six video duplication system to run off multiple copies of porn from an original DVD master, a widescreen television for checking the picture quality and a vast library of VHS tapes in plain covers piled on every available inch of floor space.

It's impossible to move in the garage without sending a mountain of tapes crashing to the floor. The tapes are all numbered, after Alex stopped writing titles on the spines after receiving complaints from his punters that their wives had taken offence at finding VHS tapes with 'Festival of Jizz' written in magic marker, hidden in their husband's sock drawer. Alex also has a funky looking iMac to mock up box covers, given he also does a roaring trade in DVD bootlegs of current Hollywood releases. "I can't even fucking use it. I can make them, but don't ask me to turn it on," he tells me.

Gareth, his oldest son, runs off covers, duplicates tapes and does the business accounts when he's back from university in Leeds. Many weeks before a film has officially opened in UK cinemas it's likely that Alex will have hundreds of copies ready to distribute in pubs and clubs across South Wales. He's reluctant to tell me where he gets them from although he does hint that his supplier — a "dodgy guy from the Midlands" — would not be impressed if he knew Alex was talking to me.

Alex also tells me that for a small charge he can 'chip' any home cable set up, allowing access to a world of entertainment without paying any monthly subscription charge. The change by cable suppliers from an analogue to a digital signal has presented a few problems, but he seems to think that within a few months he will have cracked the code and this line of business can continue.

Alex is in his fifties and he's big. In fact he's built like a brick shit house. He's casually dressed in jeans, jumper and a thick gold chain. He has a deep mahogany tan, a result of frequent trips to his holiday home in the Costa del Sol. When I arrive at the house, he shakes my hand with such force I'm sure that bones have been broken. Despite the imposing figure he strikes, he's great fun to be around. He was initially reluctant to be interviewed when we spoke on the phone ("Why would any bastard be interested in me?") but he turns out to be a natural story teller who can't resist the urge to detail his colourful life as soon as I start asking questions.

His all time favourite scam was the fruit machine rip off. "I used to make stupid money every week," he tells me. With the help of some friends he would travel across the country with an adapted

mobile phone, jamming the gaming machine's motherboard and collecting the jackpot until asked to leave by suspicious bar staff. The team would stay in five star hotels, drink like fish, eat out at expensive restaurants and still come home with a stack of cash. The only problem was changing up the bags of pound coins and fifty pence pieces. "It would get embarrassing going to the bank to pay them in, especially as I was signing on at the time."

Like all good magicians Alex is unwilling to reveal the secrets behind any of his money making schemes. But he does tell me he had to stop working the fruit machines when a number of police forces sent warning letters, along with a detailed description, to publicans and amusement arcade owners across the country.

Video Alex didn't always work in video piracy and electrical scamming. After leaving school at fifteen he spent the majority of his working life in the steel industry. During the manufacturing recession in the early seventies he was one of five hundred local men made redundant. They found out they had been sacked after watching the local news; no one thought them worthy of getting any advance notice that their lives were in the process of being destroyed.

Like many men of his age, Alex either had to retrain, die or settle for a life on the dole. After taking part in a number of compulsory government training schemes, he quickly came to the conclusion that filing, word processing or answering phones was never going to be a viable career option, so he spent his redundancy payment on getting an education.

He chose electronics because he'd recently completed a six week work experience placement, building microwaves in a factory on a local industrial estate. The money was poor and the demotivated workforce consisted of ex-steelworkers, feeding a constantly moving conveyer belt, overseen by twenty something managers who had no respect for the life experience of their work force. People struggled to retain their dignity and a fair number of the employees were sacked for throwing punches at the boss. After a lifetime of working in heavy industry, Alex started to think that he had a skill for this kind of work, given that it at least offered the vague chance of a future in an economic climate where the majority of his peers would never work again.

After spending three years at college and coming top of the class in a peer group made up of people half his age, his first big scheme was the 'phone bill blocker', a device he used to advertise in the local press and top shelf magazines. He claimed it could block the

billing system on the BT phone network, meaning punters could run up 0898 premium rate calls without having to pay a penny. He bought the units from a cockney wholesaler in the South East, spending the last of his redundancy money buying out the entire stock.

Sadly, the device never worked and as soon as his punters' quarterly phone bills dropped through the letterbox, duped customers vocalised their anger by banging on his door late at night, upsetting his wife and kids in the process. In a culture where financial disputes are settled with fists and petrol bombs rather than a strongly worded letter of complaint, Alex refunded all the cash and started to desperately dream up ways of making enough cash to pay his mortgage.

Luckily, in the early days of the video boom many major film companies were reluctant to release product into the film rental marketplace. They genuinely feared losing control of their product by making it available to a home audience. The Disney Corporation in particular had the most to lose, given that they continually re-released their back catalogue of feature films into cinemas every school holiday. This restrictive business approach meant that Disney product became major business for video pirates. Despite the poor quality of the bootlegs available they shifted by the bucket load. As many toy advertisers worked out years ago, the nag factor means children will plead, whine and beg their parents for a copy of *Snow White* or *Dumbo* after watching a grainy eighth generation copy round at their friend's house.

Alex had always operated a double video set up, running off copies of films for friends, so he was well placed to take advantage.

"It all started with the Disney films," Alex tells me. "The quality was shit. The picture was so snowy, to be honest you couldn't see fuck all but people were ringing me day and night. I sold over fifty copies at a fiver a pop in the local club in one night."

This was a rare opportunity to make hard cash in one of the most economically depressed regions in the UK and Alex took to the role of free market entrepreneur as quickly as any Porsche driving London yuppie. Soon, he became the man in the area for bootleg videos and his customers were quickly screaming for pornography. Legal restrictions were so tight on sexually explicit material in the UK it was a licence to print money.

"People kept asking for blue films. My wife was never happy with it but you have to meet the demand. I'd never even watched

dirty films before I started selling them."

Alex started with five tapes he bought off a mate in Bristol, making ten copies of each and renting them to a small number of friends. At first he didn't even ask for cash, he'd throw in a *'bluey'* for the man of the house when he shifted a Disney bootleg. To Alex, it was no different to the local barber asking you if you required something for the weekend after cutting your hair. Soon porn became the main earner and his collection of dated seventies *Swedish Erotica* titles were flying off the shelves. There was a constant stream of phone calls every night asking for new material.

"This was before mobiles, mind you. My wife and daughter would answer the phone and the person on the other end would just hang up. Not heavy breathing or anything, just embarrassment that they had got through to a woman."

Realising that he was onto a major earner, Alex invested heavily in technology. Within weeks his recently expanded video duplication set up was working twenty-four hours a day, producing hours of tapes for sale or rental. His wife wasn't happy that the spare room was becoming the base for a provincial porn empire, but they made sure that the lock stayed on the door to prevent the kids walking in and pressing play on the many VCRs.

I help Alex to load up his van with crates of videos as we are planning on going to a car boot sale in a town thirty minutes drive away. Although door to door delivery of porn to an established client base is Alex's major earner, he still attends car boot sales every weekend.

"In a few hours you can shift twenty to thirty tapes at a tenner each," he tells me. "I'd be stupid to miss out on that sort of money just to have a lie in."

When we arrive at the windswept sports field, Alex sends me off to buy coffee and bacon sandwiches, while he pulls out his trestle table and loads it with a selection of mainstream tapes from his garage. He never keeps the hardcore on open display, stashing the tapes in the van along with hundreds of duty free pouches of rolling tobacco.

He has a few softcore tapes on display to attract the attention of the punters. If they express an interest and ask if he has anything stronger he will give them the once over, and if they look safe he'll collect a tape from the van and hand it over. It's been difficult work lately because Alex's arch nemesis, the local author-

ity Trading Standards officers, have been aggressively targeting car boot sales in the area, trying to stop the sale of stolen and bootlegged goods.

"There's only four of them in total for this council and three of them are women. That's why I never offer tapes to women. The bastards swap patches as well, working in a neighbouring authority to make it more difficult for us to recognise them."

The general perception that car boot sales are nothing more than a chance to sell unwanted rubbish to a gullible public obsessed with stock piling junk, seems to be wide of the mark on my experience today. You may well see plenty of families huddled in the bitter cold, looking like Balkan refugees as they sell useless tat off tartan rugs, but take a closer look and you soon discover that they can have more in common with the mythical Interzone in William Burroughs's *Naked Lunch* than a wholesome family day out.

Video Alex points out a number of stalls worthy of my attention as we sip instant coffee and keep an eye out for Trading Standards. An old friend of his is set up opposite us, selling snide Tommy Hilfiger sweatshirts and a selection of genuine Ralph Lauren recently 'liberated' from a designer store in Cardiff. He's obviously doing well, because there is a queue of punters waiting to hand over cash, and he sells out his entire stock within an hour of setting up shop. Take a short walk across the muddy field, and you are able to buy any recent cinema release on DVD, choose from a range of pirate computer software or purchase a best selling album for a tenth of the recommended retail price. One stall is selling mobile phone card credits for fifty per cent of their face value and there are three or four stalls knocking out duty free spirits, wine and cigarettes.

Take into account Alex's collection of hardcore smut hidden in his van, and you could easily organise a budget party after a few minutes of browsing. You just need to scratch the surface and you can enjoy the discount world of the black economy.

A punter looking through the tapes asks Alex if he has any Ben Dover videos. "I haven't got a fucking clue mate, it's a lucky dip. They're three hours long and full of shagging so it's £10 well spent."

Reaching into the van, Alex pulls out a random tape along with his business card before taking the cash from the customer.

"Give me a ring if you want any more. I can deliver to your house. It's ten quid for three films, that's for a week. Or you can

buy them if you prefer, just buzz me."

I ask Alex if he watches much porn: "I did at first, but now I find it boring. I'd rather be doing it, than watching it." He's heard of Ben Dover because his cable customers are always asking for the hardcore versions of the trimmed films they see on their free adult channels. "They seem to like the British stuff," he laughs.

During a recent break from university, Gareth went through his dad's vast library of porn films looking specifically for footage of sex scenes shot in Wales. After days of blurred fast forwarding through hours of footage, he managed to edit six scenes onto a ninety minute compilation tape. Unusually, Alex's rental customers were unwilling to part with the tape when the week was up. "They fucking loved it, we sold hundreds. My boy was born for this kind of work."

Interestingly enough when I ask Alex how he thinks the liberalisation of pornography in Britain will affect his business, it turns out he doesn't even know things had changed. Despite prohibition effectively ending he remains overwhelmingly positive.

"I can't see how it will change anything. You go to the shops in Cardiff or Swansea and they are asking £30 for a video. That's stupid money. For some people it's a week's benefit. Who is going to pay that when they can buy off me for a third of the price?"

Over the course of the morning, Alex shifts twenty-two hardcore tapes, a few second hand films from the trestle table and endless pouches of tobacco. For three hours work he makes £220 tax free on pornography alone, not counting the delivery customers he has recruited to the cause.

"I've never dealt with the sick stuff," he tells me. "People have asked for bondage, animals, shitting and pissing, but I won't have it in the house."

A few years ago one of his customers made the mistake of asking for material featuring children. Alex ended up in police custody for assault. "The fucking pervert ended up dropping the charges, because he knew he'd be in the shit after I was interviewed."

Considering Alex has been in the game so long, it's a minor miracle that he has never faced more serious charges relating to copyright theft or distribution of obscenity.

"People know me, they know I'm OK. I've got coppers as customers. In the past I've given some of them a discount. If people

want to watch it why stop them. Booze does more damage and no one gives a fuck about that," he tells me.

Freezing cold, we eventually head off home around noon, stopping off at a pub for a few beers on the way back. Alex has a deal with the barman who takes delivery of a box of filth every week and sells the tapes to his customers on a sale or return basis. I tell Alex about people I've recently met who invest their money in the films he bootlegs. Does he ever feel guilty about eating into their profits?

"The simple answer is no. People here just can't afford the prices they are asking. If they reduced their prices I'd go out of business. I never feel guilty about anything to be honest. All my family and friends know what I do for a living. I've never tried to hide it. In the past I've even stored tapes around my mum's house when there's been rumours of raids. She's in her seventies and she doesn't mind. This community is being destroyed by drugs and unemployment. Kids are using heroin like we used to get pissed. The police should try and arrest the drug dealers, and the government should give the teenagers hope, rather than fucking arrest people selling a bit of slap and tickle or cheap fags."

Ever the businessman with an eye for the sales opportunity, Alex tries to sell me a stack of tapes before I head home. I manage to get a fifty per cent reduction on a box of VHS porn titles and a number of mainstream DVD bootlegs. Waving me off as I drive away he motions for me to wind down the window before shouting: "For fuck's sake son, don't tell anyone I gave you a discount or everyone else will start taking the piss."

# Sex On The Phone

## Working the Lines

JUST A FEW MINUTES AFTER I HAVE PUNCHED THE CLOCK on my night shift, the kitchen phone starts ringing. Grabbing my work survival kit of beer, cigarettes and notebook, I pick up.

First punter of the day is calling himself Shaun. He seems very nervous. Spending a long time explaining in a whispered voice that "he never usually does this kind of thing." The lady may well be protesting too much, because despite his claims of social embarrassment, Shaun's breathing is becoming increasingly laboured as we exchange small talk.

Once the lengthy introductions are over, and I have discharged my legal obligation to outline the premium rate charges, he appears much more enthusiastic about getting down to business. I think he wants to suck my cock whilst I verbally abuse him. He never vocalises this directly, but being a phone sex professional I manage to read between the lines and get the session started.

I make all the right noises, relying on my prepared mental script. I call Shaun a 'dirty bastard', claiming that he's nothing more than a 'filthy little cock sucking queer'. This pantomime continues for a few minutes, until a deep groan tells me that Shaun has ejaculated. He hangs ups immediately without saying goodbye.

After a week of working on a phone sex line, I now understand why women get so upset when their man rolls over and falls asleep as soon as he has delivered the money shot.

### I

AT SOME STAGE during the writing of this book, I knew that I'd have to dip my toes into the choppy waters of action. To gain any real insight into the sex industry, I would need to take an active

**80**

role, rather than just view events from the sidelines. Given that I'm three stone overweight, bald, have a number of badly inked tattoos, and tend to become struck mute when I'm not attached to the umbilical cord of my laptop, you can begin to understand why there was little scope to do my planned exposé on high class gigolos. My elaborate scheme to hire myself exclusively to attractive, middle aged businesswomen for an evening of champagne, lobster, intelligent discussion and guilt free sex would have to be consigned to the shredder unless my advance from the publisher was going to fund extensive plastic surgery and liposuction.

Than it finally struck me. A blinding moment of insight. A 'Road to Damascus' moment on the drive to pick up the kids from school one spring morning. It seemed that I'd finally worked out a plan to gain insider knowledge by working for a living — rather than offending the sex workers I'd met by forcing my microphone into their faces in search of the scoop.

I realised that there was only one way I'd ever make a decent living in the sex industry, and it would need to involve never being seen by my punters. This isn't to put myself down or indicate that I suffer from low self esteem as a general rule. It's more a hard edged business decision, informed by the experience I'd gained with regard to the way the sex industry works. This job is about cold hard economics, rather than any real commitment to getting people off, and I would need to make the most of my limited assets in the quest to make a decent living.

Phone sex makes millions. No surprise given the cost of the initial call, which can sometimes peak at the £1.50/minute mark. The overheads and business start up costs are very low. All you need is an office for financial administration, a bank of phone diallers, secure credit card processing facilities, an advertising budget and some workers willing to talk dirty. Although the sex workers themselves are likely to live in Norwich or Essex, the core of the operation may well be located and registered in Eastern Europe or Latin America, where laws on providing sexual services will be more relaxed and the employees will work for buttons. This has been the downfall of many a closet phone sex addict, explaining to the wife why there are so many calls to Brazil listed when the itemised phone bill lands on the doorstep.

All the major players in the flesh trade stood up and took notice when phone sex technology became easily accessible in the early eighties. Most of the services on offer at the time were little more

than a tape recording of a page three stunner detailing her horse riding lessons or night time beauty routine. Once again, as so often in the British sex industry, it was all about selling the sizzle not the sausage. You could promise the world but fail to deliver time and time again, because there was no way a duped punter was likely to write a strong letter of complaint.

Over time the trade evolved. The content got increasingly explicit and new communication innovations meant that the punters could speak direct to a real live woman. More likely an obese housewife wearing sweat pants than the fuck kitten they'd been promised, but genuine human contact all the same. As the filth levels increased, so did the voices of protest. People could complain as loudly as they wanted, but the income streams involved meant that the providers of the smut along with the phone companies (who took a fifty per cent split) lobbied hard to prevent any legal clampdown. A number of token gestures were made to ensure the phone lines did not transgress taste and decency boundaries, but the government had bigger fish to fry and the trade flourished. One plan discussed was the introduction of a P.I.N for shameless phone wankers. They'd enter the code before dialling, instantly outing themselves as deviants to a giggling group of BT employees.

Take David Sullivan, dwarfish smut svengalia behind the *Sport* newspaper stable[24]. He's made a fortune from the business for decades. This is obviously assisted by the saturation advertising he employs in his stable of print titles, filling his paper and magazines with lurid ads promising 'filthy sex which will make you cum in thirty seconds.' The beauty of his approach is he owns the phone lines as well as the source of the advertising. He can make sure that only his own sex lines are advertised, ensuring he gets a virtual monopoly on the trade among his thousands of daily readers. This highlights Sullivan's particular brand of hard nosed business genius, as well as his profound skill for always knowing the nature of the beast as it applies to selling sex to the masses. This rare gift sees him named at the highest reaches of *The Times* rich list year after year, but as a definite downside he's got plenty of enemies inside the industry, as well as the wider political establishment[25].

The average punter pays out hard cash for the *Sport*, looking for some midweek titillation. His appetite whetted by the topless photosets on offer, he may well be tempted by the avalanche of phone line advertising to spend some money on a one to one with a 'horny housewife' when the day job starts to drag. Every thread in the rich sexual tapestry of human desire is represented by a

dedicated phone sex line. In fact, looking through the adverts offering phone sex services, you are struck by the idea that some of them appear to be more of a situationist art prank than a genuine offer of audio stimulation. Bear witness to the following as a great example:

A picture of an older woman, at least seventy years old. Her sagging breasts almost reach the floor and she's completely naked except for a necklace and a pair of blood red high heels. The tagline states in lurid green font: 'I'm an old goat, fuck my throat!'

This alone would indicate that people writing the copy for phone sex advertising, have to develop the same dark sense of humour that the emergency services display when clearing up the wreckage after a fatal motorway pile up.

Don't labour under the illusion that it's just *Sunday Sport* readers who are sitting in the front room, curtains drawn, masturbating to an eerie detached voice on the end of a phone line. Take a closer look at the weighty broadsheet supplements published on the weekend, and you will soon realise that even the university educated middle classes gain an erotic frisson from talking dirty to a complete stranger.

Sadly, it would appear that my plan is doomed to failure before it's even had the chance to get up and running. Initial enquiries would seem to indicate that women just don't derive any pleasure from phone related sex talk. Women spending money ringing men is a service that just does not exist in the current marketplace. Given pornographers' keen eye for the money making opportunity, there will be a very good reason for this. Just as I start to consign the concept to the shredder and start looking elsewhere for inspiration, my eyes are drawn to a small, blurry advert hidden in the pages of the *Guardian Guide*:

1 to 1 Man on Man Line. Live your fantasies on our exclusively gay live chat line. There's men ready now, desperate to take your call.

There's a picture of a chunky, muscle clad GI on the advertising. He's giving a leering look to the punters. Dressed in camouflage pants, he's wearing a tight white vest, dog tags and sports a smile that screams lavender. He brings to mind an outrageously camp Chuck Norris, although I get the sense that if this guy found you *Missing in Action* it would not be his M16 he would start to unload.

A vague idea starts to form in my mind, despite my subconscious rushing from its usual home in the shadows to set alarm bells ringing. As I try to work out if I have lost all connection to my sanity, I suddenly realise that Chuck represents a modern day version of Lord Kitchener, the stern faced star of a thousand British army propaganda posters (after all he did have the moustache). He's been sent to show me the beefcake path I must follow. He's telling me in no uncertain terms that the gay phone sex line industry needs YOU!

## II

I HAVE ALWAYS been heterosexual. Deeply, rigidly heterosexual. This lady does not mean to protest too much, and please don't see this as an attempt to adopt the Jason Donavan approach to accusations regarding my sexuality. It's based on cold hard facts.

Unlike many of my male peers I never indulged in arcane rituals that involved masturbating onto biscuits, never fumbled with my schoolmates in the showers. I did once watch an older kid on a school trip have a wank to the preprogrammed beat of a portable Casio keyboard but the background of this episode escapes me now. Many years later I read in the local paper that the same guy had been sentenced for a sexual assault, but it failed to mention if this attack was conducted to the tinny sound of a 4/4 beat.

Over the years I have had a number of gay friends, more acquaintances than friends to be truthful, but all the same they have numbered men among them who I have admired and respected. Not least because they have answered my frequent, intrusive questions regarding every aspect of their sexual behaviour with humour and good faith. This is one cliché I have always upheld: I'm a straight man with an unhealthy interest in what gay folk get up to under the sheets. I've always taken a similar blunt approach with lesbians, gawping in wide eyed wonder as they describe their bean tickling sexual adventures. Like I said, I like to know things. Despite this fascination with other people's sexuality, I've never believed homosexual men when they tell the oft-quoted joke of:

**QUESTION** What's the difference between a gay man and a straight man?

**ANSWER** Six pints!

Given that they tell me this joke when I'm into my tenth pint of premium lager and I have just spent the last fifteen minutes quizzing them about their experiences of mutual masturbation — and *still* their 'gaydar' has not told them to try it on, you start to realise that even to some of the predatory queers I have met, I remain completely immune to any idea of same sex conversion.

In search of wisdom, I ask Christian Marshall about the 'gay for pay' scene in the porno world, and he tells me he's shot a number of men who have identified themselves as straight. He tells me about a smut peddling comrade who ended up having to play video footage of a woman being anally penetrated just off camera so a straight model could watch the action as he performed. Even more the director had to spray the guy the straight model was fucking with Chanel No.5, so that the leading man could imagine he was a woman.

"Talk about... what's my motivation," Christian giggles down the phone.

My experience of gay culture is not just limited to hanging around gay porn sets or a few drunken nights out with friends of a friend however. The following CV of gayness can amply evidence this:

**1** I once watched a Derek Jarman film at my local art house cinema. I left after an hour, but this had nothing to do with the explicit sex scenes, and everything to do with watching a naked man take thirty minutes to eat a raw cabbage whilst white noise played on the soundtrack.

**2** In an incident best described as 'Last Exit to Blackwood', I was once invited back to a middle aged man's flat after a late night drinking session with a close friend. The man worked as a receptionist at a cab office we used, and because we were short of the taxi fare home he offered me and my friend a bed for the night, rather than see us walk the six miles home in the rain. Displaying shocking levels of youthful naïvety, he got us drunk on foul tasting strawberry wine and played some porn on his VCR. Things were going swimmingly until my friend was woken in the middle of the night to find the man's hand down the front of jeans. He tried to do the decent thing, and suggest politely that he wasn't interested. Could the man please take his hands off his cock as it was late and he had school in the morning. The man acted like he'd had an electric shock, his face flushed with shame as he held his head in

his hands. He burst into tears, saying over and over again: "How could I do this to two lovely boys like you, how could I do this to two lovely boys like you." We were not shocked because he was gay, or because he'd made an inappropriate move. We were confused and socially embarrassed because growing up in a South Wales industrial town we had never seen a grown man cry.

**3** I find camp funny.

**4** I'm intelligent enough to know that when an unattractive straight bloke walks through the door of a gay club, he's not going to be pinned to the wall and butt fucked senseless. Men that can't get a sniff of a shag in the straight world suddenly think they take on new sexual powers as soon as they walk into a predominantly gay environment.

**5** I once felt another man's cock — I remember saying that "it felt like a sausage roll" — for some reason now luckily lost in the mists of time. This may indicate that I have repressed gay feelings that may be dragged screaming to the surface at a moment's notice, but it's important to remember that I was seven years old at the time.

**6** During a childish discussion in the school playground, I once made the dreadful error of vocalising that I would be prepared to suck Prince's cock (the US musician, rather than any member of the royal family). I was a big fan during the Purple Rain era, but in my own defence it was only on the condition that there was cash on the table. The taunting of my peers lasted well into the sixth form. People I'd never met would meet me in pubs years later and as soon as I mentioned my name they would say: "Oh yeah, the bloke that wanted to suck Prince's cock!"

**7** I was born in Brighton.

And finally…

**8** I went through a stage of reading Genet novels as a teenager. I never liked them, but they were considered 'cutting edge' when you grew up in the provinces. I tended to skim the bits that described blokes shagging in prison cells.

So that's me. Hardly motivated to take to the streets and violently attack gay men because they threaten my sexuality, but equally unlikely to throw myself into the world of circle jerking, heavy amyl nitrate use or fisting, either.

## III

BEFORE I CAN EVEN put my plan into action, I need to find someone brave enough to allow a bumbling heterosexual with a vague literary agenda to man their phones and risk scaring off their punters with painfully inept sexual conversation. I'll need to explain my motivation, the aim of my socio-genetic experiment. In short I want to prove that any man is capable of selling gay phone sex without any predilection to being gay himself.

It's proving very difficult to get in contact with the Mr Big behind phone sex scams. Obviously I try dialling the number listed in the newspaper and ask to speak to the boss, but the pleasant, effeminate sex worker manning the line treats my request with marked confusion, in fact he starts talking dirty before I have even finished my sentence requesting a postal address to send my pitching letter.

Given that the 'work experience' planning may take some time, I decide to undertake some background research within the local gay community. Starting by ringing the Gay Men's Health Project who are listed in the *Yellow Pages*. Formed during the darkest days of the HIV pandemic, they aim to act as a resource to prevent disease, offer support, advice, help and information for people thinking of coming out of the closet. As well as the vital issue of health promotion, their monthly buffets at the local arts centre are legendary. Many deeply homophobic men have been drawn into the dark world of anal sex and Dusty Springfield albums by the irresistible lure of their pasta salad or herb couscous.

They prove very helpful during our short phone conversation, offering to send me some of their literature. The information when it arrives isn't actually a pamphlet called *Being Gay*, but a stack of magazines, books and leaflets, including a large number of sexually explicit ones. I realise that the pamphlet I'm really looking for would be entitled, 'Pretending to be Gay for a Struggling Book Project,' but I get a strong suspicion that they don't carry this title in their regular literature stock.

As I start wondering why confused heterosexuals can't get sent

copies of *Razzle* through the post at the tax payers expense, the gravity of what I'm about to undertake starts to hit me when I flip open a copy of *Zipper*.

As expected, there are pages and pages of gay phone sex line adverts. They run the gauntlet from the naïve and charming (Tony is looking for love with a stranger. Dial Now!), the middle of the road (Alex wants cock) to the frankly terrifying (Leather master will fuck you hard and cum on your face). Given that I have a limited interest in the hardcore world of the leather man - leather tends to make my eczema flare up, and I'd end up spending a small fortune on hydrocortisone cream during the writing of this chapter if I'm forced to wear chaps - and as I couldn't be described as the wine and roses type, I'm starting to think that the middle ground offers the best chance of success.

To be blunt it's the sex industry I'm trying to investigate, so the romantic world of Tony (who appears to seek only candlelight meals and chocolate) just isn't gay enough for me.

I do however notice that in none of the pictures above the adverts is there a badly dressed, scruffy fat bloke, whose heterosexuality can be seen leaking from every pore. All the male models sport defined pectorals, bulging six packs and carefully trimmed blond tresses, but I'm imagining that they are unlikely to be the person you actually get to speak to on the phone. Just like the heterosexual phone sex world, the fantasy figure on the other end of the line is more likely to be a man with a limited social circle, no sense of shame, access to his own phone point and a need to earn some extra money.

As I read through the pages of ads, a number of disturbing thoughts start to cross my mind. It's easy to get caught up in the initial enthusiasm you get for a project, but if I do decide to put my plan in action what will it actually mean?

Does talking gay, acting gay, pretending to be gay, actually *make* you gay? Will people think this is nothing more than an elaborate scam for me to come out of the closet?

I've already fended off numerous accusations from friends and family. They've always tended to see any creative urge as deeply suspect anyway, so this project is likely to see its fair share of raised eyebrows. After all I did offer to suck Prince's cock once.

Even my wife seems to take the view that voluntarily consenting to talk complete filth to another man, who makes no secret that he'd happily gobble my dick given the chance, may indicate that I am 'confused'.

I find it almost impossible to even *write* the following sentence: "Hey buddy, would you like me to get on all fours, massage your shrivelled ball sack and gobble your hard cock until you shoot your jizz in my big gay mouth?" How the fuck am I going to be able to SPEAK it out loud, with conviction, to a complete stranger who is paying for the privilege?

Then I start seriously thinking about the idea. In the past I've written about Class War, the infamous anarchist group. Spending a week going on demonstrations with them for an Internet article which no one read. I ate, drank and slept the Class War philosophy, but strangely enough, I didn't get home and feel a strong urge to throw a petrol bomb at the next police car that drove past. Likewise I spent a period of time covering the neo Nazi rock underground and to this day I have still never publicly vocalised that all Jewish folk have beards that are crawling with lice.

My fear does however clarify an important point. I have always adopted a different strokes for different folks philosophy for living, priding myself on not subscribing to intolerance or bigotry, but a part of me is starting to make it obvious that I don't want to be perceived as gay. Even if we put aside this repressed homophobia for the moment, there's still a much bigger practical problem: *If I think this way, how on earth am I going to be able to talk a punter to messy orgasm without stuttering?*

The voices of my critics ringing in my ears, I decide to go ahead anyway and cast myself adrift in the choppy pink water, discover the raging queer within and finish what I started. If only so I can prove once and for all that a straight man can act as gay as Liberace without recourse to ever touching another man's penis.

## IV

WHILST I WAIT to hear back from my future employer, I throw myself fully into the 'scene' in the name of research. Where does this personal journey find me? In the back room of an S&M club watching men get fisted as I quietly nurse a bottle of warm lager? Hanging around the local 'cottage' playing the seedy voyeur as men hide the salami in the furthest cubicle? Listening to pounding techno in a dark club, as men with walrus moustaches, studded wristbands and tight jeans act out scenes more suited to Roman times?

Not exactly. It's 7:30am and I'm walking on a footpath on Exmoor, an area of outstanding natural beauty situated in the heart of the Devon countryside. I have undertaken this wholesome activity, because I was invited by Nigel (*name changed*), who has kindly agreed to take on the task of turning me into the big gay man I've always known lurks beneath my thick veneer of heterosexuality. It's his walking group I've come to meet. Not a gay walking group, as Nigel pointedly reminds me on a number of occasions, just a normal walking group that just happens to be made up of men who like sucking cock.

There are fifteen of us in total, a wide mix of ages and professions. The first indications seem to be good. I appear to fit in quite well, although a diet of beer and cigarettes means I'm breathing heavier than my healthier peers. Over the course of the day, I quietly vocalise my reasons for being here to individuals in the group. I explain how I wanted to get a feel of gay culture, before I earned cash offering to touch the dicks of faceless strangers. Reactions range from laughter, quiet bewilderment, confusion and a minority of the group who choose to believe that my only reason for doing this is because I haven't got the balls to come out of the closet like 'an honest queer'. This goes to prove that it's not just the heterosexual community who have the monopoly on harshly judging other people's sexual behaviour.

We eventually stop for lunch at a country pub. Surrounded by my pink focus group I detail my fiendish plan. This job is in my humble opinion all about acting, treading the boards, pretending to be someone I'm not, showing off, taking on a persona.

I start to describe the cast of characters I have created to see me through the difficult times ahead. Like de Niro or Brando I'm using the 'method'. Over the next couple of weeks I will become these people every time the kitchen phone rings and a punter starts heavy breathing...

**Meet Lance**: Lance is 6ft 4" of pure muscular gayness. He's here, he's queer, you *will* get used to it. If you don't and make the mistake of mocking his sexuality, he will not hesitate to beat shit into you, taking the chance to butt fuck you into submission when you try to pick your teeth off the floor. Lance is one bad motherfucker. His hobbies are going to the gym twice a day, injecting steroids and heavy drinking. Lance is what is known in gay parlance as a 'top', never a 'bottom'. You'd never catch Lance drinking Diamond White and shaking his stuff to a Steps song at the local disco. He's more

likely to be getting his dick sucked by some feminine pansy in the cloakroom, as he snorts amphetamine and tattoos himself with a Swiss army knife. I like Lance. He's hard as fuck and knows how to have a good time; he's also lucky enough to be hung like a donkey. Lance is in essence a portrait of the author as a gay man.

**Meet Christopher** : In direct contrast to Lance, Chris is a quiet, sensitive, creative type who writes for the local paper. He lives in a minimalist apartment with his two cats, Mini Moo and Foo Foo. He shares his home with his elderly mother, who hasn't got the slightest idea that her son is a raging fruit. She dreams of the day when he provides her with grandchildren, and finds nothing strange about Christopher's Shirley Bassey obsession. After all, "all boys need a hobby dear."

Chris struggles with his sexuality, never forgiving himself for an unfortunate incident where he was arrested by the police in a public toilet. He's a definite 'bottom', although in truth he spends the majority of his time masturbating frantically to the square jawed models in the Next menswear catalogue.

**Meet Jeremy**: Jeremy's a complete bitch. Even I dislike him and he only exists as a figment of my imagination. If there's one bitchy queen who confirms the cliché that all gay men are catty, looks obsessed and shallow, it's Jeremy. As he enters the room like a raging gay tsunami, you can hear his jealous ex-lovers exclaim, "Hark at she," before he's even had the chance to light a Silk Cut and order a G&T.

My cast of outrageous gay stereotypes is met with a disappointing reaction from the crowd in the pub. During my 'Jeremy' pitch, even Nigel my main support mechanism can't avoid the temptation to start tutting. People seem disappointed that I feel the need to hide behind a mask. Claiming that I am paying no attention to what might well be the only real selling point I have. The simple fact that the idea of straight Bruce, unembellished, speaking the truth will probably pack a more powerful erotic punch than the composites I have managed to dream up. Feeling disappointed that I have fallen at the first hurdle, we all finish our drinks and head back towards the moor, a light drizzle starting to fall as we leave the pub.

## V

AFTER A FEW WEEKS, I eventually find an employer. A London based outfit called Premium Phone Sex Services Ltd (*name changed*). Despite the grand title, they could well be operating out of a bedsit rather than a suite of plush offices, given that I have never actually met my bosses face to face. I wrote a letter asking for work via their PO Box, and a fortnight later they sent a stock reply, thanking me for my interest, and enclosing a UK based mobile phone number which I should ring for an interview. I'm surprised at how easy the interview is. There was no casting couch and no one thought to ask if I was gay or straight at any stage during the recruitment process, which involved a fifteen minute phone call to the charming Karen (*name changed*) at head office. This focussed exclusively on the many ways you can keep punters on the line to ensure the clock keeps ticking. After providing my bank details, a National Insurance number and a dedicated phone number, I was finally working in the sex industry. Karen tells me that staff turnover is currently very high, so the company is always recruiting. "It's difficult to give a general example of the staff, although we have always employed a large number of students. People tend to work for a few months to earn some extra money, than quit."

When I ask if she can give me any practical tips, she tells me to run down to the local newsagent and "buy some top shelf magazines. If you've got a quiet punter, read out the letters page, but do it SLOWLY".

The subject of money is raised, Karen telling me that I will earn a flat fee of £45 for every five hour shift I work. This increases at night and during the weekend, the company's busiest times. On a Friday and Saturday night immediately after the pubs have closed, there is often a long list of callers waiting to hook up with a worker, because there is not enough staff to deal with the volume of calls. The shift fee also increases if I decide to stay on following my month long probationary period, although the real money is to be made in the bonus system. The company pays extra cash to members of staff who manage to keep callers on the line for thirty, sixty and 120 minute blocks.

Karen has worked the lines herself many times. Covering staff sickness and helping out when there is a rush on means she is ideally placed to answer my next question. "What do I say if customers start talking about performing illegal activities or generally start freaking me out?"

In her eight years at the company, she can count the number of times she has been forced to hang up on callers on one hand. "Obviously you can't engage in any discussion regarding under-age sex. Otherwise pretty much anything goes. I have hung up on a caller who wanted me to smear his excrement in my face, and I had one guy who only wanted to talk about having sex with dead people which I found creepy."

Dealing with necrophilliacs had not even crossed my mind, but perhaps I have been naïve when it comes to the demands of the job. In 1999, a phone sex worker from Florida was awarded compensation for injuries she claimed to suffer as a direct result of her work. Following a diagnosis of carpal tunnel syndrome, she decided that masturbating up to seven times a shift was the main cause of her ailment. The judge agreed and awarded a settlement of $40,000[26].

Much like the phone sex business in general, the range of clients using gay phone services varies dramatically. Often you answer calls, only to be met with an eerie, detached silence — the caller so crippled with embarrassment they'll spend a fiver before they even speak a word. In this case you'd need to slowly coax information from them. "What do you look like?" "What do you do for a living?" "Do you use a gym regularly?" "Would you like me to suck you off?" — all the usual social niceties.

After working a few shifts, taking an average of ten to fifteen calls during my allotted hours of 7pm to midnight, it soon becomes very easy to categorise the callers.

**The Regular**: People who regularly use phone sex services, become quickly adept at recognising the scams the workers engage in to keep the call running as long as possible. Any attempt to make casual conversation about the weather, current affairs or the new Prada suit collection will receive short shift. Workers are told not to move the talk towards sex, until the client makes the first move, and when you are faced with a nervous punter this small talk can last an eternity. One guy who rang a few times each week, a 'heavy user' as Karen would define him, was a master of trimming off the fat and getting straight down to business.

**BRUCE** So tell me a little about yourself than?

**MR REGULAR** I'm not interested, tell me how much you like to be fucked!

Some regulars obviously believed that ten minutes spent masturbating to my voice, means that we have developed a serious relationship, rather than just a convenient business contract. Questions about my life were frequently asked, and luckily easily ignored by adopting the stock line, "The company forbids its employees giving out personal details, I'm very sorry."

**The Silent Type**: Given the high prices, it always struck me as strange that some punters used the service more as a counselling facility, than an aural stimulus to masturbation. Instead of sex some people appeared to want nothing more than someone to talk to. A brief love affair with a disembodied voice. One Friday I took a call from a young man who claimed he was eighteen, but I guessed he was younger. He was very nervous, but still spent an hour talking about the bullying he was experiencing in school because he was gay. He hung up without once mentioning sex or adopting the usual heavy breathing, deep groan, hang up dynamic that defined most of the calls. He was obviously scared, confused, ashamed and embarrassed by his sexuality, and rather than talking to his friends or his parents, he saw no other option but to discuss his life with a stranger. Providing sex services over the phone is relatively easy, but ask any sex worker and I'm willing to bet hard cash that they will tell you straightforward human contact is much more of a challenge.

**Cranks**: I lost count of the number of hoax calls I got over the time I worked the lines. The routine was always the same. Pick up, silence, and than a lengthy rant by the punter down the phone. Usually a variation on the 'you fucking queer' line. As Karen suggested during the interview, I'd never hang up, leaving the caller with a large bill resulting from their urge to vent spleen.

Over time it became obvious that my heterosexuality played no part in my ability to do the job. The main skill you need to sell sex over the phone isn't even an ability to talk dirty (although an active imagination can be helpful when dealing with a mute client). An ability to laugh at the way we mutually judge sexual behaviour as a society is much more important. Did I feel exploited? The simple answer is no.

Bored, tired, malaise and sometimes shocked into mute silence by some of the surreal sexual demands of the punters, but never exploited. The money is good, especially if you rack up bonuses dur-

ing your shift, but best of all there is no aggressive boss constantly barking orders over your shoulder. Unlike some large companies in the service sector, unionisation is not forbidden. Phone sex workers have representation through the International Union of Sex Workers (IUSW), currently affiliated with the large GMB union in the UK. You often have more employment rights as a phone sex worker, than a teenager earning minimum wage in a fast food franchise.

The level of anonymity offered by phone sex, means working the lines give you a secret insight into the lurid fantasies of the great British public. It's worth remembering that you hear things from callers that are usually kept secret from their closest friends, family members and even their partners. This may explain why so many married men ring gay sex lines. During one shift I took a call from a softly spoken man, and during the small talk I noticed that there was someone else listening in on another line. I asked who it was, and he happily confirmed that his wife was on the bedroom extension. It was the only contact with a female I had during the time I worked the lines, and I came to the conclusion that if I could work exclusively in the heterosexual phone sex domain it would be the greatest job in the world.

After completing my ten shifts and retiring from the business (despite Karen pleading with me to cover just "one more weekend"), I get in touch with Sally, a veteran of the lines and the longest serving employee of the company. Sally has worked in the trade since the early days of inane recorded messages on 0898 numbers. "How has your experience altered your perception of men?" I ask.

"It hasn't made a difference," she tells me. "I've been married for twenty years, to an understanding, lovely man who treats me very well. He's never objected to how I make my living. I always knew that the vast majority of men can't be trusted, and this work has confirmed that. I really enjoy it, I wouldn't want to do anything else."

Sally does miss the old days, before the technology evolved and large numbers of workers would often operate out of vast call centres, rather than work from home.

"It was funnier then, because you could take the piss out of the punters and make each other laugh by pulling faces when you were taking calls. The best thing is I'm fifty-seven now, but I don't have to think about retirement. I can still talk dirty when I'm in my eighties."

# Mr. Allen

## Dirty Old Man or
## Sexual Revolutionary?

MARCUS ALLEN IS A LIVING LEGEND IN THE UK SEX business, not least because he's making a living in an industry that has historically been the exclusive preserve of the young. He's the self proclaimed 'oldest swinger in town' and will soon celebrate his sixty-seventh birthday yet still appears to have no immediate plans for retirement. He performs in his films as well as acting as sole cameraman, using the remote control function on his camcorder to direct the action. Marcus doesn't have to fork out on expensive locations, given that he shoots the majority of his titles in his flat after converting his bedroom into a fully functional studio. This is a no frills operation with low overheads, which maintains a loyal fan base and should in theory be raking in the cash.

As well as filming hundreds of girls over the years, Marcus has a varied CV in the flesh trade, which includes running a model agency, an escort service and spending a number of years at Her Majesty's pleasure for non sex industry related offences. He also has an encyclopaedic knowledge of the changing face of the UK sex industry over the last thirty years, because he's been on the frontline throughout — making a living in a business that was subject to frequent police raids, in the days when filmmakers risked serious prison time for distributing hardcore.

"I'm a pornographer, not a businessman," he tells me over the phone.

In fact he's one of a rare breed who can happily boast of facing the wrath of the law and winning, after beating a number of charges relating to the distribution of filth at Bow Street Magistrates court. Rubbing it into the nose of the prosecution, he was eventually awarded costs after the case was thrown out of court.

When I tell my wife that Marcus has agreed to be interviewed she asks who he is. I tell her it's a guy we saw on a Channel Four documentary[27] a few years ago. "You know the old bloke that films himself shagging models in his flat?"

"Oh yeah... the really sleazy one!" she replies within seconds.

This is not an isolated response, given that Marcus has been the subject of vilification in the press over the years.

"I broke the nose of a *News of the World* reporter once," he tells me.

Spend a few minutes with Marcus and it quickly becomes obvious that he views communication with the press on a par with making a pact with Satan. "The media are almost 100 per cent guilty of hypocrisy where sex is concerned, especially the tabloids. They carry ads for escort agencies and telephone sex chat lines, but their reportage of sexual high jinks by celebrities or vicars carries the high moral outrage of a violated virgin. The English mentality where sex is concerned is fucking weird, if you keep things hidden it just makes people want to do it more."

I thought his appearance in the documentary did him no favours, but Marcus seems happy with his portrayal. Maybe my wife's reaction is easy to explain. Put in the simplest terms, most people just don't like to see old people fucking. I watched *Senior Service* and *Kinky Wrinkly*, his latest video releases, as research before our meeting and I have to confess that seeing Marcus on the job does have a lingering visual power.

There is however another reason why people have targeted Marcus for vilification in the past and this is entirely due to the type of women who appear in his films. In his long running *Marcus Allen Interviews* video series and his new Virgin Breakers website, he focuses on performers new to the industry — porn debutants who come from all walks of life and are entering the business for a multitude of different reasons. After filming a brief interview they get down to business and viewers are sometimes left in no doubt about the amateur status of the girls taking part.

Although Marcus has discovered starlets who have moved on to establish careers both here and in the USA, he's also filmed a fair number of single mums who have entered the business purely as a way of making an easy buck. In some of his releases, you can't escape a niggling feeling that the performers look a lot like rabbits trapped in the headlights of an oncoming car. They probably thought making porn films had a sheen of glamour, but this illu-

**97**

sion would have been cruelly shattered as soon as they saw Marcus heading towards them with a dildo and video camera.

On one of the hottest days in British history I meet Marcus in his London flat. His escort business is obviously doing well because the phone never stops ringing all the time I'm there. Marcus has a lot of phones, I count four but there are probably others hidden around the flat. One caller is an escort punter who can't provide an address for the booking he's made for the evening. Marcus patiently outlines his policy on booking girls, insisting that he will not honour the agreed arrangement, unless he can ensure the girl's safety at all times. On the afternoon I visit, a petite blond of Eastern European heritage sits at his computer, asking for assistance whilst composing an email back home.

The flat is light and airy and bears no relation to the under lit, shadowy pornographer's lair I remember from the documentary. TV crews covering the UK sex industry seem to have a contractual obligation to shoot interviews with sex workers using the minimum of lighting and a soundtrack of foreboding music more suited to a horror film. The shelves in the living room contain houseplants rather than pornography, the television is tuned to a golden oldies music station and pride of place is given to a large climbing frame being used enthusiastically by the Chairman, Marcus' cat.

In the flesh Marcus appears slight, fragile even, although his wiry frame hints that he would have made an excellent middleweight boxer in his army days. He chain smokes unfiltered cigarettes throughout our interview, and given that he also enjoys a reputation for liking a drink it's a miracle he's survived this long. People tell me that Marcus suffers from an alcohol induced lycanthropy, turning him into a different person when he's half way through a bottle of scotch, but he's been charm personified during our contact. Besides, it's difficult to find Marcus offensive, given that at first glance he reminds me of Bob Todd, the long standing comedy stooge in *Benny Hill*, who provided a running visual gag every time he got his head slapped in the 1980s.

Marcus got into the business following his release from prison in the early eighties. A friend had set him up with a South American hooker as a coming out present and they ended up spending a week together, the conversation eventually coming around to the many opportunities she saw to make money in the sex trade. Inspired by the chance to make an easy buck, Marcus decided to set up his own escort business and model agency. Other options were limited because of the close eye of his probation officer, making it impos-

sible for him to continue his old line of work.

"I was a safe breaker," he laughs. "I've been a thief most of my life, although I've never robbed an individual or burgled anyone's house, I always went for institutions. Blowing safes is what fucked my back up, although I don't regret a day of it."

Marcus may have a past best described as 'colourful' but throughout our conversation he still shares his generation's tendency to document every ache and pain in detail. You'd never guess from his appearances on video but he suffers from chronic arthritis as a direct result of his criminal activities.

Following a lengthy stretch after a failed blag, he decided to seek less risky employment and the smut game appeared to offer a good opportunity to mix business with pleasure. He'd previously operated a 'high class' hostess club in Soho, so he knew some of the players in the industry who could help him get started.

Porn as a career option has always attracted a strange mix of outlaw spirits, mavericks, lunatics, petty criminals, visionaries, social misfits and freedom fighters — the kind of people who couldn't give a flying fuck about the opinions of the majority. Porn veterans talk about the glory days of the eighties and nineties with misty eyed nostalgia. The risk that the dirty squad were going to bust down the door at six am, our filth baron asleep next to a glamorous dolly bird in the master bedroom of his Essex bachelor pad, is the kind of buzz so lacking in today's British sex business. Obscenity offences apart, it's not unusual to find that some porn producers are no strangers to spending time in the nick. Porn was often a sideline, a pleasant diversion that offered easy cash for the minimum of hassle and it meant you were always surrounded by tasty birds.

Marcus has crossed paths with a lot of people over the years and he tells me a number of outrageous stories about vintage Soho, including some choice gossip about a number of current major industry players. At this point I start cursing the libel laws, which don't allow me to repeat his allegations in this book[28].

Marcus is a blunt speaker, reluctant to add any positive spin to what can be an occasionally demanding and unforgiving business for the many women who show up at his Edgware Road flat. I ask whether he finds himself telling some women that they just haven't got what it takes to make a living in the flesh trade.

"Oh yeah, a lot of the time, especially with the top shelf magazines. For that work women have to be perfect, no stretch marks or saggy boobs. Often as soon as they take their clothes off you know they're wasting their time. I try to be as kind as possible and I never

blame the girls for trying, even if they look like the back end of a bus. One girl had a terrible row with me because her boyfriend was convinced she should be on page three. She was a lovely looking girl with her clothes on, but when she took them off her tits hit the floor. We had a big argument and her boyfriend used to ring to threaten me. There are other reasons for turning people down as well. I won't deal with junkies, not for any moral reasons, it's just they are always unreliable and they usually come with a pimp or dealer attached. I get girls coming here who are so desperate they'd go out and fuck a donkey for a tenner. I won't have anything to do with them because a few years down the line they'll end up regretting it. You also get some filthy ones. I had a girl once and I could smell her across the room. She started taking her clothes off and the stink wafted across the room. 'Sweetheart, you have to go,' I told her and she wasn't happy. Some of them take their clothes off and you think, Jesus when did they last have a bath."

Marcus says he can usually find most women work of some kind: "The vast majority of punters prefer a natural look, ordinary girls I guess. People like seeing ordinary girls do naughty things on video. They can identify with that, because they like to think they're in with a chance. Watching Pamela Anderson they know they've got no fucking chance."

Lately Marcus has drawn the conclusion that there just isn't the talent around any more. In the old days he'd have queues of women outside his flat wanting to join his model agency or get filmed having sex in his box room. His agency used to provide models for the all the glossy top shelf magazines but over the past few years the stream of talent has all but dried up.

"The killer was the advent of table dancing clubs," he tells me. "A girl would ask herself the question: should I get shagged silly for £300 and be publicised everywhere or work harder with no publicity and get something like a grand a week?"

Marcus takes great offence when I ask him if he's kept count of all the women he's fucked over the decades. "I'm not the sort of guy who keeps notches on the bedpost. That's never been my style," he replies, indignant. In fact any critic who claimed his outlook is defined by misogyny would be surprised to find that Marcus reserves his real loathing for the male of the species. "Men should never be trusted," he tells me.

Despite his libertarian outlook on matters sexual, Marcus is best described as a reactionary when it comes to the wider world of politics. In this sense he shares a lot in common with many other

pornographers I've met. For example, he is as firm a believer in capital punishment as the average *Daily Mail* reader, despite on the surface appearing to have nothing in common with the majority of rabid Middle Englanders.

When critics of pornography link explicit material with the sexual exploitation of children in a bid to muddy the waters of the debate, they should bear in mind that people involved in the sex trade are likely to hold even stronger views on the appropriate punishment of paedophiles. Anyone who has spent time in prison will tell you stories of how sex offenders are treated by the general prison population, and it's obvious that Marcus would be ecstatic to see the same approach taken in the outside world.

Key targets in his firing line also include critics of sexually explicit material who argue that sex is designed for procreation.

"If that was true," says Marcus, "all the relevant areas of anatomy would not be sensitive in a way that causes sensations of pleasure. Second only to self preservation, sexual activity is man's biggest driving force, and yet there are vast sections of the world population who ostensibly pretend that the simple act of procreation is the be all and end all of the matter."

I ask him what he would say to people who claim he is exploiting women purely to make money.

"They are basically imposing their will and tastes on other people. We all have our opinions but I don't feel the need to shout mine at other people. If someone doesn't like porn then don't fucking watch it. It's restricted anyway and I have no problem with regulations as long as they are sensible. In their own cynical minds I'm sure anti pornography campaigners believe they are doing the right thing, but I can't see why they don't look at the broader picture and ask why they feel a need to impose their will on millions of other people. Personally I think their attitude is no different to suicide bombers killing innocent people to impose their way of life on society."

As our interview draws to a close, I ask Marcus when he is going to call it quits. The liberalisation of smut has led to a new breed of pornographer entering the arena and natural selection would suggest that his time left in the business is limited, especially when you take his age into account.

"I can't retire, I'd waste away. In fact I'd probably drink myself to death. People can call me whatever they want, my life has been an open book because I've never tried to hide anything. I can't think of a single thing I've done in life which I'm ashamed off and I don't think there are many people who honestly could say that."

# M.B.S.

## (Manager Boyfriend Syndrome)

I'M WAITING TO MEET ANGELA AND MATTHEW IN A North London pub. They are both new faces on the block, keen to travel the spunky path that leads to fame and fortune on Planet Smut. Angela has only appeared in a small number of films so far, but has drawn many positive comments about her performances on Internet forums devoted to pornography, so her future in the business looks bright.

Matthew also fucks on film. Initially they performed exclusively as a couple, but in the last few months they have had to go their separate ways in order to make a decent living. Often male performers who enter the business as part of a couple find themselves quickly living in their partner's shadow. Fresh girl meat is the bread and butter of the sex industry, and as quickly as their debut performance has been edited, she will be offered work as a separate entity. Often they will mutually agree that she's allowed to take on girl/girl work, as long as unfamiliar dick remains firmly off the menu. Throughout this contract however, the male partner usually gets to dip his wick into any performer he chooses, whilst his girlfriend is expected to behave like her vagina has been stitched over.

The domestic porn industry seems to be littered with examples of Manager/Boyfriend Syndrome (M.B.S.), although this seems to have very little to do with an innate male need to control women, and everything to do with the economic forces at play in the sex industry. The easiest way for a wannabe stud to gain a foothold on the sex career ladder, is to come to the table with a stunning looking female partner. In fact this will virtually guarantee entry to the exclusive club. The answer to the oft heard question: 'How

**102**

does a bloke like me go about making a living in the porn business?' is simplicity itself. 'Bring your saucy looking girlfriend who will be willing to fuck on camera.'

Although the British sex industry tends to be run exclusively by men, it's no more sexist than the board of News International or HSBC. In fact you could make a strong argument that women in the sex industry face less of a glass ceiling than their corporate sisters. There's no block on female performers turning to production to increase their life span in the industry. Although British women have historically been slow to produce and distribute their own lines, it seems to have more to do with a lack of imagination than any sexist conspiracy theory.

There's a strong tradition in UK magazine publishing for giving editor positions to female performers; even if it is a cynical move by publishers to distract accusations that the business is nothing more than a men's club. If nothing else it gives a good indication of the real selling power of an established female star. Even stranger, some male smut peddlers have been known to adopt female pseudonyms in order to make the great British public think there is an attractive woman in the chief executive chair.[29]

Given that women can hold powerful positions in the sex industry, it strikes me as strange that so many of them are managed by their partners. Over the course of writing this book many producers of smut told me that there's often a dodgy boyfriend hanging around in the shadows, not just demanding that his partner is treated fairly but occasionally taking care of business in a way that is not much different to an inner city pimp looking after his stable of crack whores.

Back in London, Matthew goes to the bar and I'm left alone with Angela. After outlining what the book is about our conversation turns to our plans for today. During a number of phone calls over the last month, I have arranged to shadow the couple as they meet a client producing a foot fetish custom video.

As a general rule, making contact with people involved in the sex industry is difficult, especially when you approach female performers who tend to be understandably nervous about obsessive fans. Sometimes you have to spend hours trying to convince people you are not a crazed stalker, and on occasion they still choose not to believe you.

Initially I was naïve, and imagined that the chance for performers to appear in print would be my passport into the business.

Sadly, it seems that the 'I'm writing a book' line is one of the most popular excuses porn fans use to gain access to their object of desire. The scope for confusion that can arise may well be responsible for the stormy look on Matthew's face when he returns from the bar carrying a tray of drinks.

In fact, he makes no concessions to hiding the fact that he doesn't want me here. I try asking a few inane questions to break the ice, but Matthew immediately switches off my recorder and requests that I don't tape our conversation. After an uncomfortable silence, my heart sinks as Angela leaves the table to answer a call on her mobile phone. Now with just the two of us, Matthew can vocalise what his problem is.

"We should probably talk about money," he tells me.

The most infamous manager/ boyfriend in the adult film industry was Chuck Trayner, who controlled the business interests of Linda Lovelace in the seventies. In her autobiography *Ordeal*[30] (1985) Linda claims that their years together were defined by rape, beatings, satanic sex rituals and psychological abuse. Trayner took great pride in his greatest find, claiming that he had taught Linda her trademark deep throat technique. As a registered hypnotist he'd programmed her to destroy her gag reflex to make the trick easier to perform[31].

Trayner was a misogynist to the core, slice him open and the word would have been stamped on his internal organs like the spidery lines in a stick of Blackpool rock. He maintained rigid control over his product and domineered every aspect of Linda's life. At his request she performed in a number of sleazy bestiality loops featuring a german shepherd[32] in the early stages of her career. Trayner would often encourage her to re-enact these episodes of animal sex as live cabaret when they were entertaining important contacts in the business. The trauma meant that in later life, Lovelace claims she was unable to even say the word dog, spelling out D.O.G. when asked about the incident in interviews[33].

Despite Trayner's extreme reputation, he still managed to hook the legendary Marilyn Chambers into a management contract. Chambers[34] was on a roll following her success in *Behind the Green Door* (1976) and was at this point in time a true global superstar. Chuck had struck gold again. The relationship wasn't destined to last however as the usual pattern of abuse, control and exploitation started soon after the couple got married. Chambers wasn't willing to play the victim like her colleague and left Chuck a few

years later. In order to gain her freedom she had to sign over fifty per cent of her earnings to Trayner for the next five years. Even though the relationship had broken up he continued to milk her as a cash cow, booking her increasingly explicit nightclub gigs, one of which ended in her arrest for soliciting after performing a raunchy dance gig at the Mitchell's Brother's O'Farrell theatre in San Francisco.

Up until his death (ironically, just a few months after Lovelace's fatal car accident) in 2002, Trayner managed a gun club and firing range in California. A condition of his license application was a clause that made him agree to have no further interests in the pornography business. A new generation of female performers probably breathing a sigh of relief at the news. Chuck was the Ike Turner of pornography, claiming that he had always had the best interests of his clients at heart, and never accepted that he'd caused his lovers any intentional harm. In fact he took full credit for their respective success, claiming that all relationships require one dominant partner to thrive and he was simply adept at playing the role.

In a minimalist North London flat, Angela is booked for a solo shoot with Charles (*name changed*), a bohemian, middle aged amateur photographer/filmmaker who shoots videos with a heavy focus on 'foot play' for his own private collection.

For a £250 fee, Angela will walk around the flat looking saucy in an outfit chosen by Charles, before slowly undressing down to her stilettos and being filmed using a vibrator. It shouldn't take longer than a few hours and she seems very comfortable, partly as a result of having worked with Charles a number of times before.

Amateur work is a key source of income for women in the sex industry. When professional shoots dry up there is always a large number of keen photographers willing to pay hard cash for a shoot with an adult film performer. Most of the finished photo sets or videos will never be seen in the public domain, except for a small number which are sold on to top shelf magazines. The amateur world is a place where you find an interest in some obscure fetishes not catered for by mainstream porn producers. In the absence of material on the open market, some people see no choice but to produce films catered for their own tastes. Lovers of hairy chicks, fat girls, obsessive leg fans and men who get an erotic charge from filming models smoking cigarettes whilst wearing scarlet lipstick are all well represented on the amateur scene.

Our director has been shooting custom foot fetish videos for ten years now. He started hiring glamour models for stills work after a messy split up with his wife, who had never been keen on his hobby. As soon as she left him to move in with a work colleague he was on the phone to local modelling agencies, but not before racking up major credit card debts with footwear retailers across the capital. He estimates that he's taken photos of over three hundred female feet in the last decade, although he's keen to point out that he likes taking pictures of animals and sporting events as well as shapely arches and immaculately pedicured toes.

He doesn't limit himself to shooting professional models, and tells me he often approaches women on the street. Surprisingly, Charles claims that many of them are flattered rather than offended, although he admits that he has been told to fuck off more times than he cares to remember. When I ask Charles to explain the sexual appeal of feet, I mistakenly unleash a lengthy eulogy to his fetish.

"I've always loved feet and I've always loved shoes," he tells me. "I tend to get erect every time I walk down the street, especially as my eyes are always focused at ground level. All types of footwear can get me started, although I tend to like high heels, kitten heels, patent leather and white trainers best. I fantasise about taking off the shoes, sniffing them, asking the women wearing them to stand on me while I have a wank. I'm aware that some people see it as a perversion but I think it's a pretty harmless one."

He's very proud of his reputation, telling me that some amateur photographers have been known to come on to the girls during a shoot, which tends to tarnish all photographers with a sleazy reputation. He has never had any interest in selling his finished product, but is obviously very pleased with his work, reaching into a cupboard to pull out a number of photo albums featuring models he has shot, before pointing at a shelf groaning under the weight of his video back catalogue. Charles' enthusiasm for the day's work is refreshing, especially after spending an hour fighting Matthew's negative vibes.

He offers everyone a drink within seconds of us walking through the door, greeting us like old friends as he turns up his stereo and skips across the floor to adjust his lights and video equipment. Take a quick glance through to the living room, doubling up as a studio, and you can see hundreds of pairs of shoes, many still in the boxes, along with a coffee table laid out with a number of thick lines of white powder.

"It's cocaine, not speed," Charles helpfully clarifies when he notices me staring.

As soon as I've accepted a bottle of lager, Charles motions towards his stash and tells me to help myself. I decline, but notice that when Angela leaves to get ready she stops for a nosebag on the way to the bathroom.

Charles apparently has a thing for uniforms as well as feet, providing a traffic warden outfit for Angela to wear today. It's not the kind of *faux* outfit you buy in a sex shop either, it's the genuine article. When I ask him where he managed to get hold of it he smiles and places his fingers to his lips, before singing along in falsetto to a Queen track and giving off the strong impression of a man who decided to get the party started early. I ask if he has a VCR where I can watch some of his tapes, and he leads me to his conservatory. As soon as we are alone I ask him what he makes of Matthew.

"Typical of the breed to be honest," he replies. "I can never understand why people try and make money in this business if they suffer from the green eyed monster."

Charles' TV flickers into life with the grainy image of a woman walking slowly across his living room, the camera zooming in on a freakishly high pair of leather boots. Charles tells me he recently changed all the flooring in the flat, because the thick carpet he had laid didn't have the same erotic appeal as the sound of stiletto heels tapping on laminate flooring. This is a man so motivated by his fetish it even impacts on his home furnishing decisions.

After a short wait Angela appears in the conservatory, fully kitted out in her roadside Nazi regalia. Charles' eyes light up, and we quickly move into the living room so he can get his model to try on some footwear.

A pair of strappy sandals is instantly dismissed. "Not high enough," Charles claims. Likewise, his large selection of patent leather boots are deemed unsuitable for reasons of continuity.

"What sort of traffic warden would wear these?" Angela giggles. "Their feet would be killing them after they walked a few miles."

It's decided that a dark blue pair of kitten heels are the perfect match, and as Charles moves towards his camera tripod to start filming, I decide to grab an interview with Matthew whilst everyone gets warmed up.

Matthew's in the kitchen, sipping a bottle of mineral water, smoking a joint and sporting a face like a smacked arse. I attempt to start up a conversation by saying how sound Charles seems.

"Yeah, for a fucking pervert," Matthew responds with venom.

Sensing that I'm in for the long haul, I change tack and ask why he wanted to get into the sex industry. "Money. Pure and simple," he tells me. "Angela knew some girls who were working as lap dancers and they were always getting offered money to model. They didn't want to do it, so they passed on the numbers to us and we agreed to do boy/girl scenes as a couple."

I ask if there is much difference between on screen and off screen sex.

"Of course there fucking is. There's usually people watching for starters, two cameras, a stills photographer and some twat like you."

Even though I've never claimed to hold psychic powers, there appears to be some tension in the air and the interview is unlikely to be a success. Despite this I'm so socially embarrassed I don't quite know what to do. Unsure of how to proceed tactfully I ask how it feels for Matthew to watch his girlfriend stripping off for a total stranger. With the benefit of hindsight this is a big mistake.

"Look my friend, we're here to make some money — although I'm not sure why you've come. We agreed to talk to you but I've changed my mind, it's probably best if you fuck off. Angela doesn't want you here."

Matthew is now inches away from my face and his raised voice has attracted the attention of Charles, who has walked into the kitchen to see what the fuss is about.

"Everything OK lads?" he asks in a chirpy tone of voice.

Matthew throws me a look of contempt, mutters something under his breath and storms out of the kitchen to talk to Angela. Charles shrugs and reaches into the fridge to grab two beers. As I reach for my bottle I notice my hand is shaking.

"Look Bruce, don't worry about the drama queen, it's the same story every time. On the last shoot he wanted to charge me double. Luckily Angela's such a pussycat she'll sort everything out. Give him ten minutes to clam down," Charles tells me.

We stand in silence listening to the sounds of shouting next door, our protagonist letting rip with a torrent of abuse that continues until we hear Angela sobbing as she pleads with Matthew to clam down.

"Fuck this," Charles mumbles, heading out of the kitchen as I quickly follow behind. As we enter the front room, Angela is in floods of tears, has a raised mark on her cheek and looks terrified. Matthew is shouting at her, holding her arm and seems completely

oblivious to our presence. You get a strong sense that it's only a matter of time before he hits her again. His hand is raised and his face hints at a brutal, point of no return mindset, chillingly familiar to anyone who has ever been the victim of a motiveless violent attack.

It's a saga played out in thousands of homes across the country every night of the week. Women living in fear of being battered by loathsome fucks who get high off the power that comes from destroying the people they claim to love. Although we shouldn't pretend that some gals don't keep their male partners in pink handcuffs tight enough to restrict blood flow, for most men, hitting a woman is like mixing chocolate and beer or writing a West End musical about paedophilia: fundamentally wrong.

Angela may be dressed in a traffic warden uniform, there may be lights and cameras around, but this episode isn't just related to the porn business. It's a result of the need some people have to be in complete control.

Once when I was at college, I briefly fell in love with a girl on my course. The epoch defining moment when I realised the relationship was moving from friendship to love, came when I was inexplicably drawn to picking up her coat and smelling it every time she left the room. It sounds creepy now, but she smelt so fantastic I just couldn't fight the urge to bury my head in her clothing and breathe in her scent. Not for the first or last time, I made the mistake of blurting out my true feelings following a drunken pub crawl and was politely told that a sexual relationship was never going to be on the agenda. Despite the rejection we stayed friends and she eventually hooked up with a musician we both knew. He seemed like a decent enough bloke, but this illusion was soon shattered when she started turning up to college lectures covered in vivid purple bruises.

I tried to talk to him, but every attempt to resolve the situation ended up in a fresh beating for my friend. Even a short spell in hospital with a broken cheekbone couldn't motivate her to leave him, because each and every punch would be followed by a tearful apology and a promise to change. They stayed together, her friends slowly disappearing as a result of her unwillingness to call time on the relationship. It's likely that she is still on the receiving end of regular beatings a decade on.

"What the fuck are you two looking at?" Matthew says when he finally notices we are standing just a few feet away.

Charles picks up the phone, holds it up in the air for everyone

to see and slowly dials 999. "I'd suggest you fuck off now Matthew before your problems really start."

Ironically, Matthew is smaller than both Charles and myself, so he eventually makes the decision to leave the flat without throwing a punch. As soon as I hear the door slam, I start to regret not landing a firm punch on the back of his head as he leaves the building. There's something about perpetrators of domestic violence that suggests the Ghandi approach is impotent as a response to their brutality.

Angela is very apologetic, claiming Matthew is under a lot of pressure and never usually behaves like this. Charles gives a cynical shrug of his shoulders and walks into the hall to remove the batteries from the doorbell connection. The constant ringing stops, but you can still make out Matthew screaming outside.

"Look I should talk to him," Angela says. "He's upset."

Charles persuades her to leave him alone, although Angela seems to find it difficult to resist answering her mobile phone, which has just started to ring. Everyone's mood has turned slate grey and I can't wait to leave, although this would involve sliding past a psychotic Matthew at the door.

A few hours later and the laughter has returned, mostly as a direct result of Charles and Angela undertaking an extended nosebag session from the flowing stream of Class A drugs on the coffee table. They have also managed to capture some footage of Angela pacing up and down the front room wearing a variety of shoes, our starlet happily taking up Charles' offer of a free pair of Prada which have historically taken pride of place in his collection. The phone and doorbell have stopped ringing, but given Matthew may still be lurking at the fringes, Angela has decided to stay the night at the flat.

She gives me a hug and a kiss goodbye, still feeling the need to apologise for her awful taste in men. She's quick to defend Matthew's behaviour today, because she's worried that he may come out as 'unsympathetic' when the book goes to print. Looking at the two people left in the flat, I also get a sneaking sense that their relationship may well extend beyond the bounds of professionalism, which would go some way to explaining the events of the day.

I came here today to grab the opportunity to make some easy gags at the expense of a foot fetishist, although the end result has been a depressing clarification of something I've always known. A number of my male comrades can be complete bastards, and as

difficult as this may be to understand, some women seem to find this behaviour attractive.

As if to confirm my point, when I return home after my visit to London, still feeling freaked out by the episode, I ring Angela on her mobile to see how things have been. It rings three or four times, until it is answered by the unmistakable voice of Matthew. He realises it's me straight away and hangs up. I can't get the image out of my head of an enraged Matthew putting down the phone and directing his anger at Angela, giving her a kicking for some perceived slight, only to adopt the usual approach of tearful apology when he looks at her battered face and the guilt starts eating into him like cancer.

Like Shirley Bassey says: it's all just a bit of history repeating.

# Fur Coat and No Knickers

## The Golden Age of the UK Sex Shop

I

IMAGINE THAT THE YEAR IS 1985. THE CONSERVATIVES are in power and riding high in the opinion polls as a result of their success in the Falklands war. Television is still limited to four channels, but at least broadcasters have finally realised a nation finds it patronising being told when to go to bed and the screen has stopped going blank after the pubs kick out. Channel Four, the most recent addition to our TV screens has only been on air for a year, but has still managed to draw thousands of viewer complaints. None of these outraged viewers were teenage boys as far as I can remember. They were too busy waiting for the 'red triangle' device to appear warning of explicit programming. Although it had more in common with a William Castle advertising gimmick than a genuine attempt at warning viewers that problematic content was likely to appear, it was still responsible for legions of British youth cracking one off to subtitled art house cinema as they laboured under the illusion that the product was pukka filth.

Cinema goers were queuing around the block to watch *Gremlins* at the local Odeon and most teenagers spent their weekends drinking cider and taking part in break dancing duels round the back of Iceland, rather than grinning inanely as they dropped their third pill.

Armageddon was imminent in the mind of the doom obsessed teenage author at the time. This acutely exacerbated by the fact that the first girl he had ever fingered had recently dumped him.

Claiming "she just wasn't interested in men" she attended a party a mere forty-eight hours later, that resulted in her being christened with the nickname 'gobbler' well into the sixth form.

The Internet is in its infancy but remains a closely guarded secret, populated exclusively by geeky university students who send each other lists of their favourite film quotes which will take days to download. For the majority of people not doing computer science degrees, the blocky graphics and painfully slow download time required to access the television listings on Ceefax is about as close as they got to riding the information superhighway.

Duran Duran are at number one with Wild Boys. George Michael is straight. Michael Jackson is black and Gary Glitter enjoys a reputation as a family entertainer. More important to this story however is Eric Stevens, a forty-nine year old counter clerk who works in a hardware shop and is looking for some titillation to escape from the fuck coma of his sexless marriage.

Eric has already been the cruel victim of a mail order scam after sending a personal cheque to a PO Box in Essex, on the understanding that he would receive a number of pornographic videotapes. The advert promised 'Scandavian, full strength scan films', but sadly our hero's tapes never arrived even though the cheque has long since been cashed.

Despite writing a strongly worded letter of complaint to the company he still hasn't had a reply, although he's reluctant to inform his local Trading Standards department for fear he will be branded a pervert.

Regardless of this minor set back, he is still looking for something a little bit stronger than the photosets on offer in *Escort* or *Fiesta*. No real surprise, given that this is a time where top shelf editors have no choice but to airbrush out any sight of a puckered hoop in centrefolds, in order to avoid tempting the punters to engage in acts of sodomy, still very much a crime for consenting adults.

Taking a train to central London from his suburban semi, Eric eventually disembarks at Charing Cross and heads for the fleshy temptations of Soho, specifically the area around Brewer Street which has historically been home to the largest number of sex shops, clip joints and walk ups.

In possession of a large wad of money, he glances around the street to make sure that none of his regular customers happens to be in the area before darting furtively into a dimly lit bookshop. Inside the building he initially thinks he has made a mistake as

the shop looks like it's in the process of closing down. The gloomy interior has no stock on display, except for a few shrink wrapped porn magazines and a selection of flesh hued dildos limply hanging from a display board.

A Mediterranean man sits behind the counter reading a newspaper, whilst a portable television with the contrast set too high plays a Euro fuck film with the volume turned up too loud. This in itself is a profound culture shock, because Mr Stevens always watches his pornography with the volume turned off. This way he can hear his wife's footsteps on the stairs and jump up to turn off the video before she enters the room. He longs for the day when he can afford a VCR with an infrared remote control.

Uncomfortable, embarrassed and ashamed but very keen to score some decent muck, our protagonist approaches the counter, waiting for what seems like an eternity for the shop assistant to look up. When he finally does, he casts a dismissive glance and throws Eric a well thumbed photo album containing b&w photocopies of video box covers.

All aspects of human sexual desire are contained within. Straight sex, gay sex, menstrual dwarves, anal, eel fucking, golden showers, S&M and lurid depictions of shit eating are preserved in thin plastic, each cover providing a profound testament to the futility of prohibition.

After a few minutes of browsing, Eric suddenly becomes aware that the police could storm in at any moment, so he points at random to the cover of a film whose content is obscured by a title is written in a foreign language. Without speaking a word the guy working the counter beckons over his assistant from the back of the shop with a click of his fingers. He quickly disappears from the premises, only to return a few minutes later, short of breath and holding a VHS tape. The man behind the counter walks towards the shop television and puts the tape into the VCR.

The room is quickly filled with loud groaning as the screen flickers to life with the snowy image of a busty farm hand getting rear ended by a greasy looking stud. Happy that the tape is kosher, Eric eagerly hands over the cash, snatches the tape and escapes into Soho daylight, the beginnings of a persistent erection flowering in his grey work suit.

## II

UNTIL THE RECENT liberalisation of UK classification laws the British sex retail business had one major obstacle to face — one that would appear insurmountable on the surface, especially given the many promises filth peddlers were making to the patrons of their shops.

In short, they were unable to sell hardcore pornography in any shape or form. Any video or magazine daring to show something stronger than softcore groping was liable for prosecution under the Obscene Publications Act (1959). As a result, British filth was the only porn in the world where the female cast kept their knickers on during the sex.

Pornographers could easily be forgiven for thinking that the vice squad were in possession of a set of secret Kafkaesque guidelines that outlined the maximum distance labia could be splayed before they were allowed to start busting down doors. A conviction under Section Three of the act was no great shakes, usually involving a destruction order, delivered by a magistrate on any smut the police had confiscated during a raid. This was seen as an occupational hazard and businesses quickly recovered by passing on any legal costs directly to the consumer. Much more serious was the risk of a criminal section two prosecution, which carried a heavy fine as well as the genuine risk of imprisonment.

Section two charges were rare during the 1970s, but dramatically increased in volume when the Conservatives took power in the 1980s. Many famous faces still working in the industry today have at some time spent a short spell in prison following this Thatcher driven crack down, partly a result of Westminster council being 'blue' in its politics as well as its cinema.

If you imported smut from Europe to sell in the domestic market place. you'd fall foul of the Video Recordings Act (1984), which makes it a criminal offence to own or distribute any video recording which has not been categorised by the British Board of Film Classification. This applies to all commercial video content, including mainstream feature films, cartoons, music and sporting events as well as deviant smut.

Just to make sure the state retained full control over the viewing habits of its subjects, The Post Office Act (1974) made the delivery of sexually explicit material through the postal system a criminal offence. This was an attempt to regulate the growing trend of people buying pornography via mail order. This is given a sense

of added irony, when you take into account that the most reliable provider of decent smut in my youth was a postman by trade.

There were some exceptions to the open labia and close up fucking drought. During the late eighties there was a brief phase of 'educational' video releases, which allowed full penetration to be shown on film as long as a doctor made frequent appearances to ensure the punters did not have the opportunity to get a bone on watching uninterrupted bump and grind. The effect of a middle aged man suddenly appearing on screen to give a lecture on clitoral stimulation just as the viewer reached vinegar stroke was never documented, but this chapter in British sex film history soon exhausted itself.

Frustrated self manipulators had no choice but to continue to watch page three stunners soap their titties as a comedy stooge gurned on the periphery in the never ending cycle of *Electric Blue* films, a typical example of the product available at many sex shops at the time.

On the plus side sex shops did stock some items of value. Many a small town youth will have had their first drug experience with a bottle of Rush or Liquid Gold, trade names for the same product, amyl nitrate. Providing a buzz similar to a hard punch delivered without warning to the side of your head, the stuff has its fans and the sex shop was the place to score.

As a country Britain has always placed every possible obstruction in the way of the flesh trade developing and continue to do so even today. Take for example the local council, who are the first port of call when you apply for a licence to open a sex shop. Currently the annual licence fee to operate a business where the stock is predominantly defined as being of 'a sexual nature' ranges from £4,000 to £24,000 depending on where you live. In contrast, you can licence the sale of alcohol for a tenth of that sum. The inflated licence fee costs would seem to indicate that as a country we see free sexual representation as more of a dangerous concern than the well documented health and social problems arising from alcohol abuse.

This fee alone is enough to stop all but the most committed smut traders looking for vacant properties in your home town. Even if they have the disposable income to fund a licence application, they still have the trauma of the planning process to look forward to.

All councils have a legal obligation to publicise planning applications that will change the business use of any retail property. For example if you want to convert a butcher shop[35] into a Starbucks

franchise, the public gets to vocalise an opinion during the consultation process. This is often the major area of concern for any businessman planning on opening a sex shop, especially when it's situated in a conservative town miles away from the bright lights of the capital.

Anti-smut campaigners are organised, occasionally fanatical and well versed in writing strong letters of complaint to authority figures. Porn consumers however, are usually desperate to retain anonymity and are unlikely to put their heads above the parapet and share with the world their keenness to purchase sex films or magazines within walking distance of their homes. Therefore the consultation process tends to be woefully unbalanced and licences are often refused on the strength of just a few objections.

Strong censorship laws and the difficulties in obtaining a licence lead to a thriving black market in the sale of pornography. As in all cases of prohibition, shadowy figures stepped forward to meet the market demand for product. Some operated illegally, setting up unlicensed shops and storing their stock away from the business premises in order to avoid getting cleared out during police raids. Local Trading Standards could raid the premises in the morning and by the afternoon the shop would be fully restocked ready for business.

Unlicensed sex shops attracted a diverse and occasionally sleazy crowd. 'Rain coaters' flocked to them in their droves and middle aged men who fulfilled every cliché of the porn consumer could often be seen furtively darting into the premises when the coast was clear. Sexually liberated couples would spend time browsing, sometimes asking for legendary titles like *Deep Throat*, a film that had been the butt of comedians' gags for a decade, despite not being officially released in the UK until quite recently. Any request for a definite title would always be met with a thumbs up, even if the counter staff had to quickly write the title on the spine of a blank tape with a magic marker before handing it to the punter.

Most illegal set ups operated a useful returns policy, a discount on new material if you part exchanged your old purchases for re-sale to other customers. This was a godsend to the cash strapped wanker, given that in the early days of the video explosion licensed shops often charged upwards of £50 for a ninety minute feature film.

Because of their infectiously sleazy vibe, sussed punters would happily choose an illegal set up rather than risk the scams in operation at licensed shops. They may have been seedy, dirty and dark, but they offered decent filth for a fair price. This was never

guaranteed if you bought from licensed units — in fact it tended to be the legitimate businesses rather than the criminals that were more likely to scam you.

The vast majority of licensed sex shops in the UK, especially outside of London, were owned by the David Sullivan publishing empire. Sullivan went on a property buying binge in the late seventies and early eighties, buying shop fronts in towns across the country and converting them into the familiar Private Shop brand.

It was a formulaic set up which featured blacked out windows and no open display of product to offend delicate sensibilities. Placing starkly worded notices on the door warning of the sexually explicit material on sale inside made the punters think they were entering sexual nirvana, rather than a tacky shop with little to offer in the way of decent filth. To be fair to Sullivan, a figure widely loathed in the British sex industry as a result of grievances at his occasionally sharp business practices, he fought long and hard to take sex to the suburbs, often facing intense local campaigns to shut him down or deny him a licence to operate.

A conviction for pimping[36] didn't help his case, especially given that anyone with a criminal record is unable in law to hold a licence for a sex shop. Adopting a low profile ever since with regards to the Private Empire, confusion remains as to his exact role in controlling the chain of shops following an apparent buy out undertaken by his management team following his conviction.

Private Shop selling techniques during the seventies and eighties have become the stuff of legend. You would be easily forgiven for thinking that Sullivan's business manifesto at the time appears to have been heavily influenced by Barnum's maxim: 'there's a sucker born every minute.'

Punters would enter the shops to be faced with a large number of explicit looking shrink wrapped magazines. The Private chain[37] often bought remaindered back issues of top shelf magazines and replaced the covers with more explicit imagery, often the Color Climax brand that was universally respected by wankers for delivering the goods. When people arrived home and eagerly tore open their purchase with sweaty hands, they'd be shocked to find that despite the lurid packaging, the content was nothing more than a second hand copy of the '76 Christmas edition of *Knave*.

Sullivan produced or imported all the sex toys, erection creams and nipple clamps sold in his shops, so the profit margins on goods were incredible. Items that cost pennies to manufacture were marked up by a vast percentage, each purchase represent-

ing a big profit for the company. As the counter staff worked on a commission basis, they'd aggressively pitch items to the customer knowing that the majority would become mortified with embarrassment and happily hand over cash just to be left alone. Speak with people who used the shops at the time and they talk of very heavy selling techniques being used by some rogue management teams.

Some of the dodgier illegal set ups were even worse. If you decided not to part with your cash after browsing through the limited range of goods, you'd occasionally be stopped at the door by an irate staff member asking why you were wasting their time. One infamous scam involved adopting a confrontational stance with the general public and threatening to call the police to report that they'd requested paedophilic material if they didn't make a purchase before leaving. Some brave souls told the counter staff to fuck off and walked out, but a minority would be driven by fear to pick up a selection of magazines selling at an inflated price to win their freedom.

Female clients were as rare as Dodo eggs. Both the illegal operations and Sullivan's shops were designed for a male clientele unlike high street sex chains like Ann Summers.[38] It was always men who bought the chinese love eggs and clitoral butterfly sex aids that were on sale, probably in a last ditch attempt to perk up a love life which consisted of Saturday night missionary position sex.

If you wanted a PVC nurse's outfit that would ignite into flame the moment you walked within a metre of a three bar electric fire, or a rubber doll of such surreally bad quality its frozen, scarlet grimace would return to haunt your nightmares, the British sex shop was the place to be.

Repulsed wives and girlfriends could be easily forgiven for refusing to let the sex toys anywhere near their erogenous zones. They looked cheap and nasty, were shoddily produced and were always made of the same pink toned plastic. Only the brave, adventurous or mentally enfeebled would have used one of the mains operated contraptions on a moist spot.

Sullivan maintained a virtual monopoly on legally selling sex and often told the press that he was keen to sell legitimate hardcore in interviews. He was after all paying out a small fortune on local authority licence fees when illegal operations were setting up just down the road without any apparent pressure from the police or Trading Standards.

Ironically enough, if a Private Shop manager did start knocking

out filth from under the counter they were subject to disciplinary procedures. All the videos on display were produced by Sullivan holding companies and the magazine stock was often exclusively made up of his titles, so the risk of obscenity busts threatened his multi million pound annual profit. Happy with the status quo, Sullivan made little effort to invest the money required to effectively lobby for a change in the law, although over the decades he has spent a fair amount of time in court defending the way he makes a living.

Luckily, not all smut vendors were happy to adopt a relaxed approach to the consumer rights of the general public. Your Choice are a British company that provided a beacon of light to frustrated self abusers throughout the dark days of sexual prohibition. Formed by husband and wife team Patricia and David Waterfield, they left England in 1987 to register Your Choice in Amsterdam and offer adult videos by mail order. With the videos backed by a full money back and delivery guarantee, punters could at last obtain decent porn with a degree of confidence.

Patricia tells me via email that there was nothing quite like it at the time and it quickly became successful. "David was one of the men who had a reputation for challenging the repressive censorship laws in the seventies, and had been successful in bringing a number of infamous porn films to Britain. A loophole in UK law meant he could show them, alongside other uncensored 8mm porno films in his private cinemas in London."

The Your Choice distribution system is quite secretive, a necessity given some of the legal problems they have faced over the years. Patricia is however happy to tell me the following. "When a customer order arrives in Holland it is discreetly faxed to our agents in Britain. All the stock is then sent from within the UK. The system gives a fast, quality service at a reasonable cost. Administration is done in Holland — no names or address are kept in the UK."

Like everyone you speak to involved in the smut trade, there is a story about the fateful day the dirty squad came a knocking: In May 1995, following a year long investigation by the Manchester porn squad the British side of Your Choice was raided. 'Operation Dare' was the largest in the squad's history. Charges were brought against some agents under the Obscene Publications Act. Of the cases proven, sentences varied across the country — from a nine month prison sentence and fine for one man, to community service and costs for others. Fines ranged from £500 to £110,000. Customer loyalty kept the company going and orders continued to arrive.

The Waterfields divorced in 1997 but Patricia continues to run Your Choice from her Amsterdam base. Her experience at the hands of the law means she is rigidly opposed to all censorship of consensual pornography.

"Juries in numerous cases have judged that consensual, explicit sex does not deprave or corrupt the viewer. After all, adults choose to view these films to relax and be entertained, not corrupted," she tells me.

"It is a basic human right not to be subjected to any form of censorship and also that ignorance promotes fear. One's sexuality and what you do in the privacy of your own home, if it does not involve minors or harm anyone, is your own business."

Mail order sales are currently the key battleground in the British smut trade. Everybody acknowledges that the next few years will be vitally important to how the sex trade develops. Although technically illegal, there are still hundreds of companies registered both here and abroad who offer hardcore to the public via this route.

Trading Standards still bring test cases before the courts, safe in the knowledge that most magistrates are happy to convict. The usual result is the imposing of large fines on distributors. This tends to make some online smut peddlers nervous for a few months, with some companies, especially the smaller operations, going as far as shutting down their online business until the heat is off.

I speak with Ben, a fifty something veteran of the sex trade who started working the illegal Soho set ups in his early twenties, moving on to setting up 'hit and run' illegal sex shop operations throughout the South East. He has graduated to owning a large online distribution and retail firm which he would prefer I didn't name and tells me he also retains a number of non porn related business interests. He's seen a number of radical changes happen in his time but remains deeply cynical of the motives behind the recent move to liberalise sexually explicit material.

"Things still don't make sense," he laughs. "We're told it's acceptable to sell pornography which has been cleared by the British censor, but the restrictions they have kept in place mean you still risk a prison sentence for knocking out videos via mail order. I can't understand why it's OK for newsagents to carry hardcore magazines on the top shelf, where it is much more likely to be seen by kids, but we are told that moving images still have the power to turn punters into violent sex cases. Personally I believe that if it wasn't for the pressure coming from some European companies keen to exploit free market laws and enter the British market, the

government would still be treating us like children."

Ben likes to see himself as a freedom fighter as well as a smut peddler, the reason why he'll quietly admit he's happy with the current situation. One of the reasons he was drawn to a career in the sex industry in the first place was the fun of breaking the law and he can't resist grinning when he tells me about the constant pressure he faced from the strong arm of the law.

"I still love taunting Trading Standards, it's a great buzz. It's the same feeling I'd get in the old days when the police would storm into the shop, clear out the stock and as soon as they had left we'd be fully operational within ten minutes. Punters would be happily queuing outside waiting for the shop to open as the police were carrying out the evidence bags. You would sometimes see the same coppers walking past a few hours later and the look on their faces was priceless. They were powerless to act because a warrant was only good for the one raid. I still miss that face to face side — although the Internet operation has made much more money. Unless you live in a city, it's unlikely your local council will grant a sex shop licence, meaning the majority of people in Britain have no access to a walk in sex shop and as a direct result the Internet business is going through the roof."

He has started to miss the good old days lately. Operating out of a nondescript office on a bland industrial estate means he doesn't get to engage in banter with the punters or swap gossip about busts with the dodgy characters who made a living on the Soho beat. Most of all he mourns the missed opportunities to fleece the public blind every time they stepped through the door.

Ben used to take great pride in his formidable reputation within the business for encouraging customers to spend more than they intended by pitching what he euphemistically terms his 'special deals'.

"You could always spot a gullible punter within a few seconds of them walking into the shop. Anyone who smelt of tourist was fair game, it's down to the way they dress, and accents were always a dead giveaway. Welsh, Scottish, Irish or Northern it made no difference, as soon as they opened their mouths you knew you were onto an earner. If someone came in looking nervous you'd pile in straight away and start offering bulk discounts, lure the punters into thinking they were getting a bargain when all you were doing was shifting stock no one wanted. I never felt guilty about it — at least they'd leave the shop with genuine product. It wasn't as if we were ripping them off like the dodgy hostess bars, although to be

honest I did shift a fair number of dupes over the years. I always respected people who had the balls to come back and complain, I'd make sure they were well looked after. Personally, I always blamed people involved in the clipping trade for the constant clamp downs we had to face when I worked in the shops."

Now based in Essex, Ben rarely makes the journey to Soho anymore. The last time he visited was to help an old friend with the opening of their fully legit sex shop. He tells me he was almost in tears when he walked through his old stomping ground.

"The place is so fucking bland now, full of mincing queers and Eastern European girls forced into prostitution by traffickers. If you look into their eyes you can't see anything, they're blank from the drugs. Soho was always a Mecca for queers. I sold hundreds of gay loops on 8mm in the seventies, but now they seem to run the place. Some of the old shops are unrecognisable from the dives they used to be. It's lost all the danger and the glamour that attracted people like me in the first place. Now it's all stripped pine, supermarket shelves, gormless teenagers, halogen lights and credit cards. Credit cards for fuck's sake? The first thing I ever learnt in the business was cash only. Wages, stock, rent, utility bills, everything was paid in notes. That way the authorities could never trace a paper trail. When I started I never even knew who I was working for, it wasn't the kind of job where you had an interview. Someone would turn up to collect the till at close of business and hand over your wages and any bonuses you'd earned. I had a number to ring if there were any problems with plastic gangsters turning up demanding money, or if the dirty squad kicked the door in, but that was my only point of contact. When the police would ask for the name of the owner during a raid I was being honest when I told them I didn't have a clue. I don't understand why the people involved in the sex trade now don't set up McDonald's restaurants rather than selling porn. We're British after all and what's the point of sex if it doesn't feel dirty?"

part
2

# Tide of Filth!

## Deep Inside Mediawatch-UK

MEDIAWATCH-UK IS A VOCIFEROUS CAMPAIGNING organisation with a long, and some would argue, illustrious history. In its previous incarnation as the National Viewers and Listeners Association (NVLA), it was blessed with Mary Whitehouse as its formidable figurehead. Her rare skill as a media savvy self-publicist, along with her obsession with a perceived drop in moral standards and the rise of a permissive agenda, meant that the concerns of her small number of NVLA members were never far from being aired on a public platform. Whitehouse was many things, some of them deeply unpleasant in the minds of free thinkers, but even her most vocal critics would reluctantly admit to a certain professional jealousy at the place she held in the British psyche. There is a picture of Mary Whitehouse and Margaret Thatcher, taken at a party in Downing Street in 1984, the same year as both the video nasty moral panic and the miners' strike. They are both grinning, managing to ooze a pathological smugness that still sends a shiver down my spine to this day. Apparently they got along famously, completely unaware that a teenager in South Wales was holding them personally responsible for both a cinematic muff drought and the traumatic political upheaval of his youth. As pickets fought bloody battles with the police, and families struggled to survive on tinned food donated by well wishers, I always imagine them discussing the rise of pornography and violent films in outraged tones over canapés, completely oblivious to the fact that entire communities were in the process of being decimated.

Soon after Whitehouse's death in 2001, the organisation was rebranded as Mediawatch-UK, a change that was entirely cosmetic, given that the core principles of the organisation remained identical: the promotion of traditional values like marriage, faith, decency and chastity in all forms of broadcasting. You could easily

be forgiven for thinking that the only profound transformation was the new and improved logo on the organisation's letterhead. The group has fallen slightly off radar over the last few years, but they are still actively involved in signing petitions, lobbying politicians, and writing consultation documents on issues of decency and the promotion of wholesome Christian values in all forms of media.

The organisation is undergoing something of a recruitment crisis when I get in touch with John Beyer, the current director. There is dark talk of a haemorrhaging member list, a situation so serious the group may well cease to be financially viable in the next two years. An indication of how they are struggling to maintain morale among an ever decreasing membership, is amply demonstrated when you take into account that over 1.5 million people signed the NVLA sponsored Nationwide Petition for Decency in 1972, but only 500 turned up for a recent march in Trafalgar Square, less people than chaotic stoners manage to gather for 'Legalise Pot' rallies.

This apparent malaise among the white, Christian, suburban, middle classes that represent the core Mediawatch demographic, comes as a surprise. Especially when taking into account the dramatic increase in television stations, digital media, Internet use and radio broadcasts. Given the current plunge downmarket in television, which is partly being driven by vastly increased consumer choice, there is plenty of material every day for people to take offence at. Even the fact that hardcore pornography is finally available in most UK newsagents, has not motivated the 'silent majority' to put their heads above their privet hedges, question their shared apathy and sign up for the crusade against wickedness. Their chairman has kindly agreed to meet me for lunch, seeming very keen to be interviewed, phoning me immediately after reading my polite pitching letter. As a man who visibly cringes if people are shagging on television whilst the kids are in the room, I should in theory find the aims of John Beyer and Mediawatch-UK admirable.

I recognise Mr Beyer as soon as he reaches the entrance of the London hotel where we have arranged to meet. He's short, balding, overweight, carries a briefcase, wears a suit and tie, and on first impressions looks like a bank manager preparing himself to refuse an overdraft extension. As we enter the plush hotel, I ask if my casual dress is likely to be a problem. "Well I'm OK!" he mutters disapprovingly, giving me a lingering look of distaste before walking briskly to the bar.

Describing our encounter as an interview would be stretching the truth, given that he doesn't specifically answer any of my ques-

tions, choosing instead to deliver a lengthy monologue, that has probably been recited to journalists, college students and Mediawatch-UK members on hundreds of separate occasions. Given that his role as director is a full time post, a career as well as a personal mission, he's reasonably well read on the subject of pornography, and claims he can back up his view point with a wealth of research based evidence — even if some of the partisan organisations funding it may not stand up to close scrutiny. Many of them have the word 'family' in their titles, which doesn't inspire me with much confidence in their data collection methods.

The Mediawatch view on smut has not changed since the days when England boasted a world cup winning football squad: "We believe, with good cause, that all pornography is in itself corrupt and that it spreads corruption to all who have a depraved desire to see and use it."

What John sees as a 'cancerous growth', I view as part of everyday life, a result of our culture's need to commodity everything, even something as private as sex, in order to make money. Pornography may not benefit society to any great extent, but neither in my opinion do fast food restaurants, alcopops or shell suits, and I don't feel the urge to vilify people who go shopping for Bacardi Breezers dressed in leisure wear.

Throughout the afternoon, John displays barely concealed loathing that the floodgates are finally open. The fact that adults are now free to choose to buy pornography comes as a bitter personal disappointment, especially given the energy he has devoted to campaigning against its evil and pernicious influence. Despite coming to terms with the reality of sexual prohibition in the UK finally ending, and losing a large majority of his troops in the battle, John still doesn't strike me as a man who is ready to declare surrender on the war on smut. Interestingly enough, for someone who devotes so much time to keeping a professional finger on the porno pulse, John doesn't seem at all comfortable with today's subject matter. The look of revulsion written on his face when the conversation turns to the 'dehumanising' effect of male ejaculation in pornography is priceless. He obviously has difficulty saying the expression 'facial cum shot' out loud, scanning the empty bar, before leaning in towards me, and whispering it with a look of extreme distaste.

John is very concerned about pornography because he feels it leads to the destruction of relationships, especially the sacred institution of marriage. "People watch women performing unusual sexual acts on video," he tells me, "and demand their wives do the

same thing in bed at home."

He doesn't clarify what unusual sex acts consist of, but I get a strong sense that cunnilingus and fellatio are amongst them.

He is also keen to blur the lines between consensual adult pornography and the sexual exploitation of children. Although this oft repeated libel has no basis in truth, it helps muddy the waters when vocalising an incoherent argument. One that in John's case is equally defined by both faith and politics, but lacking in common sense. To illustrate his point, he recites a foul story he recently heard about sex tourism in Asia. He claims that young boys in Thailand are often forced to sit on rows of wooden plugs, in order to dilate their anus in preparation for work as prostitutes to wealthy European sex tourists. It is a deeply disturbing image and one I could have done without hearing, but more importantly it bears no relation to the topic we are discussing. Dropping it into our conversation serves only one purpose: a shock tactic used to plant the subconscious idea that watching consensual adult porn has a direct link to child abuse.

The Manic Street Preachers, a band born a few miles from my childhood home, once wrote a lengthy manifesto of rock. It may have been a touch pretentious for local comprehensive boys, and dragged in places, but it was forgivable because it included this genius line: "We reserve the right to contradict ourselves whenever we want." I find it impossible to believe that John Beyer holds any opinion on what happened to tragic guitarist Richey James, but he does appear to adopt this clause as gospel for the duration of our meeting. Ask about how his faith drives his beliefs, and John claims that it's not just religious folk who care deeply about the spread of filth. He's keen to highlight the minority of secular folk who share his concerns. This leads to the first of today's many glaring contradictions. Given that John's entire philosophy of life is based on the concept of male/female marriage as the only foundation for a healthy society, he is still willing to form convenient allegiances with lesbian groups and bean tickling academics. People who have chosen to adopt a lifestyle he would usually vocally condemn, have became staunch comrades in the revolution to destroy filth.

Strangely enough, John actually likes films and television, and he's very positive about the impact of the Internet, despite serious reservations about the easy availability of dirty pictures online.

One of his recent letters to the press featured a plea to the government to subsidise digital television boxes for every house in Britain, funding the project through the national lottery. He's

also a firm supporter of the BBC, vocalising the same argument I do for retaining the licence fee, a shared pride in its politically detached, public broadcasting remit. The NVLA has in the past sponsored a number of media awards, in a bid to change the widely held public perception that they are little more than career moaners. They present honours to programmes that best represent the values they hold dear: *Jim'll Fix It* and *Yes, Minister* have both been awarded accolades in the past. In order to strike up a casual conversation, I ask John what his favourite film is. He tells me he's very fond of *The Rebel*, the moribund 1960s Tony Hancock comedy vehicle. This comes as a surprise in that he doesn't strike me as a man with a well developed sense of humour.

His organisation doesn't just restrict itself to the lowbrow world of television, radio and cinema; on occasion it fancies itself as something of an art critic. Theatre has been caught in the cross-hairs of their scope in the past, when the play *Romans in Britain* running at the National Theatre led to a Whitehouse private prosecution for obscenity in the seventies. This came after the Director of Public Prosecutions said he had no interest in pursuing a case against an obscure, and painfully dull stage play whose audience could be counted in the hundreds. Despite this, she still proceeded with legal action, eventually facing public humiliation when the case was thrown out of court. Even this high profile failure, and the additional embarrassment of being forced to pay costs to the theatre director wasn't enough for the NVLA to beat a dignified retreat.

Historically, the easiest way to earn an obscenity conviction has been to cast naked gay men opposite Jesus. Hence the motivation behind the NVLA campaign against James Kirkup's poem The Love That Dare Not Speak Its Name, a homoerotic imaging of Jesus Christ's lust for a Roman centurion that was published in the *Gay Times*. The idea that poetry can deprave and corrupt may be a difficult concept to swallow, but the poem was declared obscene and forbidden to be read or broadcast. The author received a suspended prison sentence for 'blasphemous libel' in 1974, and the poem went unspoken for years until it was eventually reanimated as part of a season on censorship. John wanted to bring a private prosecution, especially after the Crown Prosecution Service refused to bring charges against a serious documentary. Eventually the matter was dropped when John realised there just wasn't enough money in the Mediawatch coffers to fund his case.

I'm tempted to ask John if Mediawatch hold a view on whether mime or puppetry can be a corrupting influence, but given that he

already seems to see my relaxed dress code as a sign I may be 'off message', I decide not to antagonise him any further.

There is an occasionally disturbing conspiratorial element to the Mediawatch outlook on life. One that sees, according to Beyer, "an unsuspecting society being undermined by a dedicated handful of radicals". Despite my atheism (which means you can use the term 'giant ant' in place of 'God' and the conversation would still make as much sense), I can't help thinking this is a criticism that was probably aimed at Jesus when he started preaching Christianity. I'm also willing to bet hard cash that if Jesus did return to earth, he'd be more interested in dealing with genocide, famine and the African HIV epidemic than complaining about the use of the word 'fuck' in gritty television dramas.

The 'radicals' that Mediawatch are fighting are always trying to implement their manifesto of filth. Clogging the TV schedules with cheap programming featuring hairdressers getting their knockers out in Corfu, shooting porn on camcorders, writing dirty books and making adult cartoons like *South Park*. Vigilance is the key to turning the tide — making sure that Mediawatch members sit through the worst of the smut, so they can write a strong letter of complaint to the authorities first thing in the morning.

Some groups believe giant lizards control the UN, and others think that there is an ancient Jewish conspiracy in place to control the world through newspapers and banking. Mediawatch have an enemy that is much more treacherous. Namely, the *Guardian* reading liberals who work in the British media. They believe broadcasters are using the propaganda power of mass media to destroy traditional values, promote promiscuity, drug use and homosexuality, in order to maintain a "secular stranglehold" on our lives.

A recent report by the organisation devoted itself to monitoring all the films transmitted after the watershed, on all terrestrial channels over a five month period. Every expletive used was listed in the final document, which compiled a blacklist of the worst offenders. To protect the delicate sensitivities of Mediawatch members on publication of the report, they adopted the famed asterisk device, rather than listing the swear words in full.

The research proved that some films aimed at adults and broadcast on television do indeed contain bad language. The expletive f**k was used on 1,429 separate occasions. There was a liberal sprinkling of s**ts. Even worse two films featured the use of the term c**t, cited as a serious cause for concern in the report. Given that the data was compiled by Mediawatch volunteers, who believe

strongly that TV has the power to corrupt viewers, we can only hope they weren't so manipulated by the foul language they suffered an episode of TV related Tourette's syndrome when the collection plate was passed around the congregation on Sunday morning.

John displays a rare skill for blaming television for every problem in society, even at one point making a lengthy argument that cookery shows promote obesity. "They use cream and butter and wonder why people are so fat!" He's not a big fan of the growing trend in DIY, lifestyle or home renovation programmes either, which makes me think he should spend more time reading books or painting watercolours and less time flicking through channels with his remote control and notepad.

Soap operas are also in the firing line, as they don't promote the value and worth of stable marriage and tend to feature ratings grabbing plot lines, rather than families gathering around the table to say grace. On this occasion he may well have a point, but despite claiming he is fully literate on all aspects of the media, he fails to realise that agreement, peace and harmony make incredibly dull television. I'm left thinking that if TV does wield this kind of power over the public imagination, how come atheist viewers like myself don't become born again after watching *Songs of Praise*?

Which brings us to the term 'family values'. Not an expression John uses during our meeting, but one that provides a neat summary of his strongly held belief system. When *Brass Eye*, the satirical show created by Chris Morris, aired its one off special on paedophilia in 2001, it was met by a mass chorus of outraged voices. Mediawatch wasn't alone in declaring the programme obscene[39]. There were a number of high profile celebrities, tabloid columnists along with a government minister, who rushed to condemn the programme without making the effort to actually watch it. Tabloid anger soon turned into an aggressive witch-hunt, and the cast and crew were subject to door stepping by journalists, as well as being 'named and shamed' by a right wing newspaper. In the rush to vilify Chris Morris for transgressing acceptable boundaries of good taste, a key point of the programme was all but forgotten. Namely, the current obsession with sexual predators that lurk in the playground, waiting to pounce on all our children, distracts from the true and horrifying nature of abuse. Put simply, the overwhelming majority of cases of sexual exploitation of children take place within the family unit, and are not committed by a small number of registered sex offenders. Like society in general, John obviously finds the reality too disturbing to accept and is happy to

stifle debate, to avoid engaging with the chilling reality.

In fact 'denial' would appear to be a key tenet of the Mediawatch-UK philosophy. They seem to exist in a nostalgic world where doors remain unlocked, families gather around the piano each evening, people rush to mass on Sunday mornings and children play football on the village green rather than batter prostitutes around the head with a lead pipe on their PlayStation. Which of course, brings us to the classic question, one that John must hear every day of his professional life: *"If you don't like it, turn it OFF!"*

I honestly thought John would have a killer soundbite ready to be dropped. Surely Mary had a cutting response that could be endlessly recycled in the face of new criticism?

"When you watch a programme and there is a warning of swearing or sexually explicit material being shown, you can turn over and guarantee that you will see another one straight away."

Taking for granted the fact that John isn't aware that people do manage to survive without a television, he's still got a world of wholesome options in the multichannel utopia of satellite and cable. Search the furthest reaches of Sky Digital and you will find a vast network of faith themed channels, where no viewer will ever feel challenged, shocked, angry or outraged. If he sets the parental lock feature on his remote control, he will eliminate any risk that he will be corrupted by the sight of nudity, homosexuality, cream cakes, MDF or an actor mumbling the word 'twat' in a film shown well after the pubs have closed.

The shadow of Mary Whitehouse looms large in John's world and colours the conversation throughout our meeting. I discover that we have both recently read *What Happened to Sex?*, a seventies Whitehouse autobiography that looked fun in the second hand book shop, but quickly became a major struggle after a few pages. John tells me he was even flicking through his copy for inspiration on the train to our interview this morning. Mediawatch members have always felt that Mary Whitehouse deserved more establishment recognition than the CBE she was eventually awarded. There's even been talk that a statue of the reactionary pensioner should be commissioned to celebrate her legacy.

Whitehouse's power to place her supporters' concerns in the spotlight for over three decades is something that must constantly play on John's mind. As heir apparent to her throne he has failed dismally to maintain anywhere near the same media profile, highlighting yet another deep contradiction. John is trapped in a dysfunctional relationship with the media. He is the battered wife,

returning to the man she loves because she knows nothing else. The media has on occasion validated his world view, given him a platform to air his views and also provided an opportunity to attract new campaigners to the cause. Lately the media has decided not to return his calls, and as we all know nothing makes a man more bitter than unrequited love.

The problem is that John just does not have the authority, intellectual weight or personality to make you stand up and listen. In fact, on one occasion he vocalises beliefs that suggest a course in diplomacy might be a good idea and says: "There was no pornography in Spain under Franco!"

Whilst living under the glories of fascism may have provided the Spanish with the fringe benefit of having supermarket shelves stripped of dirty magazines, it also crushed the dissenting voice of groups just like Mediawatch. This rare error in John's use of language may well provide a clue as to where he sits on the political spectrum, although in his defence he realises his mistake immediately, and adds the disclaimer, "although of course... I do believe strongly in democracy."

All the time I'm speaking to John, I pray for his mask to slip and reveal the real man beneath — keeping my fingers crossed that he keeps a stack of dirty pictures in his tool shed or cracks one off to programmes he's watching for research purposes. I'm willing to confess to doing it during the writing of this book, and it's likely to be our only shared experience.

Unfortunately for his many critics, this is just not the case. Put in the simplest terms, John is a man who feels deeply that our society is lurching towards the gutter, a result of a liberal conspiracy to set an agenda that takes no account of faith, monogamy or suburban dullness. John would claim he comes from a background of Christian values, but he appears to be completely lacking in compassion, empathy and tolerance, surely the dictionary definition of faith.

As he prepares to catch his train, I ask why membership subscriptions have fallen so dramatically over the past few years. He gives a deep sigh, and tells me: "People just think there is no point anymore, nothing seems to change."

Even now, when I'm watching television and somebody says 'fuck', I'm sure I can hear John vocally complaining to his wife over 300 miles away in Kent.

Sadly for him, his voice will never be that powerful.

# The 12 Steps To Chastity

## Joining a Support Group for Pornography Addiction

**It's always the shallowest people who trawl the deepest.** *Julie Burchill*

## I

I DON'T THINK IT WILL COME AS ANY GREAT SHOCK TO MY friends and family if I state for the record that I am no stranger to the pleasures of thyself. In the years between my twelfth and fifteenth birthday, I rarely left the self-imposed spasm chasm of my bedroom, spending hours trawling through the TV schedules for any programme that offered a glimpse of flesh. Along with the lingerie section of the Kay's catalogue and the regular sex scenes in pulp horror novels, it completed the masturbatory trinity of my small town youth. Like the protagonist in Phillip Roth's *Portnoys Complaint*, I was very keen on masturbation, a long-term love affair that continues to this day. Although in my defence, I no longer reach for my wife's collection of celebrity exercise videos as soon as she leaves the house.

If my experience is anything to go by, men tend to be more honest about vocalising self-abuse than women. In reality the fairer sex are just as keen, although there's a good reason for the silence of the sisters.

Most women have been conditioned by society to see masturbation as sinful, "something good girls should not do," whilst males

**134**

are lucky enough to grow up in a culture that accepts lurid discussions about onanism without a raised eyebrow. When discussing the topic with female friends however, I have worked out that you can be *too* honest.

If nothing else, masturbation is a great way to fill a few minutes when work starts dragging, a cigarette is not available or you have time to kill waiting for a dental appointment. Unlike other much maligned pleasures, there's no link between masturbation and cancer. You need no specialist tools except for a fully functioning hand, and best of all it costs nothing. Given my own history, you will understand how shocked I was to hear that there are some enemies of the practice who claim a tendency for self-gratification is evil personified. Not just sordid, funny looking and a bit sad in a man of my age, but likely to make me a bad father, destroy my marriage and lead me down the path to sexual assault and child abuse. This is obviously a grave cause for concern for millions of men worldwide, including a number of close friends, but I was especially surprised not to see the dangers reported in the mainstream media. Seeking forgiveness for the many thousands of sins I have committed since I discovered auto manipulation, I decide to search out these vocal opponents of self-abuse and see if they are able to cure my chronic condition, and lead me to the path of righteousness.

The Minnesota Model (better known as the Twelve Steps programme) has become the standard tool for curing people of addiction. If you have issues, however obscure or self-indulgent, there will be a group offering to help. Take for example Marijuana Anonymous, a self-help organisation based on the Twelve Step model, which aims to free victims from the grip of reefer madness. As a life long toker I'd argue that quitting weed takes nothing more than a bank refusal to extend your overdraft, a social life and avoiding calling around your dealer's house when there's nothing on the telly. Twelve Step devotees however, feel strongly that some omnipotent force is responsible for folk like me spending too long on the bong or fiddling with themselves. Until I acknowledge that I have no control over the puppet master who compels me to reach for my flesh comforter or a fat spliff, I am — to put it bluntly — fucked.

Despite my many weaknesses, I'm still determined to cure myself of my 'masturbation hell', so I search for a meeting in my local area. After a lengthy search and a number of embarrassing phone calls, I find one listed a few hours' drive away. There is a

problem however, as it's not taking place for another two days and I'm aware that temptation to indulge may strike at any moment.

Given the deadly risks I take if I continue to touch myself, I decide to adopt more traditional methods of self-denial to tide me over the next two days. My plan is to use a Victorian medical textbook I picked up at a car boot sale as my main source of support and information.

The Victorians were a peculiar bunch. Despite a reputation for remaining chaste at all costs, their society was bubbling over with barely suppressed sexual obsession. This is evident in the thousands of pulp pornographic novels that were produced during the period. Victorian erotica is among some of the most twisted ever produced, transgressing all modern ideas of taste and decency, and in the process making contemporary smut seem wholesome in comparison. Take *White Thighs*, written anonymously in 1856, which swiftly became something of a best seller among the chattering classes. The novel charts the sexual adventures of a naïve country girl as she travels across Europe in search of an 'erotic education'. It is populated with a surreal cast of dwarves, magicians, opium smokers and 'fearsome and savage' dogs, all of which become sexual partners to our heroine at some point in the narrative.

Sex, drugs and bestiality would make a heady mix even today, so you can imagine the impact the book may have had in more innocent times.

My battered edition of Dr Norman Charles' *Complete Encyclopaedia of Sexual Behaviour,* published just three years after *White Thighs,* will be my self-help guide as I attempt my wank detox. The 677 page, leather bound, heavyweight tome has three specific chapters devoted to preventing what it terms the 'solitary vice', so I can't cite lack of information as an excuse for failure.

### DAY ONE

JUST TO MAKE THINGS more difficult during my recovery, I have the house to myself, and a jiffy bag packed with smut that needs to be reviewed for this book has recently landed on my doorstep. The Victorians never had Sky Digital offering constant fleshy temptation, so the odds are stacked against me from the beginning. I start frantically thumbing through Norman's weighty tome to prevent a relapse at this early stage:

*Daily exercises and games in the open air played to the point
of fatigue, occasional sawing or wood chopping and tiring
house work are all splendid diversions. [p 67]*

Well, my wife has been asking me to fill the skip at the side of
the house for weeks now, so this would seem to present the ideal
opportunity. Two hours of heavy lifting later and I'm back in the
house, sweating into my sofa. Confident that I can complete my
self-imposed cold turkey, I seek sage advice from my denial bible
before I turn in for the night:

*People have found that a tincture of opium or a mercury
infusion added to a milky bedtime drink can assist the patient
in falling deeply to sleep, reducing the temptation to commit
the sins of youth. [p 94]*

As there's no heroin based soothers immediately to hand, and
I'm loath to break open a thermometer and drink the silvery con-
tents, I settle for a cup of tea and a cigarette before retiring to
bed. I take heed of the following advice when I'm choosing a bed
time book:

*All reading matter should be carefully chosen. Humorous
articles, sea stories, adventures which awaken enthusiasm are
not only strong incentives to activity, but also indispensable
as a source of recreation and diversion... Obscene literature,
which stimulates the thoughts and imagination in unhealthy
ways, is to be rigorously avoided. [p 96]*

## DAY TWO

*The onanist should go to bed thoroughly tired, and rise as
soon as he wakens. The patient should not be allowed to lie in
bed awake. The bedroom should be cool, and at least one upper
window may be left half open. Tight clothes are forbidden. The
trouser pockets should be at the back above the waist, and not
at the side or the front. [p 101]*

I'M UP EARLY and feeling fine. Sadly my usual three minute
morning shower will need to be replaced by a more intense clean-
ing routine:

*The treatment of onanism must be carried out as follows.
Absolute cleanliness of the whole body. A bath, at first in
tepid (30°C) and later in cool (25°C) water is to be taken in
the morning on rising. The sexual organs are to be washed
with mild soap or with pure cold water. The presence of
worms is one of the contributing causes of onanism, and their
elimination is an urgent necessity. [p 112]*

I'm starting to realise that the Victorian approach to curing
masturbation is very labour intensive. This early morning ritual
alone has meant I'm running an hour late for work, and I haven't
even attempted to purge any parasites I may be carrying. To make
sure I don't lose sight of my personal goal, I need to remind myself
of the problems I will face if I don't complete the course:

*There is hardly a morbid symptom, from the most innocuous
to the most deadly, that can not be attributed to masturbation.
Embarrassed looks, a tendency to blush, paleness, rings
around the eyes, hollow cheeks, thinness, anxiety, depression,
sensitiveness to cold, hesitating manners, and agitated
appearance, shortness of breath, a tendency to solitude all
result from allowing the condition to go untreated. The most
serious of evils for which onanism is to blame, is epilepsy and
general paralysis. [p 32]*

Clean and serene I head off to work, the consequences of any
relapse fresh in my mind. All goes well during the early part of the
day, in fact the thought of cracking one off does not even enter my
head. Lunchtime arrives, so I seek the wisdom of the good doctor
on dietary matters:

*A well chosen diet with a daily ration of sour milk will be
helpful. Wine, beer, liqueurs and even fermented fruit wine are
harmful to the onanist, as are coffee and Chinese and Russian
tea. Meat should be eaten only sparingly, and pork, smoked
meat, ripe cheese and caviar should never be taken. Spice such
as cinnamon, pepper, and cayenne pepper are to be avoided.
[p 142]*

If I start to reach a low ebb at any point during my treatment,
I read the good doctor's words of medical wisdom as they relate to
the 'obscenity of homosexuality' to cheer myself up. This makes

me realise that my life is a cakewalk compared to any man who displayed signs of campery in Ye Olde London with its no nonsense cure involving 'blood letting', 'sulphur enemas' and 'regular worship and prayer'. At one point Dr Charles even warns that the treatment has caused serious illness in a number of his patients, but such is the severity of their deviancy this is a risk well worth taking to set them on the path of marriage and decency.

## II

**Do you view pornography in order to escape or numb your feelings?**[40]

CLEAN AND SERENE after adopting the Victorian approach, I eventually find the building where this evening's meeting will take place: a church hall on the outskirts of a large city in the South West of England. It's due to start at 7:30pm and I've spent the last hour parked up outside casing the joint, chain-smoking cigarettes like a private detective gathering evidence in an acrimonious divorce case. I have the same nauseating sense of unease that you get before a job interview or a driving test, but after the long journey I'm determined not to chicken out.

Eventually people start arriving. A bloke in his late thirties opens up the doors and switches on the lights, turning to give me a smile as he passes the car. A few minutes later two older men arrive, stopping to chat before going in. Taking my cue, I spring into action, leaving the safety of the car, and taking the first small steps on the long journey to cure myself of my evil and wicked urges.

Inside there are six of us, including the man who smiled as he passed me earlier, the two smokers and some late arrivals. John (*name changed*) is the leader of the group. He makes the coffee, gives out literature, books the venue and is first to extend his hand in welcome when I enter the building. Given the group's motives for being here tonight, I have to make a concentrated effort not to look repulsed when I shake it.

After heading for the refreshments (trestle table, kettle, UHT milk, instant coffee, plastic cups) we settle in a semicircle, sitting on school assembly chairs. Staring blankly into the middle distance, a solitary fan heater pumping out a weak heat, we all avoid making eye contact. When it is clear that no one else is coming, John stands under the numbing glare of the overhead fluorescents and

begins the meeting. He warmly welcomes us, commending us on our bravery in seeking help, starting the ball rolling with his own testimony of his 'slavery to sexually explicit material'. It is echoed in the cavernous hall, a practiced, dull monotone, which suggests that we are not the first people to hear his tale of masturbatory woe.

## Do you dig through other people's garbage to find pornography?

John was once a happily married man — two daughters, mortgage, steady job, six monthly dental check ups; a white bread suburban success story. He was a man you would never guess was hiding a dark sexual secret, namely a hidden obsession with owning pictures of naked chicks getting dirty, that would eventually lead to a very public downfall.

John had been a keen consumer of sex magazines since his youth, stockpiling a healthy collection of *Knave*s and *Razzle*s under his mattress throughout his teenage years. It was normal for young men to look at pornography, he told himself. He knew for a fact that his friends were doing it, because they'd often trade magazines when they grew bored of seeing the same faces. Happily masturbating up to four times a day during college, he didn't show much interest in the opposite sex, despite being a reasonable looking guy with a good sense of humour.

The reason for this was simple: the women available on his course just did not match up to the lovely ladies spreading their legs in his extensive collection of jazz mags and videos — a library that was increasing in size dramatically, his credit card bill often showing purchases of pornography in the triple figures every weekend.

Soon he found himself unable to engage in idle chit-chat with the opposite sex without being struck by a strong urge to nip to the toilets to bang one off halfway through the conversation. He started to think that he might be developing a problem, but was too ashamed to discuss it with anyone. The walk to college became a living hell, his mind in turmoil as he imagined all the women he passed in the street with their kit off. No female was immune to his sex-ray vision: middle-aged secretaries, teenage mums pushing prams, lollipop ladies, skinny chicks, fat birds; all of them were fair game for his lecherous gaze. Any shape, size, age or ethnic origin, he'd fantasize about seeing them with their blouses open.

Undertaking an extended period of porn cold turkey during his

late twenties, he managed to keep a lid on his deviant urges; especially after falling in love with a girl he met at work, who he later proposed to and married. They settled into a pleasant, if slightly dull life in a newly built house complete with en suite bathroom and conservatory.

Just when life was peachy, John's demons came back to haunt him. His wife had recently given birth to a second child. The labour had been traumatic and he was in the midst of an eighteen month long sex drought. Browsing through a newsagent one day, he found himself grabbing a handful of top shelf smut, throwing the money at the cashier and driving home at speed to review his booty. The cycle had begun again. The slow trickle of porn purchases quickly became a flood. Over the next year he hid hundreds of magazines and videos in his garage, accumulating so much material that he genuinely thought his only option was to rent storage facilities to keep them hidden from his family.

Making excuses about servicing his car when he wanted to get his freak on, he'd spend hours digging through his stash, dick in one hand, a copy of *Juggs* in the other, constantly listening out for the sound of the garage door opening. This was an aspect of his life he had never discussed with his partner, preferring to live out his fantasies in private, careful to ensure that no member of the family would stumble across his secret shame.

John's wank 9/11 came when he was attending a week long conference with some work colleagues. Unable to get through, his wife had left a tearful phone message demanding that he return home immediately. Fearing that the children were ill he set off for home straightaway.

Rather than finding whooping cough when he arrived back, he faced his distraught wife, who was standing next to a large pile of pornography that had been dumped on the living room floor. Inconsolable and incoherent, she had apparently stumbled across his stash when she was looking for a screwdriver in the garage. She'd spent the last few hours ploughing through the spread labia photosets in tearful hysterics. *How could he do it? What sort of man had she married?* This was worse than adultery, a dirty minded perversion that had no place in their lives.

Next to the stash of muck was a packed suitcase. She demanded John move out that very night. She wasn't willing to discuss the issue or hear his excuses. She wanted an end to the relationship, because after all, what is the point of a marriage if there is no trust?

He left, and despite his pleading for forgiveness she could never erase the sexually explicit images she'd witnessed that day. She kept saying it wasn't the magazines themselves, "it was the sense of betrayal that was the problem." She felt she could never trust John again; he'd managed to keep this a secret so what other skeletons were lurking in the closet? They tried marriage counselling, but John's taste for pornography was the stumbling block to reconciliation at every session. Soon after they divorced. His wife's forthright explanation when it came to friends and families, meant he quickly became a porn pariah, shunned because of his love for the sexy ladies.

As John finishes his speech there is a mutual sigh of recognition among the group, all of its members nodding their head in empathy at this sordid saga of broken trust, damaged lives, traumatic divorce and spunky knockers.

After a long silence, John invites someone else to speak. Like overeager schoolchildren keen to impress teacher, everyone's hand, except mine, shoots up in the air.

### Have you lost a job or risked losing a job because of your involvement with pornography?

Paul (*name changed*) is next at the confessional. He's a fifty something insurance salesman with a visible urge to unload to his auto fiddling peer group. It's obvious that he's a regular, because John doesn't ask his name. We will soon discover that Paul's story relates to the dangers of technology and workplace snooping, as much as it does his urge to view porn. His motivation for attending the meeting is part of an agreement he made with his employers following an unfortunate episode at work.

Paul never really had an interest in smut, until he became computer literate following a two day course at work. Despite being terrified of the new computer system when it was first installed, he discovered that it was quite simple to operate. He discovered the joys of word processing after decades of manual typing, loved to play chess in his lunch break, worked out all his household finances on spreadsheets, booked holidays online, and fell in love with accessing images of 'normal looking' girls getting penetrated.

He was busted during an unannounced audit of the office network. A firm of external snoopers were contracted to take a look at a random sample of the staff's Internet use. Paul's trail of filth wasn't difficult to follow, given that he'd never been taught to de-

lete his online steps like a seasoned pervert. His taste for 'flogging on' led to a deeply embarrassing meeting with his senior manager, who was forced to bring disciplinary action against Paul for breach of contract. Company policy expressly forbade the downloading of pornography on office machines. Rather than being sacked, Paul was given the opportunity to make amends by attending a pornography addiction group, along with regular managerial supervision sessions at his workplace. Always a company man, Paul was true to his word and has not missed a meeting for months. In fact I get the sense that he enjoys the process; his grin indicates that the group provides a rare opportunity to spend the evening away from home.

Paul isn't just a company man, he's also a poster boy for the twelve step approach to dealing with addiction. He talks of 'forces' compelling him to view pictures of sodomy at his office desk, making no acknowledgement of the fact that it was him, rather than a 'higher being' who double clicked his mouse when the link to a feast of filth popped up on his PC.

Strangely enough, the pernicious power of the Internet to offer millions of easily accessible dirty pictures is something of a reccurring theme tonight.

Luckily, help is at hand for the guilty one handed surfer. Just download Covenant Eyes, a US based program, which emails a full history of your nightly smut trawls through porn sites to a named 'accountability partner'. The website suggests that you ask your church minister to adopt this role, which is likely to have a profound libido destroying impact on even the most shameless pervert.

## Do you look at pornography or masturbate while driving?

The use of technology as scapegoat is confirmed when George (*name changed*) steps up to the mike and takes us on a journey into the inner workings of his grubby mind. Like Paul, his problem was amplified when he brought a computer into his home.

Thirteen hour sessions trawling for pornographic images left him with a massive phone bill, bad eyesight, destroyed his social life and he only narrowly escaped becoming crippled with masturbation related repetitive strain injuries. George used to confine his muck surfing until after his wife had retired for the evening, using the line beloved by all middle class wank fiends: "You look tired darling, go to bed, I'll be up after *Newsnight*." As soon as he heard the bed

creaking, he'd cook up a recipe of keyboard tapping and frenzied stroking. He'd see the morning sunrise reflected in his VDU, forcing himself to sleep for an hour or two, before waking up exhausted to the sound of his alarm clock ringing shortly afterwards.

In George's defence he bangs through his life story quickly. A brief moment passes, before I get an uncomfortable sense of the group's attention focusing on me. To my shame I never outlined my motives for coming here during the brief introductions we shared at the start of the meeting. The event was described as 'open' on the listing, meaning rubbernecking members of the public are allowed to attend, observe, giggle, but don't necessarily have to disclose any personal information. Given that my life has never been ruined by an urge to obsessively watch pornography (although to be fair I can't take the moral high ground given my own history), I really don't know what to say. As the pregnant silence extends to levels I haven't been subject to since I first met my Christian father-in-law, I realise I haven't even come prepared with an exit strategy.

### Do you feel empty or shameful after masturbating?

Bored of hearing the same stories over and over, the group was expecting entertainment — a virgin's confessional; the opportunity to sit listening in respectful silence, whilst secretly breathing a sigh of relief that the new guy's problems are just as bad, if not worse than their own. As I battle with the urge to make a bolt for the door, I'm saved by the timely intervention of John. "We all remember how difficult it was when we first came, Bruce. Just think about the steps you should follow to seek peace of mind."

### Does it seem as though there is another person or force inside of you that drives you to pornography?

Which reminds me, let's go through the steps and evaluate their practical worth for a low threshold self-abuser like myself. The key to succeeding within the rigidly defined parameters of the twelve step program, is denying that human beings have any inbuilt sense of control.

You must stand in front of an audience of your peers and loudly proclaim: "I am a puppet under the control of a higher spiritual force, be it God, Allah, Buddha, Jimmy Saville or any number of obscure Hindu monkey gods."

You must destroy any concept of ego, self-control, personal power

or responsibility if you are to become clean. An even simpler way to describe the process is to keep repeating: "It's not *my* fault." Personally I've always respected good old-fashioned Dunkirk spirit. Keeping your problems to yourself; never washing your dirty laundry in public. Whilst some people see a man bursting into tears as a sign of emotional literacy, I tend to become socially embarrassed.

Once, during my monthly session with my good-natured, but often way off the mark psychotherapist — a situation I was forced into by my employer because of a day job that involved dishing out syringes to heroin injectors — I couldn't help noticing that he appeared to be racking his brains in a desperate bid to offer me a blinding insight into the human condition. I'd been complaining that my eczema had flared up in the summer heat, an annual event that signals obsessive scratching from June to September. He leaned forward, his head cupped in his hands, waiting for a brief moment in order to non-verbally indicate that great wisdom was about to be spoken and said: "Well, you see Bruce, your skin condition represents unexpressed anger."

In the polite way you tend to communicate with people who have learning difficulties, when they start talking about dancing frogs or picnicking dinosaurs, I mumbled "oh really" and continued to watch the clock. What I really wanted to tell him was I'd had enough. That I'd come to the conclusion that it would be much more positive from a mental health perspective, to spend his £40 fee on beer and Indian food.

Looking into those calming eyes however, I realised that he'd probably be professionally embarrassed if I was brutally honest. So, I toned down my urge to indulge my cynicism, claiming that I now felt so much better it seemed pointless to carry on with any more sessions. He smiled, obviously thinking that his skill for sitting in silence for forty-five minutes at a time, whilst he waited for me to ramble inanely to fill the gap, had cleared me of every irrational thought that had ever entered my head. Given that his job was to recognise and deal with my every shifting mood, he seemed completely impotent when it came to realising that I was telling him a blatant lie.

We live in a secular world. A spiritual vacuum. Most of us are happy to loudly deny the existence of God without fearing eternal bad karma, but still seek answers to our shared malaise by flocking to support groups, counsellors and psychiatrists in our hundreds of thousands. Personally, after twelve months of polite nodding every time my psychotherapist made an inane observation, I'd come to

the conclusion that watching television is just as effective as a coping strategy for the struggles of modern day life. A good example of the therapist's dark art can be found in the pearl of wisdom above: *"Your eczema is caused by unexpressed anger."* Given that all the Barnard males have at one time or another sported genetic patches of inflamed skin, it seems nonsensical that my inflamed dermis results from my inability to start fights outside kebab shops. For all I know the Dalai Lama suffers from eczema, and as far as I know he's not the type of guy that has to stop himself ranting at traffic wardens. My grandfather spent his entire working life labouring underground in a mine, banging into the coalface with an industrial hammer in pitch darkness and freezing conditions, the threat of a cave in constantly playing on his mind — I'd have thought that he'd have had ample chance to express his anger on a daily basis. Despite this opportunity his hands remained cracked and flaky throughout his life.

Support groups and therapists serve only one purpose in life: to conspire with their punters to rationalise, justify and actively encourage the worst kind of self-indulgence. An obsession with the self, which is not only egocentric and narcissistic but also ultimately extremely destructive. Like your mam and dad in the Larkin poem they want to *fuck you up*.

Therapy is a relentless voyeur, and it longs for you to drop the 'stiff upper lip' approach to life which seemed to work so well for previous generations, most of whom never felt the urge to constantly trawl through their psyche, highlighting every area of doubt or unhappiness until it becomes a full blown mania.

Take for example my nan: ninety years old, crippled with arthritis, survivor of the Great Depression, bombing campaigns and the scheduling of late night erotic thrillers on Channel Five. Despite losing kids during childbirth, seeing both her brothers get killed by the Hun in WWII, and living a lonely thirty years without the man she loved, she has never once suggested that she was dealt a bad hand. Now take a long hard look at the patrons in the church hall tonight twitching with excitement at the chance to vocalise their sexual weaknesses in front of complete strangers, and decide if you think Britain could survive another blitz. As more people continue to lose faith in any concept of God, they seek to fill the vacuum by looking for answers to the big questions in life through their fellow man. A primary school student of history would happily confirm that this is a big mistake. The concept of an omnipotent force controlling our destiny and forcing us to click on that spam

email offering 1,000 free hardcore images has a certain kitschy charm, but fails to explain the roots behind the problem faced by John, Paul and George.

Namely, they are here tonight because they are desperate to conform.

Many campaigners against smut are quick to tell you that pornography is directly responsible for destroying marriages. In John's case however, it wasn't the top shelf that led to his divorce, it was his inability to discuss the issue with his wife. Poor communication, dishonesty and keeping dark secrets will sound the death knell of a relationship much quicker than watching Michelle Thorne take a deep anal on DVD.

Who knows, perhaps if they had discussed it, John's wife would have happily sat and watched his collection, God forbid she may even have enjoyed it. Some women really dig pornography, and even if they don't, the vast majority tend not to harshly judge those who do. Maybe John's wife would never have agreed with his hobby. Maybe she had fundamental moral or spiritual objections. If that was the case I don't understand why he didn't dump her years ago and shack up with someone more slutty.

Contrary to popular belief, being a man isn't always chocolate. We commit suicide in vast numbers, are butchered in wars, die young, cry alone and suffer the indignity of our prostate glands swelling to the size of a balloon as soon as we hit middle age. Despite our many vocal critics, some of us have tried our best to make amends for the behaviour of previous generations of men folk. After some pressure from the sisters, we finally discovered the G spot, the clitoris, cunnilingus and sexual sensitivity. Sadly, despite these major compromises, we are still cast as the villain of the piece. Because it is always men in positions of power, as some female critics would argue, we are fair game when it comes to taking a direct hit from the shrapnel that so frequently flies in the gender war. Try telling this to a father denied the right to spend time with his children, because his ex-partner has ignored a court order. Women have every right to criticise the inequalities between the sexes as it relates to wages, but tend to remain mute on the discrimination that applies in family law.

If you have a dick, you act as a magnet for all that is wrong in the world, but despite this it's still considered beyond the pale to vocalise that maybe the sisters aren't 'all that' either. My own experience indicates that if you show me a confident, intelligent woman who claims pornography is inherently corrupt, I'll show you a bitch

that treats cock like kryptonite. Modern critics of pornography, be they feminists, right wing politicians or religious groups, have much more in common with Dr Norman Haire than they would be happy to admit. Put simply, they share his urge to condemn. This peculiar outlook on male sexuality hasn't been challenged over the last 150 years, despite the fact that prehistoric man probably scrawled pictures of naked chicks on caves as visual stimuli to having a wank in the primordial midst of time. 'New Men,' the sandal wearing gender traitors of the established patriarchy deserve the worst of our loathing. Ask any of your female friends and I'll bet cash they would always choose an unreconstructed chauvinist over a sensitive man in touch with his feminine side every time, even if the majority would be too scared to admit it. Men who accept the dodgy hand that the Y chromosome deals us, tend to be more fun to be around.

Critics of porn insist we live in complete denial of our gender, using the established formula of guilt, a ruthlessly efficient approach that has been so effective in the world of religion. They say John should feel ashamed because he gets the occasional urge to watch naked chicks get fucked on film. Paul is personally responsible for the sordid exploitation of the sisters every time he boots his computer. When George 'flogs on' to the Internet, his actions lead directly to poverty stricken single mothers taking part in sleazy hotel gang bangs, in order to buy their children shoes for the new school term. Rather than choosing to ignore their critics, the closeted slut junkies I meet tonight are consenting to go to war with their own sexuality, purely in order to fit a distorted, narrow view of what makes men good or bad. The people at the support group tonight haven't got a problem with pornography addiction, they have a problem with male guilt.

As I leave the meeting and head home, I realise that I've drawn one conclusion from my experience tonight. In the future, if I am in the local newsagent and the sudden urge strikes me to buy a magazine off the top shelf, I'm no longer going to try and hide it. The days of waiting for the shop to be clear of customers, getting the exact money ready and not maintaining eye contact with the cashier are long gone. From now on, I'll bide my time until there is a queue of people, casually walk to the counter and wave the booty around with a big grin on my face.

It's been a long time coming brothers: say it loud, I've got a dick and I'm proud!

# Cut and Paste

## The British Board of Film Classification

THE OFFICES OF THE BRITISH BOARD OF FILM
Classification (BBFC) are situated at the heart of swinging Soho
— historically the centre of the legitimate British film industry, as
well as its more famous role as a neon wonderland for provincial
tourists seeking illicit thrills. As a youth, I never believed that the
streets of London were paved with gold, but I knew for a fact that
Soho was full of strippers, sex cinemas, drugs and Maltese gang-
sters; a shopping list of things I was obsessed with at the time.

To get the true sense of a red light district, you need to experi-
ence it in the daytime. Bright light is anathema to smut peddlers
and the quiet hours before the UVs and neon spark into life and
tourist gawpers start the nightly trawl to rubberneck at sex work-
ers, provides a rare chance to glimpse the reality behind the fantasy.
Like seeing a picture of a faded movie star without her makeup.

Amsterdam is a classic case in point. Walk down Amstraat in the
early morning, just as the shops are opening, and you get a sense
of the place as a functioning community. Grocers and newsagents
exist next to porn cinemas and live sex clubs. Elderly matrons
chat with 6ft tall transsexuals dressed in sequinned ball gowns,
whilst Eastern European prostitutes, Somalian drug dealers and
native smut merchants politely say hello as they pass each other
in the street.

Despite the best efforts of moral campaigners and developers
rushing to gentrify the West End, Soho has managed to retain
some of its alternative charm. Westminster council has managed
to clamp down on 'walk ups', the one bedroom flats used by pros-
titutes, and there are very few surviving clip joints in the district.
However the large number of dirty bookshops, street dealers, pubs

**149**

and shady doormen pitching their wares, remind you that despite all efforts to clean up the area, you still only have to scratch the surface to access illicit thrills.

The flesh trade in London has diversified in recent years, spreading out from the West End. Shoreditch has taken Soho's mantle of London strip capital, and now has a number of specialist pubs, where you can watch a non-stop performance of gyrating girl flesh for the price of a £1 coin deposited in a pint glass. At the luxury end of the market, there are the new wave of lap dancing clubs. Although dismissed as 'pay per view' by deviants who begrudge handing over the high entrance fee, they often manage to attract the big city spenders, the Holy Grail for muff peddlers, who like nothing more than respectable businessmen funding their leering on a work expense account.

The Board's Soho Square location makes perfect sense, when you take into account that it is the child of the domestic film industry, established as a voluntary body by the major studios in 1912 to ensure some uniformity in censorship decisions.

Cinema has historically been subject to an arcane set of laws that were born as much by chemistry as they were politics. Celluloid used to have a tendency to ignite into a ball of flame when running through projectors, so local councils have always wielded a degree of power over the films displayed. Under the Cinematograph Act (1909) statutory powers on films shown in public were given to local authorities, who still have the power to overrule any of the Board's decisions, pass films the BBFC reject, waive cuts, institute new ones, or even change categories for films exhibited under their own licensing jurisdiction. By the mid 1920s it had become general practice for local authorities to accept the decisions of the Board, although councils and the BBFC do still engage in dick waving power struggles over films labelled 'problematic' to this day. Take the battle over the sex and wrecks themed *Crash* (1996). Despite being granted an 18 certificate by the Board, the film was banned by a number of outraged local authorities including Westminster council, ironically the home of the Board's Soho Square offices.

In the early years, sex was never a major concern for the BBFC, as it was more actively involved in political censorship, rather than trimming displays of flesh. The Board was a patriotic British institution devoted to ensuring that film studios always showed the Empire in a positive light. If a scriptwriter or film director were brave enough to hint that it would be a good idea to give the native population in India the vote, the scene would be quickly trimmed

# Battles On The Home Front   151

before distribution in order to avoid offending the good name of Her Majesty and encouraging the ungodly darkies to take to the streets in protest. Censorship is at its heart nothing more than state suppression of information, and this has historically applied as much to politics as it does sex.

The video explosion of the early eighties brought about a profound change in role for the Board. The Video Recordings Act (1984), a parliamentary response to the panic surrounding the easy availability of violent video films, gave the Board dramatically increased powers to classify material intended for home use. Previously they had no input on video releases, focusing their attention exclusively on viewing films for cinema distribution.

As soon as the Act became law any video release not carrying the official BBFC stamp of approval was deemed illegal, and remains so to this day. The penalties for offenders are harsh, including the genuine risk of a heavy fine and a lengthy spell in prison. The Board changed its name as a result of the new act, dropping the harsh sounding 'censor' from their title and adopting the much fluffier sounding classifier tag.

The Act was drawn up as a result of flawed research, tabloid hysteria and the frenzied lobbying of organisations like the National Viewers and Listeners Association. Rumour dictates that Mary Whitehouse had been touting a 'Best of Video Nasties' compilation tape at Conservative party conferences, so there were legions of rent a quote MPs happy to be dragged from the twenty-four hour Commons bar to provide easy copy for tabloid hacks. Paradoxically, it did at least include a ray of light for punters wanting to buy hardcore smut. It included provision for a brand new category, the Restricted 18 certificate, which although only available for sale in licensed sex shops, finally seemed to offer a frustrated UK public the chance to glimpse some muff.

Although it met with the support of pornographers when it was first announced, people soon realised that the Board had not undergone any real change in attitude. They still rejected any imagery that showed unsimulated shagging, although they sometimes did allow female performers to take off their knickers during the sex as long as the camera didn't linger on their groin for too long. Outer labia could be shown, but any sight of the inner labia was met with a chorus of outraged tutting and a race for the scissors.

The only reason the board currently finds itself in the position of allowing smut into the home, is as a result of its own appeal committee throwing out one of its decisions on the classification

of hardcore porn tapes, opening the door for every smut producer with the available cash to finally go legit and seek mainstream distribution for their work.

I speak to Peter Johnson, a senior examiner with responsibility for answering questions about the R18 classification. He is engaging, open, honest and displays a nice line in dry wit, although I'm guessing our conversation would be more fun if we were speaking off the record, given that he makes no apology for his willingness to strongly defend current BBFC policy.

This is confusing, when you take into account that in the digital world censors are rapidly becoming impotent. The Internet means that anyone with a computer can in effect download DVD quality, feature length films within seconds of turning on their laptops. Whilst this may be a cause for concern for society, let's not pretend that it makes the reality of Board examiners spending hours watching video smut seem anything but a worthless exercise.

BBFC examiners classify work at the R18 category in pairs, rather than alone as they do for all other material. This ensures that all potential releases have been thoroughly assessed before hitting the market-place, whilst also providing the unspoken fringe benefit of preventing any examiner from slipping one off in the screening room.

All employees assess sexually explicit material. There is no scope to object on religious, moral, ethical or gender grounds. Classifying pornography is an important part of the job and this aspect of the role is discussed at length during the interview, mostly to ensure that new examiners don't turn up for their first day of work and vocalise that they are deeply offended at being asked to watch people fucking before their coffee break.

Examiners usually classify five hours of material a day, chosen at random from across the range of certificates. Arriving at work in the morning, they may find themselves watching a trailer for a forthcoming cinema release, a big budget Hollywood action movie, *Essex Pub Orgy* or *Slamming Granny up the Fanny*, before ending on an episode of *Barney the Dinosaur*.

There is formal support on offer should any of the examiners start to identify symptoms of being 'depraved and corrupted' by their constant exposure to bump and grind, although Peter tells me it's currently an underused resource among the staff.

It's worth bearing in mind that Board employees are put in a unique situation, given that they watch porn from right across the spectrum of human sexuality, unlike most consumers, who often

have interests in one specific area. Examiners classify gay, straight, bi and transsexual material regardless of their own sexual orientation. Despite this they don't seem to be running to a therapist to cleanse the images from their heads after they have clocked off, a situation that would appear to offer a strong argument that a daily diet of filth has little power to deprave or corrupt, especially when you take into account that Board employees see footage denied to us mere mortals.

Peter tells me he finds the repetitive viewing of real life war and atrocity footage much more soul destroying than watching smut. Anyone who searched out the grainy video images that became available online after the beheading of a number of Iraqi hostages would probably be quick to agree.

Fees paid to classify R18 material made up around ten per cent of the Boards annual income in 2002[41], but this is likely to rise over the next few years, as more producers submit their material for classification in order to access the recently opened UK market-place. Before the liberalisation of the R18 category, the Board would examine around twenty-six explicit fuck films a year, a figure that is likely to be nearer to 1,000 tapes in 2003. The sheer number of submissions is creating something of a bottleneck of product in the market-place given the limited number of shops who are legally able to sell the certified tapes once they have the official stamp of approval.

If there are any issues of concern or areas that require clarification, the BBFC will consult independent experts prior to making a classification decision. Take the hot potato issue of female ejaculation, a porn speciality act that always falls foul of the censor's scissors. The organisation has sought advice from a number of sexual health experts in the past, to gauge if 'gushing' or 'squirting' (to coin the charming sex industry term) is physiologically possible. The medical response came back decidedly mixed, with some experts claiming that women can indeed ejaculate, whilst others tended to view it as a physical impossibility, nothing more than a pornographic urban myth. Because of these mixed messages the Board chose to take the viewpoint that female ejaculation is nothing more than an excuse to include the dreaded act of urination in fuck films.

"As an organisation we don't hold a firm position on female ejaculation," Peter tells me.

Women working in the smut trade claim the Board approach to cutting footage of the squirting goddess is a blatant sexist double

standard. If male ejaculation is widely acceptable, why not female ejaculation? They tend to draw the conclusion that their sexuality is being institutionally dismissed. As one female performer told me, "I know that ejaculation is possible, I can do it. How can the Board deny my own experience?"

The Board are not big fans of 'squirting', because it presents a window of opportunity to include footage of urination: something that is acceptable in a non-sexual context, but quickly becomes a major taboo if any sexual activity is taking place at the time.

The R18 guidelines directly address this concern so no pornographer can claim naïvety of the rules as an excuse to appeal rejected footage:

*Penetration by any object likely to cause actual harm or associated with violence, or activity which is degrading or dehumanising (examples include the portrayal of bestiality, necrophilia, defecation, urolagnia) are forbidden.*

This rule also means 'fisting' footage will be trimmed as a matter of routine, although producers can get around this clause by making sure that the performers only insert four fingers — if the thumb remains visible than everything is fine and dandy.

The consumer driven demand for including water sport footage in films, highlights a number of problems the Board face when making decisions on specific titles, as well as policy making for the R18 category in general. As they are unable to pass material that risks facing charges under the notoriously vague Obscene Publications Act (1959), they need to apply strict criteria to what they can allow for public consumption. This avoids the professional embarrassment of having coppers mounting sex shop raids and confiscating material that bears a legitimate BBFC classification tag.

The Obscene Publications and Internet Unit of the Metropolitan Police when asked about their guidelines on bringing charges under the Act stated, "the minimum we can prosecute for is urination or defecation into another's orifices[42]." Consequently, the Board tends to take a cautious approach.

Some of the guidelines confuse rather than clarify. A good example being the guidelines for R18 material, which state:

*... the Board will not pass any material which is in breach of the criminal law.*

This is often cited when pornographers submit explicit material, which has been filmed in the great outdoors. Producers often try to include hardcore footage they have shot in cabs, railway stations, fields, beaches and car parks. If any unsuspecting member of the public finds themselves appearing in a cameo role, the footage will be rejected outright. There is however a relatively simple way around the problem. If the company submitting the smut are willing to write a letter claiming that they took appropriate steps to ensure that any people passing by were not subjected to displays of public indecency, then they may have a small chance of getting the footage passed. It's the equivalent of forging a sick note from your mother to cover up the day you played truant from school.

As Peter tells me: "It's common sense. You find most producers organise a look out or use mobile phones and walkie-talkies. If they can assure us that they weren't breaking the law and risking possible legal action we may be willing to pass the footage."

More problematic is current legislation that applies to soliciting offences. In theory directors may be guilty of committing the crime when they cast their films, given that they are actively recruiting people to have sex. Although fucking for money is not illegal in itself, touting for people to perform sexual acts is. This is especially applicable to group sex events where amateur male performers pay a fee.

There may well be a degree of paranoia in the sex industry, especially when it comes to legal grey areas. A number of female performers are willing to speak off the record about police visits and informal chats, where senior officers have expressed reservations about the organisation of gang bang and bukkake events. Despite this the Board will happily pass group sex footage on video if it remains within the rigid boundaries of the R18 guidelines, despite there being a risk that the production of the film itself may be illegal.

More of a genuine fear are charges relating to the offence of 'living off immoral earnings'. The law is vague on pimping offences as they relate to producing pornographic films, so producers perceive themselves to be in a risky legal situation. One novice director who has only worked in the industry for a short time told me, "I'd love to see them try and take me to court for living off immoral earnings, given that I'm four grand in debt and haven't made a fucking penny yet!"

Board examiners liaise closely with the police and customs in order to seek expert advice and informal guidance on any mate-

rial that they are concerned may be at risk of breaching UK law, although Peter clarifies that he has not been made aware of any cases of porn producers being brought to court for either of these offences. The police themselves have never raised it on the agenda at meetings as a cause for concern, so the Board fail to see any problems with the guidelines as they currently stand.

The BBFC is subject to much criticism and it's hard to find anyone who seems willing to vocalise that they represent a pragmatic response to changes in community standards. There is however a consensus of opinion (of which, pornographers provide the loudest voice) that the following clause is essential:

> *Material (including dialogue) likely to encourage an interest in abusive sexual activity (e.g., paedophilia, incest) which may include depictions involving adults role-playing as non-adults.*

The Board take a zero tolerance approach to any material that breaches this rule. Any filmmaker shooting footage of models in pigtails or school uniforms can expect their work to be refused certification, even if the performers are clearly not of school age, sport caesarean scars, laughter lines and faded tattoos. Cuts have even been imposed on films shot in homes where family photographs are visible in the final edit.

What about titles, I ask. Walk into any sex shop and the shelves are filled with tapes titled *Slut Fest*, *Ass Banged Gaping Whores* or suchlike. Does the BBFC hold an opinion on this move towards misogynistic product names?

"We take the view that people buying tapes in licensed sex shops will not be offended by the titles, especially given the sexually explicit content inside," Peter replies.

Despite this apparently relaxed approach there have been problems with a number of titles in the past. Peter confirms that the US based series *Rocco's Animal Trainer* was one case where the Board demanded change. They told the production company involved, it would be prudent to amend the title to *Rocco's Sex Trainer* in order to avoid offending any innocent member of the public who took umbrage at the description of women as 'animals' whilst trawling through the shelves of a sex shop.

Rocco Stifferdi, a veteran of the porn business who claims to have slept with over 4,000 women is one performer whose submissions often provide a challenge to the narrow remit of the R18 category. His work occasionally has an aggressive edge, involving gagging,

verbal abuse and spitting, all activities that are strictly out of bounds under the Board's current guidelines which state:

*The infliction of pain or physical harm, real or (in a sexual context) simulated is forbidden.*

"It would be easier on the examiners if we did not have to classify as much of the extreme American material as we do now. Rocco's stuff, especially the older stuff, is a problem," Peter tells me.

Paradoxically the Board had no objections when Rocco undertook a rare mainstream acting role in the French art house film *Romance*. His casting came as a surprise to many people, not least his fellow actors. The female director kept the Italian Stallion's involvement a closely guarded secret because she feared if news got out the cast would walk off the project. The finished film when submitted featured explicit shots of masturbation, penetration and S&M more suited to pornography than mainstream narrative cinema. The Board deemed it as having artistic merit and passed it at 18, despite a simulated rape scene placed among the hardcore imagery, which would have meant outright rejection for the film at R18 due to its breach of another guideline:

*The portrayal of any sexual activity, whether real or simulated, which involves lack of consent if forbidden.*

This decision was one of the many occasions where the massed voices of native pornographers could be easily forgiven for screaming hypocrisy outside the Board's offices. As *Romance* was intended for a middle class, literate, educated audience, it was unlikely to cause much of a media stir. Mindless filth on the other hand tends to be consumed most heavily by working class males. The Board appear to be saying that you are more likely to be depraved and corrupted by smut if you earn less than £25,000 a year and don't have the benefit of a university education. A good example of why the organisation is prone to accusations that their outlook on the lower orders has not changed since the formation of the Board in 1912.

I flippantly ask Peter a question about the difficult issue of context. If I produce a hardcore, full on mucky film but encourage the cast to offer blinding insights into the human condition or recite experimental poetry as they take a double penetration will the finished product be viewed as art or smut?

With a weary sigh Peter tells me, "Look, I watch the film and make the decision if it has any artistic merit."

This neatly highlights the concerns of many free speech advocates in that, much like beauty, 'artistic merit' is in the eye of the beholder. As a general rule most smut peddlers are an unpretentious bunch who just want to capture people fucking on film. If however they held delusions of grandeur and attempted to add some social commentary in between the blowjobs and double penetrations their muck may well be viewed in a more positive light by Board employees.

# Ground Zero

## Opening the Doors of the STD Clinic

IF PEOPLE KNEW THE TRUE EXTENT OF THE bacteriological and viral war being fought every time we had sex, many of us would turn celibate overnight. Our bodies are home to billions of microscopic life forms, a flesh colony rich in minuscule flora and fauna, some of which occasionally decide to kick start a biological revolution just for the hell of it. If the simple act of shaking hands can transfer levels of bacteria measured in the millions, imagine the germ jamboree that takes place when we link up our moist sexual organs and cause friction.

The British may not be able to win Wimbledon but we top the European league table of sexually transmitted disease year after year. Add to this our high rates of teenage pregnancy and it's enough to start the tears welling up with national pride. We are an island defined by our dirty dicks and oozing snatches, a country where a large number of the sexually promiscuous population are constantly fermenting a rich, bacterial stew which longs to break away from its host and start mingling with other party guests.

If you are lucky you may get bacterial vaginosis, chlamydia, genital herpes, genital warts, gonorrhoea, parasitical infestations, syphilis, pelvic inflammatory disease, thrush or trichomonas vaginalis. Usually signalled by inflammation, a flood of sunshine yellow pus and the feeling that you are pissing razor-blades, all these can at least be cured by a week long course of antibiotics. Moving up to the premier division there is hepatitis B and C, likely to cause serious liver damage and chronic ill health, but still preferable to the black cloud of HIV infection.

On a bright September morning, I am waiting in the staff room of the Genito-Urinary (GU) clinic in a large hospital in the South

**159**

West of England. The clap clinic is situated down a long alley, next to the bins, purposely detached from the main hospital to spare the blushes of the thousands of patients who attend each year. I'm hooking up with Sarah (*name changed*), the unit manager. She's thirty-three, has a filthy laugh, adopts a non-judgemental approach to the sexual peccadilloes of her patients and has no shame when it comes to discussing sexual practices that would shock the vast majority of the UK public. We hit it off straight away. In a previous life I worked as a registered nurse, so we share the dark sense of humour that comes from dealing with sheepish patients who have 'accidentally' managed to get a socket set clamped onto their genitals. Anyone who has completed a shift in an accident and emergency department, is likely to have a number of lurid stories about patients with foreign bodies lodged in their rectums. The appetite among a small section of the community for inserting carrots, torches, batteries, vacuum cleaner extensions, bottles and action men figures into their anus is a constant source of wonder for medical staff.

It's always struck me as strange that nurses have historically been major figures of sexual fantasy. My own experience would indicate that after finishing a twelve hour shift on the wards, the vast majority of them are more likely to spend their evenings drinking red wine, chain-smoking Silk Cut, necking Valium stolen from the drug trolley and whining about pressures of work and low pay, rather than begging for your cock whilst dressed in their uniform.

Sarah's major concern at present is the continuing rise in viral infections across the country. Many people seem to think that HIV is no longer a major threat, despite the statistical evidence indicating that positive diagnosis for the disease was up by twenty per cent in 2003.

"People seem to think that HIV is a disease that only impacts on the gay community, when the bulk of the new cases are linked to heterosexual transmission. The reason that the rates of sexual infection in the UK are going through the roof is simple: a blanket refusal to wear condoms," she tells me.

Interestingly, the media response that greeted the new HIV statistics did not focus on the refusal of great swathes of people in the UK who choose not to use barrier contraception. Instead the story was given a racist spin, with some reporters claiming that the increase was related to the large numbers of asylum seekers arriving in the UK who already carried the virus. This is an ap-

proach with a strong historical precedent, taking us back to the days when VD was commonly referred to as French Pox, in a bid to distract from the poor sexual health of our own population. People have long sought scapegoats from across the channel.

Although it is unfair to focus specifically on the sex industry, given that the general population is equally reluctant to rubber up or adopt safer sex advice, the adult entertainment business's desire to show us new sexual practices as yet unseen can lead to increased health risks for performers. Take anal to mouth (a2m), a pornographic speciality act that is proving popular with producers and consumers alike.

It involves the chosen starlet performing oral sex immediately following her anal penetration; captured with a single camera shot so the punters can guarantee there's no visual trickery at play. The frothy faecal and saliva cappuccino that can result is likely to carry a high risk of bacterial and viral infection. Sarah has never heard of the practice, leaning in closer with a look of barely disguised fascination and mock disgust as I explain.

"I'd be very concerned about the risks of parasitic infection and gastroenteritis," she tells me.

Anal sex is a key transmission route for sexual infection, especially when you take into account that the sex industry is currently suffering from acute proctomania. What was once a novelty act has become the norm, with most producers viewing lengthy anal scenes as the modern day equivalent of the magic beans in *Jack and the Beanstalk*.

Anyone in doubt about the potentional health implications of frequent bouts of frantic onscreen anal sex, just need look at the case of UK starlet Alicia Rhodes, who recently spent a short time in hospital after suffering anal tearing on set. She says that the most embarrassing part of the episode was explaining the cause of her condition to the medical staff treating her. Despite this set back, she's still very much a game gal, showing a level of professionalism beyond the call of duty every time she is filmed anally fisting herself.

"The definition of high risk behaviour is currently listed as any patient presenting at the unit, who has had more than five sexual partners in the last year," Sarah tells me.

Given that some UK performers often have unsafe sex with multiple partners in the same afternoon, it's surprising that the UK porn business has never been subject to an STD epidemic. People in the business always tend to make the argument that because

the industry is so small and uses a limited number of regularly tested performers, they are acutely aware of the health risks and can take steps to prevent infection.

Even though porn performers may well display more knowledge of the risks of sexually transmitted disease than the general public, Sarah has a different view. "It's probably as much to do with luck as it is anything else," she states bluntly.

It's an area that most people are reluctant to discuss, but some women who work in the UK porn trade also undertake escort work. The term prostitution is not regularly used to describe female performers fucking on camera, although a number will happily confess that this is what their film career amounts to. Many others would disagree. For example, one high profile pornographer told me, "I'm not paying for people to fuck. I'm paying for the privilege of filming them fucking."

Escort work has a number of advantages, for starters it can increase salaries dramatically. If you are getting paid £300 for a sex scene, it's not hard to understand why the chance to earn £500 for an hour spent in a hotel room, away from the prying eyes of the video camera is a tempting proposition. Female performers who escort also have the advantage of having a ready-made business card of their sexual prowess, in the form of their video releases, meaning there is a ready-made client base of punters, keen to turn fantasy into reality and nail a genuine porn queen.

Escort workers are, however, strictly vanilla in the deviant hierarchy of some GU clinic attendees. This is a working environment that often highlights dark sexual obsession and extremes of human sexual behaviour. As well as a musical term to illustrate the freestyle vocalisations of a jazz musician, 'scat' is the term used to describe faeces as sexual fetish. Sarah tells me that when she delivers education packages to her scat punters, who often present at the unit with eye infections, she advises that they should substitute mashed up fruitcake for faeces to prevent the risk of disease, although she's resigned to the fact that the majority will ignore her.

Patron saint of shit eaters across the globe, is aging rock legend Chuck Berry, a man with sexual tastes that cross the line from bizarre into the realms of the deeply disturbing. Following a raid on his home and business premises, police seized a large collection of recording equipment and VHS tape to be filed as evidence relating to crimes of sexual voyeurism. The case arose from a number of complaints that the author of My Ding-A-Ling was using secret

cameras in his club's toilets in order to capture women and children defecating on tape.

It took weeks for the police to watch the evidence following the raid, viewing hours and hours of footage that featured victims from across the age spectrum. In the process of gathering evidence, they also found the Chuckster's personal stash. A garage packed to the rafters with home-made filth, including one infamous tape that has now passed into rock legend. A fuzzy video image captures the aging guitar genius squatting over the face of a blond women whilst muttering the immortal line: "Hey baby, come and get your breakfast!" to a soundtrack of retching and groupie tears.

I ask Sarah why she thinks Britain has the highest number of people in Europe queuing in clap clinic waiting rooms. "It may be related to our culture's approach to sex. The way we tend to view sexuality in terms of a dirty secret. Even in this environment where we offer complete confidentiality, some patients are still reluctant to tell the truth."

Critics of explicit material often claim that it is responsible for the premature sexploitation of our children. In the rush to apportion blame on pornographers for poisoning the well of innocence, they fail to see the bigger picture. Take a walk into a clothes shop on any British high street and look at the stock aimed at pre-pubescent girls. Padded bras, short skirts and lacy thongs hang from the shelves, items aimed squarely at the 'tweenage' market, a new demographic of eight to thirteen year olds identified by marketing agencies as having a large disposable income to spend on consumer items.

The local newsagent will also carry a large range of lifestyle magazines aimed at the same age group, many of them carrying problem pages devoted to acne, exam stress, boyfriend trouble and the mechanics of oral sex. People concerned with high rates of teenage pregnancy should lower their gaze from the top shelf, in order to find the culprits responsible for the push to adulthood that young people increasingly face.

Many boys, myself included, gained the bulk of their knowledge in matters sexual from the letters and stories contained in top shelf magazines. Granted some may have been subjected to a brief run-through the sexual organs in biology class, but generally the nitty gritty comes from reading porn. Anyone who has read a letter from a middle-aged reader of *Fiesta* will be only too aware that it isn't the best education on the complex gender dynamics of the sexual battleground impressionable teenage boys could have.

Despite this, it does at least go some way to filling in the gaps in sexual knowledge that young men are subject to purely because of the social embarrassment among our parents and teachers, which means discussion of sex is rarely on the agenda.

Our unwillingness to engage children in direct discussion of sex means they are more likely to make wild stabs in the dark on the journey to sexual maturity, leading to increased pregnancy and higher rates of sexually transmitted disease.

"The most difficult part of my work is seeing the same patients presenting at the unit, time and time again," Sarah tells me. "Especially when you have to go through the traumatic process of partner notification."

Partner notification is the deeply embarrassing process in which patients are encouraged to inform their recent sexual contacts that they are at risk of sexually transmitted disease. For the partners of infected people who are married or in a long-term relationship, a letter from the GU clinic telling them to present for treatment, understandably tends to signal the death knell of the love affair. Infidelity alone is a difficult concept to accept, and this is amplified when the betrayal involves an element of bacterial baggage. "People can often be very angry when they open their post and ring for an appointment," Sarah informs me.

I ask Sarah if the constant procession of oozing, swollen, inflamed dicks at the unit has twisted her outlook when it comes to her own sex life.

"It's something you get used to, and I'm very aware that the vast majority of sexually transmitted infections are easily preventable, so it hasn't turned me to a life of celibacy yet."

# Marathon Man

## 24 Hours on Planet Porn

### FRIDAY MORNING 6:00 AM

THE ALARM CLOCK WAKES ME AT 5:30 AM, SO I CAN shower and clean my teeth before assuming my position on the sofa. After the weekly nine-to-five grind, some people will escape from the day-to-day stresses of work by spending the weekend in Prague or Barcelona, taking advantage of cheap flight deals to explore the cultural highlights of our European capitals. Others will throw themselves down mountains, play football, walk to the park, take bicycle rides or go disco dancing.

Instead of undertaking any of these wholesome activities, I've foolishly committed to spend the next twenty-four hours watching mindless filth with no socially redeeming value whatsoever.

When I say twenty-four hours, that is exactly what I mean. Apart from toilet breaks (which I've decided can last no longer than two minutes) and the odd visit to the kitchen to warm something under the grill, I will spend an entire day of my life doing nothing but watch people fuck on tape.

Next to my television is a metre high stack of pornographic DVDs and videos. My fridge is stocked with beer, last night's pizza and an eight-piece fried chicken bucket slowly congealing in its own fat. The phone is off the hook, the curtains are drawn, the family are away for the weekend and I'm all set to go.

The experiment kicks off with a well-packed Turkish eye opener, a bacon sandwich and a viewing of *Anal Attraction*. A 1980s German fuck fest from Teresa Orlowski, the woman behind a thousand Aryan cum shots. Despite the spoof title, it's not a pastiche of the Glenn Close/Michael Douglas paean to infidelity, more a simple meat and potatoes anal sex romp with a mixed cast of fleshy Germanic blonds and hirsute studs imported from the US. Whilst

**165**

most porn consumers don't devote much time to the narrative, I like to see an attempt made at plot when I'm watching smut, although *Anal Attraction* proves to be a challenge when I realise that it hasn't been dubbed into English.

The minimal story seems to involve an upper-class gent who has wired all the rooms in his vast mansion to video cameras, taking the opportunity to masturbate frantically as he watches his guests bone each other over the course of a day.

Ron Jeremy makes an appearance early on, not as porcine as he is today but still sporting a vast girth and jiggling man tits under his yeti like chest hair. He's fucking a bored looking Euro slut next to a pool and it is obviously cold, given that the sky is grey, you can clearly see her breath and she has goose bumps larger than her nipples. Ron's been around the block and has a reputation for delivering the goods in extreme circumstances, so a frosty Munich winter is not going to put him off his stroke. Practicing the 'sewing machine' fuck style you only tend to see in porn films (frantic banging–pause–frantic banging–pause), it quickly becomes obvious that Ron must have lost a grandparent in WWII. How else can you explain his switching lanes before indicating without taking the time to apply lube?

With the startled face of a lottery winner, our heroine releases a feral grunt and selflessly submits to the Hedgehog's rectal exam without raising a single complaint, although her facial expression seems better suited to a soldier returning from a tour of duty in 'Nam than a woman enjoying the sex.

After a few minutes, Ron goes for the messy facial, his female co-star mumbling with mock enthusiasm at the prospect of getting drenched in man slime, whilst frantically bobbing her head up and down in order to minimise the extent of the jizz shower. A ploy termed 'cum dodging' by some cynically minded porn fans.

### 7:30 AM

THE POST MAY not have arrived yet, but I'm on my second film of the day. Chosen from my 'lucky dip' pile, namely a large number of VHS bootlegs I borrowed from a friend that haven't got any titles written on the spine. Choosing at random, I settle into my chair, press play and see the opening title credit sequence of *Black Street Hookers 24* come up on the screen.

To describe the concept behind the series is as simple as the

people who produce it. Our protagonist takes his video camera, along with a large wad of cash and trawls through the red light zones of various US cities propositioning crack whores to fuck on film. Unlike the vast amount of gonzo porn, where the introduction is faked and the performers have met beforehand, this seems to be the real deal. The action is shot in cars and cheap hotel rooms and all the negotiations are filmed. My heart sinks when the male lead starts haggling with the prostitutes over a few dollars when quoted a price for oral sex. As you'd expect, the sex is always perfunctory and deeply unappetising, but more importantly it raises an obvious question: why would an American punter pay $25 for this tape, when they could drive to the nearest inner city and fuck the stars for the same price?

Anyone who believes this is an isolated example of the genre, should take a look at [**w**] crackwhoresconfessions.com, an infamous US based website that promises 'America's Dirtiest Crack Sluts' for $16 a month.

## *BUSTED!*

I'M WATCHING *Black Street Hookers 24*, when around halfway through the tape the action changes and the picture suddenly goes snowy, the sex disappearing altogether as a lame BBC2 sitcom appears on the screen. Outraged that Mark (*name changed*), who I got the copy off, would tape over filth — regardless of its quality, taping over muck remains a cardinal sin for the male of the species — I ring him to vocalise my disgust.

Mark seems very confused as to how the TV show ended up on this particular tape.

I forget about it until a few weeks later when I get a phone call from Martin (*name changed*), Mark's neighbour. He's screaming down the phone, telling me "It's all your fault". Slightly confused, I ask for an explanation.

It seems Martin was recently house sitting Mark and his wife's place while they visited relatives in Italy. They left him a spare key so he could feed their cat, water the plants and collect the post. One afternoon, Martin's bored, so he nips around to the house and starts 'investigating'.

He won't confess to rifling through the knicker drawer or flicking through photo albums for topless holiday shoots, but he has a reputation for being a super freak and happily admits that he went

through the video library looking for smut. Picture Martin's look of excitement when he finally stumbles across some genuine filth.

Settling down on Mark's brand new, chocolate brown leather sofa, he drops his trousers and starts wanking like a condemned man with an appointment with the electric chair. He shoots his muck, wipes up, pulls up his trousers, lights a cigarette and in his blissed out, post orgasmic state, forgets to return the tape back to the shelf. It's left in the VCR that Mark has set to record a number of TV programmes in his absence.

As soon as I told Mark about the fact that his copy of *Black Street Hooker 24* had been recorded over, he puts two and two together. Shocked and nauseated to discover that someone he trusted could have cracked one off in his living room and risked soiling his new furniture (not to mention the volcanic reaction of his repulsed wife), the pair never speak to each other again.

### 8:45 AM

IF YOU ARE in any doubt that pornography is often as much about the spectacle as it is the sex, then the next tape provides ample evidence. Shot on 16mm film stock and transferred to video, *Bizarre Dwarf Orgy* is a charming eighty minute insight into the lives and loves of the little people. Reeking of the 1970s, each and every cliché people attach to pornography of the time is here. Crashing, hand held zooms onto pimply arses, pubic triangles the size of oven gloves, vivid purple bruises, track marks, a funky soundtrack of Hammond organ and fuzz tone guitar and a cast of greasy faced, lank haired performers who look like they could all do with a good scrub. In the words of Freak View, a US based website that specialises in displaying 'a cavalcade of sexual oddities', midget folk have always represented 'nature's most erotic mistakes'.

In *Bizarre Dwarf Orgy*, a full sized starlet sporting a vast afro, a face that hints at a hard life and stretch marks so acute she looks like she's wearing a flesh toned tiger cat suit, happily consents to a five pronged dwarf attack in a flimsily constructed wrestling ring. She takes on a new tiny contender every time the bell is rung, rather than consenting to a no holds barred dwarf free for all.

Achondroplasia phobia sufferers aside, any casual viewer would have to give maximum respect to the male talent in this flick. They attack their object of desire with a commendable gusto, a direct

result of a sex life limited to ladies who struggle to reach the 4 ft 5 in mark.

Interestingly, midget mania in porn can't be subjected to the usual accusations of exploitation aimed at smut in general. Dwarf performers are exploited in the mainstream film world as well. Given that I'm willing to defend anyone's right to fuck without ridicule, I think I should extend the manifesto to weird looking folk as well as performers who look like the result of a secret porn eugenics programme.

A midget actor may have spent three years at RADA honing his or her craft, appearing in experimental theatre and reciting difficult Shakespeare monologues, but as soon as they start looking for paid work they will only be offered roles that relate to their disability. Imagine the depression that strikes when you go to see an agent only to be told: 'Well, there's pantomime of course, and I heard that David Lynch is casting. There's also an audition for an alien in a big budget sci-fi film, although the audience won't see you because you'll be covered in layers of special effects make-up.'

## NOON

AFTER SPENDING SIX hours of watching non-stop filth I'm in need of some spiritual healing, so I allow myself to watch a few minutes of *The Miracle Show*, an evangelical broadcast from a Canadian religious festival that is showing at the furthest fringes of the Sky Digital TV schedule. For any reader keen to check it out for themselves, you'll find it situated between the *Islamic Quiz Show Network* and *World of Bees*.

The venue is a vast convention hall which is capable of holding 40,000 worshippers, a location that looks more suited to playing host to a cock rock band rather than a fire and brimstone preacher. As the congregation eagerly run into the building, they are handed forms to complete which list a number of common medical ailments. Today is not just a glorious celebration of the Bible, it's something much more entertaining: a live demonstration of the power of Christian healing.

Strangely enough, the programme is shot on exactly the same digital video equipment that is used to make smut and after a few minutes I start getting confused, wondering why no one has started to undress.

After spending a year writing a book about sex it seems I have

proved that constant exposure to sexually explicit material can have an impact, albeit a minor one. Expecting the performers on a Christian television programme to get down and dirty is just one example of the syndrome. I also find it impossible to walk down the fruit and veg aisle in my local supermarket, without thinking it would make a great location for a reverse cowgirl anal.

Reverend Leslie is the man with the healing hands. He's quite handsome in a slightly sinister, dyed hair, sharp suit and beaming white smile kind of way. After a brief sing song and loud prayers broadcast over the PA system, his appearance on stage is signalled by puffs of smoke, strobe lighting and a pyrotechnic display that would shame most metal acts.

The good reverend works the crowd like a true professional, moving towards the audience from the stage to be met by a sea of hands. People flock forward in large numbers to grasp at the chance of receiving his healing power. He has a fair number of fans in the crowd, just take a look at the large number of worshippers who are sporting Rev Leslie T-shirts and you realise he's working on the principle that the eleventh commandment is: always be aware of the power of merchandising.

After a brief sermon, the main event takes place when a line of crippled folk start gathering at the edge of the stage, waiting eagerly for their appointment with the sweaty hands of Jesus' earthly disciple.

The first victim is an elderly woman, leaving her wheelchair with the assistance of two helpers to slowly make her way up the stairs and into the spotlight. Forcing a microphone into her face, the good reverend asks for her personal testimony and in a weak voice she delivers it. Susan tells us she has been trapped in a life of discomfort, struck by arthritic pain since her teens, is unable to move any great distance and is dependant on a constant stream of pain killing medication. The Reverend's face oozes the fake compassion I tend to adopt when forced into hearing the life story of a homeless person pan-handling next to a cash point dispenser. He's so overcome by the tragic tale he seems on the verge of tears, resulting in a hammy expression of concern and understanding that seems more a product of acting lessons than real concern for his fellow man.

He gives the crowd a foxy smile and moves nearer to Susan, placing his hand on her forehead and loudly making a noise that will be familiar to any parent who has hired a magician for a kid's party. Susan falls back into the hands of Rev Leslie's glamorous

assistants looking like she's just had an electric shock.

Praise the Lord, a miracle seems to have occurred. Perhaps I should grab myself a plane ticket and see if the Reverend can cure my cynicism?

Susan starts to take a number of small, painful steps forward on the stage, her face a curious blend of agony and joy. She manages to walk a few feet before collapsing back in her chair, the crowd ecstatic at the miracle they have just witnessed. As Susan is tactfully dragged from the limelight, I start to realise that the worshippers at the *Miracle Show* appear to be guilty of committing more of the seven deadly sins in their church service, than I will manage throughout my porn marathon. That's the problem with sin: much like beauty it's in the eye of the beholder, meaning even the holy setting of a church meeting can offer temptation to the weak willed.

**Lust**: The way some of the ladies in the crowd gaze lovingly at Reverend Leslie seems to me they'd like his healing hands to address the needs of their genitals, rather than their irritable bowel syndrome.

**Greed**: You can clearly see the queue for the merchandising stand increasing dramatically during the course of the broadcast.

**Envy**: The look of disappointment on the faces of the people who never reach the stage is priceless. "Why did God give me insulin dependant diabetes when I needed lung cancer?"

**Sloth:** Hypnotised by the Reverend's performance I haven't moved from the sofa for the last twenty minutes.

**Pride:** A token glance at Reverend Leslie's dental work would be enough evidence for any sensible jury to convict.

My keenness to watch the Rev Leslie dog and pony show indicates that I may already be trying to subconsciously avoid watching pornography despite only being in the first quarter of my task.

### **4:00 PM**

I HAVE SPENT the last two hours watching *Blue Matrix* and *Gag Reflex 4*. The latter is a US gonzo series that is infamous for its terrifying video box tag line 'these bitches suck cock so deep they puke'. If petite blondes, painful retching, watery eyes and choking noises are your thing then I heartily recommend this. If however you have a shred of compassion for your fellow man then it's probably best avoided. This is pornography that moves beyond any

attempt to sexually stimulate and instead seems to aim to induce nausea in its audience.

Much is made in the US of a film's capacity to cross over into the 'couples market', the large rental market that exists because adventurous lovers often attempt to spice up their sex life by picking up a XXX video from the local hire shop.

Thousands of glossy films that feature plot, tortured dialogue, costumes, soft focus sex and attractive performers are produced every year to tap into this expanding cash cow. This type of American pornography, much like its wrestling is presented in such an OTT manner the sugary coating is enough to get your teeth tingling to a point where you start reaching for your toothbrush in the middle of the afternoon.

*Blue Matrix* is a good example of the genre. Condom only sex, MTV visuals, no anal scenes and a general aesthetic designed to pave the way for pay-per-view distribution in hotel chains. *Gag Reflex 4* represents the polar opposite. As a couple's tape it is completely useless, unless you currently happen to be in the process of wining and dining Rose West and want to make the grand statement.

As I press eject I'm hoping for something a little more wholesome. Luckily, given that I'm at such a low ebb the screen sparks into life and I'm faced with something so hideously British it makes me break out into a warm glow, just one of the symptoms of a condition best described as pornographic patriotism.

The reason for my new found lust for life is the opening credits of *Essex Pub Orgy*. An example of a porn film doing just what it says on the tin, it's the first film to be shot exclusively on location in a public house and features Video Kim, a big star on the British DIY circuit who is now playing the professionals at their own game by seeking wider distribution for her work.

*TAKE MY WIFE!*
SWINGING ADVENTURES WITH KIM AND JOHN

IT'S MIDNIGHT WHEN I take the call from Kim, porn star, swinger and owner of an expanding business devoted to selling amateur sex videos via her website. Kim's long list of titles includes *Black Meat*, *Kim's Bukkake* and *Essex Pub Orgy*. She features as the star attraction, whilst John her partner takes care of camera duties.

Now in her forties, Kim is best described as being at the mature

end of the market. Having missed the sexual revolution first time round she is very much a late bloomer, especially when you take into account that for years she lived a vanilla life no different to her schoolgirl peers, after getting married with her virginity intact on her eighteenth birthday.

Although she always liked sex there was one major barrier holding up her mission to become a sexual super freak, namely the simple fact that she spent the first twenty-five years of her life as a devout Jehovah's Witness.

"Don't tell me what the Bible has to say about sex, I spent years studying it," she tells me with a dirty laugh.

Her mother is still part of the church and Kim thinks the shock of finding out what her daughter does for a living would probably kill her.

"Luckily, she's not the sort of woman who would ever buy the *News of the World*," Kim tells me.

This is a stroke of luck, given that Kim has been a victim of tabloid moral crusading on a number of occasions. First there was the media storm that greeted the filming of Kim's Shanty Orgy, a group sex event that took place on a boat called Gladys, moored at Benfleet Motor Yacht Club on the River Thames.

Under the bold headline 'Sea Dogs Turn HQ into Secret Love Boat', it detailed the chaos caused when Kim (described as 'a porn again sex bomb' in the article) hired the boat for a private party. The club's committee were expecting a wedding reception or birthday party and were apparently completely unaware that a gang bang was going to be filmed in the ship's bar. Club spokesman Jack Howitt, speaking in an outraged tone to the tabloid journalist covering the case, was very keen to point out that "none of our members were involved".

Proving that class is sometimes more of a concern than group sex among some British folk, Commodore John Hancock, spokesman for the more expensive Yacht Club situated directly opposite the Gladys, chose to use the incident to score points against those who use motor power to propel themselves through the murky water of the Thames.

"We have nothing in common with those lot over there. We're sailors, they're more like Ford Escort drivers on water."

The coverage of *Kim's Shanty Orgy* was with hindsight merely the calm before the storm. Further vilification, and the risk of serious exposure came when the *News of the World* covered the making of *Essex Pub Orgy*.

The video was shot during an orgy Kim had arranged in a Essex pub and the bulk of its ninety minute running time involves her and a friend taking on all comers across pool table, bar and fruit machine.

"The newspaper printed my full name and where I lived. It could have been a disaster," she tells me.

Apart from her elderly mother, Kim also has two teenage kids, who are blissfully unaware that video covers featuring their mother caked in jizz line the shelves in many British sex shops.

Kim sometimes worries about the kids finding out, given there are likely to be mean spirited neighbours who have read the tabloid press and would take great pleasure in letting the cat out of the bag, but she's chosen to deal with the trauma when it occurs, rather than spend too long dwelling on it.

Kim and John have never subscribed to bigotry on terms of race, gender, looks or sexuality, and have always tried to bring up the children with a liberal attitude to alternative beliefs, cultures and lifestyle choices. They hope this will have an impact on how the kids respond when the truth finally comes out.

"Swinging is based on mutual trust and respect. People always ask if we get jealous — I don't. I would if I ever thought John was secretly having an affair without telling me, but generally I don't."

One of the negative effects of having a job that is also a lifestyle is that the phone never stops ringing. People ordering videos, asking for help getting into porn, sometimes even seeking Kim's advice on sexual problems they are having.

"I'd like to take it a bit easier, but I feel like I'd be letting people down," she tells me. "John often says that my job should be described as sexual social work."

Another problem is the men who ring the contact number listed on her website in order to encourage her to engage in phone sex.

"I had one the other day whilst I was out shopping, I kept telling him it was inappropriate because I was in the food aisle of Marks and Spencer's but he was begging me to carry on because he was so near to cumming."

## 4:00 PM

AS ESSEX PUB ORGY comes to an end, eleven hours into my quest, I've started to notice that to avoid focusing my attention on the screen I'm subconsciously engaging in non-porn activities to occupy my mind. For example, I've just reached for a generic foreign film guide that has sat unread on my bookshelf for at least two years after I bought it from a second hand shop in a vain bid to look intellectual. I have also cracked one off using my imagination alone to prove a point, as well as preparing a pot of coffee, taking one sip, deciding that I didn't want a cup of coffee, poured coffee down the sink, cleaned up coffee grounds from sink, then spent thirty minutes worrying that the coffee grounds have blocked the sink.

I've even found myself staring outside at the garden and getting twitchy because the lawn looks like it could do with a mow. Anyone who knows me will happily confirm that this is dramatically out of character.

When forced to confront hours of pornographic images (pornography once being described as the filmic equivalent of 'a highly animated butchers shop window' by comedy writer Charlie Booker) the accumulative effect doesn't deprave and corrupt, it tends to bore you rigid.

It will take a lot to lift my malaise but salvation sometimes comes in the most unlikely of forms. In this case from a pile of unlabelled CD-ROMs, which come with a very strange history.

When I've interviewed pornographers that have had their stock confiscated in police raids they often joke that the films will end up appearing as the star attraction at the next CID Christmas party. It seems that their joking isn't that wide off the mark.

A good friend of mine has a relative who works a civilian post in the local police headquarters. Over the years it became obvious that the attitude some of the coppers took to the evidence room was — to put it politely — a touch lax. Rumour dictated that things would go missing on a regular basis, some of the staff seeming to treat the place as a supermarket where all the stock was free. Especially popular was the bootleg video games and DVD section, with people helping themselves to as much material as they could physically carry out of the premises without getting busted.

Because the boys in blue are so slack, I'm lucky enough to be sat in my armchair watching *Dave's Den,* a disc liberated from a police evidence room which gives a unique insight into the mind of one anonymous pervert.

I have no idea why Dave's porn stash ended up impounded. Although it's incredibly tasteless it contains nothing illegal and to be fair he looks like a decent enough guy.

The reason I know this is because I've seen him. As well as the 100,000 sexually explicit images on the disc, there is a file of the man himself pictured smiling with his girlfriend on holiday in Spain.

When Gary Glitter was busted for accessing sexual images of children after taking his computer to be repaired at a Bristol branch of PC World, investigators discovered that the egocentric glam rock star had hidden the worst of the material in a file named 'My Gang'. It's a sign of how shielded he felt when browsing the Internet for paedophilic sites that he didn't even bother to utilise a file wiping facility before handing over a laptop that he must have realised threatened a lengthy prison sentence.

In Dave's defence he probably had no idea that his private collection would end up being passed around a giggling group of thirty-something males, one of whom just happened to be writing a book about smut. If he did know this you pray he would have attempted to compile something much more 'mainstream'.

The first 50,000 images on *Dave's Den* are gynaecological close ups of vaginas. No faces, no bodies, no personalities, just a never-ending procession of splayed labia captured on crystal clear dig-ital film. These images alone must have taken hours to compile, especially given that our protagonist has formatted them into a slide show so an image will only appear on screen for two seconds before the next replaces it.

Some are taken from top shelf magazines, scanned to his hard drive and digitally cropped so the only area visible is genatalia. Others come from porn websites. But the strangest of all are taken from medical textbooks and include a number of crude pencil draw-ings of vaginas that could have been created in a secondary school human reproduction biology class.

Trawling to capture the perfect vagina, Dave has been inspired to create his own pornography. He obviously found it difficult to attract his girlfriend to the project, however, which explains the 1,500 images that contain pictures of nothing but Dave's erect penis. Over the course of a two hour slide show, Dave gets his dick out in his tastefully decorated bedroom, well proportioned lounge, shaker style kitchen, mature garden, small fuel saving car and sea side themed bathroom.

To add to the slightly surreal effect, a normal snap shot will occasionally appear on screen to break the cock monotony. Dick,

dick, dick, Dave sipping a San Miguel in a Costa del Sol beach bar, dick, dick, dick, Dave grinning just before he dives into a azure blue swimming pool.

Depending on your mood at the time it's either a procession of provincial obscenity that ranks as the dullest thing ever committed to the screen, or alternatively a profoundly moving example of conceptual art that subscribes to Marcel Duchamp's maxim that 'art is art as soon as the artist says it is'.

## **10:00 PM**

IN THEORY THE next few hours should be a cakewalk as it's now 10PM and, as any digitally connected sexual deviant will be acutely aware, this signals the start of easily available sexual content on satellite television.

The sheer beauty of the Sky digital porn underground is the level of anonymity given to the secretive self-abuser. There's no need to answer questions barked at you by a telesales operator earning minimum wage. If I've learnt anything about porn it's the simple fact that a system whose accessibility removes the need for human contact is guaranteed to make money.

As well as monthly subscription services, most channels offer the option of paying for the channel on a nightly pay-per-view service, the aim being to capture the occasional rubbernecking voyeur, as well as the committed onanistic demographic. PR and advertising for all the channels tends to be via ten minute long 'free-views' at hourly intervals during the night. These are often brilliantly executed examples of art meeting psychology that aim to give the punter just enough of a taste to think about shelling out £5. They consist of ordering information recited by a scantily dressed model, along with brief flashes of action edited at a headache inducing pace. Watched as a package it's easy to be left with the illusion that there is some real sauce on offer. Sadly, to gain any erotic pleasure from the advertising alone you'd need to be lucky enough to have either a photographic memory or a VCR with a reliable pause button. To really piss on the chips of any viewer aiming for a cashless wank, the action is edited way above the normal masturbation BPM.

New channels are being added on a weekly basis, although despite their promises that they will be the filthiest XXX fuck fest ever seen in the UK they are forced by OFCOM — the newly founded

television regulator — to keep programming within rigidly defined taste and decency parameters.

In 2004 some broadcasters decided to take the risk and air a degree of hardcore imagery, mostly choosing explicit girl/girl footage so the sight of erect dicks wouldn't muddy the waters. They quickly discovered that they were subject to a number of viewer complaints and as a result were forced to return to showing softcore.

I shell out an hour's wage to watch a typical example of the content available to British subscribers, choosing the Adult Channel.

*Pornomedics* is produced by Pumpkin Films, the company formed by Bristol based husband and wife team, Phil and Cathy Barry. It deals with the sexy adventures of a group of paramedics that respond to motor accidents and work related mishaps by arriving at the scene in an ambulance and fucking the victims in the soft focus, mediumcore porn style much beloved by satellite companies.

It may be an inappropriate medical response if you are lying at the bottom of a ladder with a compound tibia fracture, but in terms of UK porn, which is so often based on the principle of setting up the camera and shooting without any attempt at plot, the concept is almost Shakespearian.

Cathy occasionally appears on screen herself. She has a massive following of committed fans drawn from her days as a *Sunday Sport* model and roles in a number of Pumpkin hardcore releases.

If Cathy Barry didn't exist a horny cartoonist would have been forced to invent her, although it's likely he would have left out the molasses thick West Country accent, which always reminds me of the sexually charged animated rabbit from the Cadbury Caramel adverts. Pumpkin has a reputation for shooting glossy smut with high production values that never skimp on showing dirty sex. Cathy herself has undergone a slut-based renaissance of late, involving herself in filthy shenanigans that are even stranger when you realise that her husband is barking the orders.

In summary: the action is cut to ribbons and any sexual activity outside of old-fashioned tit sucking and simulated limp dick humping is edited out long before it reaches the screen.

### MIDNIGHT

[PHONE RINGS]

**BRUCE** Hello.

**GARETH** What you up to? We've just got back from the pub, fancy coming over for a smoke?

**BRUCE** I'm working on the book.

**GARETH** It's midnight for fuck's sake.

**BRUCE** Yeah, but I'm doing this porn marathon thing.

**GARETH** That sounds cool, can I come over?

**BRUCE** It's not cool. In fact it's fucking horrible. But yeah, feel free to come over. I'm sticking *Young and Anal 36* on next.

Twenty minutes later, Gareth (*name changed*) joins me on the sofa. He's the best possible choice to spend the final hours of my marathon with — great company, always willing to skin up and even better he's the best example you could ever find of how pornography can make anyone a victim.

A few years back Gareth surprised everyone by arriving at the pub with a stunning looking girl. This was only unusual in the sense that his love life was always defined by frequent sex droughts, a direct result of him never leaving the house for fear of separating himself from his games console. He's also crippled by both chronic shyness and pot autism, which means he's not the most gifted human being when it comes to chatting up the opposite sex.

He'd met Michelle (*name changed*) at a work Christmas party and despite feeling she was way out of his league they hit it off and started seeing each other. Michelle was a terrible snob, especially when it came to Gareth's friends and she'd often refuse point blank to go out if any of us were going to be there. Because of this he disappeared off the scene for months at a time and his peer group would spend hours ripping into him for being pussy whipped, although if pushed we'd all quietly admit that given the way she looked we'd do exactly the same thing in his situation.

They eventually got engaged and moved into a house together. Michelle was a shameless social climber and over time Gareth became unrecognisable as the person we'd all known for years. At one stage he started going to London with his girlfriend every month to watch the latest West End musical, reaching his lowest point when he came to meet me once wearing a 'We Will Rock You' T-shirt and spending an hour singing the praises of the Ben Elton

musical based on the songs of Queen.

Things were going fantastically well for him until the fateful day when he found the brown envelope in his work inbox. It was lunchtime when he finally got round to opening it, as he did a glossy magazine landed on his desk along with a hand written note: 'I thought you'd want to know that she's a slag.'

Flicking through the copy of *Posh Wives* whilst thinking he was a victim of a workplace practical joke he turned a page and sat with his mouth open as his world collapsed. The photoset he was looking at featured Michelle on all fours, naked but for a pair of high heels, arse in the air, sporting a hoop you could eat your dinner off and giving a leering grin to the camera like a true professional. The piece hadn't used her real name, calling her Lady Rose-Smyth in keeping with the magazine's spoof *Hello* theme, but Gareth knew instantly that the model was his fiancé. As soon as I saw it just a few short hours later I knew it was Michelle.

He left the office and walked the flight of stairs to the admin department where she worked. Dragging her into a kitchen he thrust the magazine at her and asked for an explanation. In floods of tears Michelle told him the whole lurid story. She was young and naïve, the guy told her it was a test shoot and the pictures would never see the light of day. It was something she had always regretted and she was so ashamed she hadn't told anyone, not even her sister or best friend.

Fast-forward a few weeks later.

Gareth and Michelle trying to put things behind them, the magazine has been torn up and binned and they are both struggling to forget it ever happened. One Saturday morning Gareth is picking up a newspaper and his attention is drawn to the top shelf. Knowing he's making a mistake he reaches for a copy of *Posh Wives*, walks to the counter and hands over the money.

It's another week before he can look at it, because he is at heart a good man who wants to forgive the woman he loves for a minor breach of trust. Eventually curiosity gets the better of him and he picks up the magazine and flips forward to Michelle's glamour modelling debut. Many months later he will quietly confess to getting an erotic charge from seeing the pictures again, but any sexual excitement at that moment soon dissolves into a creeping sensation at the pit of his stomach.

Michelle is wearing her engagement ring in the picture. The emerald engagement ring he bought her just three months ago.

Now Gareth can laugh at the sordid episode, it seems Michelle

had been having an affair with the photographer for months and the time they'd spent messing about in his studio had got out of hand when she felt guilty about Gareth and called time on the relationship.

Gareth and Michelle split up soon afterwards, mostly because every time he looked at her he had an image in his head of all his friends staring at her pictures with their dicks in their hand. Strangely enough he still carries a picture from the shoot folded up in his wallet, even in the past pulling it out when the topic is raised, putting it down on the table and proudly boasting: "I've done her."

Macho bravado adopted to make himself feel better perhaps, but judging by the reception he gives *Young and Anal 26* I can confirm that the episode hasn't turned Gareth away from the shallow joys of pornography.

## 3:00 AM

GARETH BAILED OUT after just three short hours, citing the poor quality production values of *Black Cock Smokers 4* as his excuse. Determined to stay the course I put *Spankenstein* into the VCR and struggle to keep my eyes open.

## 4:00 AM

DURING THE COURSE of this book I wrote 1,200 emails to people I wanted to interview (I recently went through my sent box and counted them all). I had just seventy responses in total, and the bulk of these never came to fruition. One of the people I tried to contact was Layla Jade, the Devon born porn star who now makes a living working in the States. I mention her only because she's the starring attraction in *The Anal Destruction of Layla Jade,* the DVD currently playing on my television. For readers of a nervous disposition I'd just like to clarify that Layla's anus was not harmed during the making of the film and she appears to be fit and well, in fact her career is thriving across the pond.

The plan was to interview her at Torquay Model World, a local Devon tourist attraction situated at the end of a pay-and-display car park on the English Riviera. The sole reason for choosing this venue was so I could incorporate the chapter heading 'Attack of

the 50ft Jizz Guzzling Slut' somewhere in this book.

To be honest I think she was a little confused by the concept and before we could arrange a meeting she emigrated to LA and the chance had passed. As failures go it was easily dealt with, much less hassle than the wasted week I spent trying to track down 'doggers' for example.

Dogging was everywhere at the time, apparently you couldn't park up in a lay-by in England without bearing witness to an orgy floodlit by the weak glow of a Ford Fiesta's internal lights. Researching the scene in detail I eventually came across an Internet site that listed a number of dogging locations just a short drive away.

The first night should have warned me away from the idea, given that I spent an entire evening driving along a major road trying to find the destination. I had directions and a map reference but still had no luck finding the site. Increasingly frustrated I looked again at my map only to discover that the road didn't even exist, it seems 'doggers' are not the most well equipped map readers and they'd confused the location of the meeting.

The next attempt was no more successful, even though I was quite excited at the chance to doorstep the players when I arrived and ask them what possesses married couples to drive to places to be watched when they have sex. Slightly paranoid that I'd end up getting arrested for public gross indecency, I'd even made sure I'd packed a notebook and a Dictaphone, so I could identify myself as a reporter if the police gatecrashed the party. I was praying that it was a line they hadn't heard before and not an excuse widely adopted by the dogging community to avoid legal hassles.

I'd been communicating with a couple that had responded to a forum post I'd made and they emailed the details of the meeting. As always I arrived early, started to read a book I'd brought to kill time, whilst keeping an eye out for other cars to arrive.

An hour or so later and the lay-by is busy, three other cars have joined me but unsure of the etiquette I haven't got out yet to walk around and discover what is going on. In fact no one has, although for the past fifteen minutes there has been some frantic flashing of headlights.

A few minutes later there is a tap at my passenger window, a middle-aged man motioning for me to open it. Keen to get the story I give him a smile and say hello.

"Are you here with Lucy?" he asks.

"No, I've come for the dogging," I reply.

"Are you sure you're not here with Lucy?" he responds.

"No mate, I've never even heard of Lucy."

"Oh, fucking hell, she hasn't shown up again. This is out of order," he spits.

Before I get the chance to ask him who Lucy is he's briskly walking away towards his car. I run after him to see if he's willing to be interviewed but he's turned on the engine and started moving before I can reach him. As he signals out of the lay-by, the other two cars follow in a dogging convoy and I'm stood alone.

During the two hour drive back home I consign the chapter to the shredder.

## 5:00 PM

THE LAST TIME I spent twenty-four hours concentrating on one specific task I was flying to Australia. Despite being terrified of air travel and breaking into a sweat at the slightest change in engine noise, it was with hindsight much easier than trying to spend an entire day watching nothing but pornography.

I remember once spending a charming afternoon with Claudia. She worked in a sex shop and had agreed to let me loose behind the counter for the afternoon so I could get a sense of what drives porn consumers. As it turned out it was a very quiet day and we only saw three punters all afternoon, so we spent hours just chatting about the sex business and she said something that really surprised me: "Do you ever worry you will go to hell for writing a dirty book, Bruce?"

I told her I had no real concerns, after all I was just an impartial observer reporting the facts.

"Maybe, but you do know that some people will think you are nothing but a smut peddler yourself, making money from talking about sex, titillating the general public."

"That doesn't make any sense," I respond. "I'm just trying to tell the truth."

Claudia gave me a smile that hinted she thought I was wrong.

"Look Bruce, in most people's eyes you are one of us now, so you may as well get used to it. Just deal with it, I say."

As I insert the film that will take me through the last hour of my marathon I realise that Claudia may well have a point. I've spent a year of my life submerged in a pornographic world, I've seen hundreds of hours of film, read thousands of dirty words, watched hundreds of people have sex and looked at many thousands of

pornographic pictures. Sometimes I still struggle to work out what all this has taught me. There have been times when I've missed out on taking the kids to the park, camping trips and going to eat in restaurants because I've been so keen to work on this project. There have been the late night phone interviews, week long visits separated from my family, my wife knowing that I'm sat in a room with people who devote their every waking hour to the guilt free pursuit of their sexual desires.

There was something else Claudia said that stuck with me, after I asked her what her rigidly Catholic family thought of her career.

"They hate it, especially my mother. She thinks pornography exploits everyone. That sex is sacred and should never be sold for commercial gain. She thinks the people who buy it are sad, unable to form decent relationships and seek human contact through pornography instead. She thinks the girls are abused and exploited by selling themselves for money, but she saves her worst criticism for people like me who aren't even motivated by the sex, but by the pursuit of money. The worst thing is as I get older I'm starting to agree with her."

As the screen flickers to life with yet another twenty-something blonde starlet in the anal cowgirl position, I can't help thinking of the song that the circus folk perform at the wedding in Tod Browning's classic 1930s film, *Freaks*: *'One of us. One of us. One of us.'*

It keeps playing in my head as I try to watch the onscreen action. *'One of us. One of us. One of us.'*

## 6:00 AM

THE BUZZER ON my mobile phone alarm clock starts, not that the time comes as any surprise given that I've been obsessively watching the clock for the last few hours. I pull back the curtains to be met with the dawning of a bright summer day. Scooping up the pile of videos and DVDs I throw them into a black bin liner and think about giving them a good home with one of my friends.

I pop open a bottle of supermarket own brand champagne to celebrate a successful mission and spend the next thirty minutes staring blankly at the wall. One of the many conclusions I draw in the silence of the moment is that I am never going to watch pornography again.

# Notes & Sources

**1** The Danish Experiment removed all the legal restrictions that related to the '*production, distribution and possession of pornographic materials*'. Many other European countries followed suit soon after, often as a direct result of the Danish government commissioning an intensive period of research that seemed to indicate that sex offences reduced in the period following the change in the law.

**2** Because of the lack of a written constitution, the UK has always been bereft of high profile pornographers willing to defend the domestic trade from a freedom of speech perspective. When Al Goldstein (*Screw*) or Larry Flint (*Hustler*) were busted for obscenity, there was the expectation that the circus would be coming to town when the case went to trial. This is in direct contrast to UK obscenity cases at the time, the accused often keeping their mouths shut and their fingers crossed at the all too real prospect of a custodial sentence being imposed.

**3** 'King Porn, Al Goldstein,' *Time Out*, Steve Grant (June 1999).

**4** Italian smut filmmakers often have a day job that involves legitimate cinema, pornography providing an opportunity to raise finance for their next mainstream project. Directors rarely use a pseudonym and are usually quite open about their work in the adult entertainment genre. One of the best examples would be the late Aristide Massaccessi (aka Joe d'Amato), who made grotesque horror films like *Beyond the Darkness* (1979) as well as the hugely successful erotic thriller *Eleven Days, Eleven Nights* (1989). The schizophrenic nature of his double life may excuse the anarchic gore/sex hybrids he created. Films like *Porno Holocaust* (1981) feature a cast that gets butchered immediately after the cum shot. They managed to alienate the raincoat and the horror audience, as well as the British censor, who have understandably never been a fan of grisly machete attacks during explicit sex scenes.

**5** There are of course a small number of exceptions. Most notably, John Lindsay (aka Karl Ordinaz) who maintained a high profile as a result of his frequent busts for obscenity. As well as filming hundreds of loops, he ran the Taboo chain of cinema clubs that showcased his own productions. Titles such as *Tea and Crumpets, The Gypsies Curse, Jolly Hockey Sticks*

**185**

and *Sex Ahoy*! are good examples of his better films, some of which display an hilarious 'Carry On' quality when watched under the influence of drugs and nostalgia. Any attempt to re-release these twisted gems under the restricted 18 classification would be doomed to failure, mostly as a result of Lindsay's trademark production style: he'd often dress his cast in school uniforms and use girls' boarding schools as a setting. A 1970s John Lindsay title like *Girl Guide Rape* would be unlikely to even make it inside a BBFC classifier's VCR before a rejection letter was in the post.

**6** The Malcolm X interview was conducted by Alex Haley, the author of *Roots*. He later co-wrote the black power icon's autobiography.

**7** Ugly George was a cameraman who shot footage of girls he'd meet on the streets of New York, offering them cash to strip or give blow jobs in back alleys. His public access cable show is widely recognised as the original gonzo series. The term 'gonzo' derives from the work of US writer, gun nut and drug aficionado, Hunter S Thompson. His work as a journalist covering politics and sporting events for *Rolling Stone* magazine, often focused on his own personal experience at the expense of the story he was paid to cover. Thompson had a number of close friends in the porn industry, maintaining a life long friendship with Jim and Artie Mitchell, coun-

terculture icons, strip club owners and directors of the seminal hardcore feature *Behind the Green Door* (1974). He once received an advance for a book project dealing with the sex industry, but sadly failed to deliver the finished manuscript to his publisher.

**8** Unlike the Spanish based Private corporation, who spent a small fortune doing just that in the *Uranus Experiment* (2001).

**9** *Adult Video News*.

**10** *Index*, Peter Sotos (Creation Books, 1999).

**11** The Japanese word bukkake translates as 'splash' in English.

**12** A large amount of domestic Japanese pornography tends to focus on rape themes. Just reading the titles listed in an export catalogue can send a shiver down the spine of the most libertarian smut fan. These films aren't designed for a speciality market, they are widely available and sell in the thousands.

**13** 'Registering' to take part in a bukkake event may involve handing over cash. The amount varies, and is dependent on what sexual services you can expect when your turn to perform arrives. Often the fee will include a souvenir video of the event. Some parties are free, which means the organisers have a ready-made defence against any

allegation of soliciting.

**14** The exact nature of the female performer's role at bukkake parties differs dramatically. Often there will be an agreement that she will allow an element of groping (although this doesn't usually extend below the waist), and some events are specifically advertised as featuring hand jobs, oral sex and in some isolated cases, full vaginal sex. To avoid social embarrassment, the first rule of the Buddha would appear to be: clarify the issue before you attempt anything too experimental during your fifteen minutes of fame.

**15** The rise of bukkake events, along with other opportunities for porn consumers to take an active role in making product, has led to some vocal opposition from many well respected industry voices. The main concern relates to lapses in viral testing among the amateur performers. Some party organisers insist that all participants provide evidence of a clean HIV test taken within the last six weeks, whilst others are happy to let men arrive and take part without the issue being raised on the agenda.

**16** *ANSWER Me!* No 4, Jim and Debbie Goad (Goad To Hell, 1994).

**17** As well as Karen Findlay, there are hundreds of other performance artists whose work has touched on similar themes. Vito's Acconci's *Seedbed* (1972), involved the artist

being concealed under the gallery floor, masturbating as visitors arrived, and providing a running commentary over the in house public address system. It's a sign of the lack of humour evident in the arts world, that not one critic labelled the piece 'Load of Wank', both a literal and a critical description of Acconci's work.

**18** For further information on Christian's films [**w**] www.corolo.com

**19** As *Sun* editor, Kelvin McKenzie developed a reputation as a genius headline writer. His finest work includes 'Gotcha!' (following the illegal sinking of the Belgrano during the Falklands war), along with 'Freddie Starr ate my Hamster' (included as a lead item purely because it was a slow news day and the editor was lacking a front page story). Some people prefer to remember him for his sickening libel of Liverpool supporters following the Hillsborough disaster, claiming they had stolen wallets and urinated on their fellow fans as they lay suffocating in the crush.

**20** Glory holes are small gaps drilled into the partitions of bathroom walls, which allow anonymous oral sex to take place.

**21** 'Bare Backing' (the term used to describe unsafe sex) tends to be an inflammatory topic within the gay community. Statistics seem to imply that a minority of younger gay men

are willing to take increasing risks in their sexual behaviour, often a result of their sexuality developing in a environment where advanced combination therapy has meant that a positive HIV diagnosis does not necessarily equal an immediate death sentence. This is reflected in some of the gay pornography being produced — in the last decade an increasingly large amount of material is available that features unsafe sex.

**22** *Pornography The Musical* (Century Films, 2003).

**23** The Bush administration has never made a secret of its commitment to aggressively fight a prolonged campaign against the native sex industry. Under pressure from Christian lobby groups, the government has also targeted suppliers of drug paraphernalia, rather than focusing their attentions exclusively on pornography. This campaign resulted in a six month prison sentence for legendary seventies stoner comedian Tommy Chong, who was convicted of selling cannabis pipes and bongs via his online mail order company.

**24** You could also highlight Richard Desmond, owner of the Express Newspaper Group (which includes the *Daily Express* and *Star*), *Cum Drinking Sluts* magazine and a large number of softcore subscription Sky Digital channels. Like David Sullivan, he made the bulk

of his cash in the flesh trade, although he now donates large sums of money to the Labour party and as a result seems to have been nominated for full establishment membership. A fact that no doubt sticks in the throat of Sullivan, who has always craved mainstream acceptability. Apparently Desmond gets extremely angry at being called a pornographer despite his background selling gash, so in the name of diplomacy we'll refer to him as a smut peddler instead.

**25** In a report commissioned by the Competition Committee, the typical breakdown of content in an edition of the *Sunday Sport* is revealed: 'Thirty per cent of available column inches are dedicated to sexually explicit advertising.'

**26** *Houston Chronicle* (November 20, 1999).

**27** *Boogie Nights in Suburbia*, directed by Edmund Coulthard (Blast! Films for Channel Four, 1999).

**28** Organised crime has always retained a keen interest in the profits to be made from smut. The thriving black market resulting from its illegality, meant opportunities were abundant for the production, distribution and sale of pornographic material by London based criminal gangs. The notoriously corrupt Met Obscene Publications squad who worked

# Notes & Sources 189

the Soho patch in the late sixties, offered little resistance to pornographers as long as they continued to receive donations to their 'retirement fund'. They were eventually disbanded in 1971, following one of the most high profile police corruption scandals in modern history. Transatlantic treaties were made by criminal gangs in order to expand mutual business interests. The London based Mitchell family linked up with Reuben Sturman, who virtually controlled the industry in the United States. Sturman was rumoured to have extensive mob links across all the territories he operated, although the American authorities could never prove this in court. They tried everything they could to destroy his empire, getting increasingly frustrated by their lack of success until Sturman was eventually charged by the IRS for tax evasion. (Eric Schlosser, *Reefer Madness and Other Stories from the American Underground*, Allen Lane Books, 2003.)

**29** As evidenced by the sordid saga of the Fiona Cooper organisation, whose adverts for mail order stripping housewife videos will be familiar to any reader of top shelf magazines.

**30** Linda Lovelace produced three autobiographies before her untimely death in a car accident in 2002. *Inside Lind Lovelace* (1976), her first, was subject to an obscenity trial in the Old Bailey after editions were seized by British customs. Defended by the well known free speech advocate Geoffrey Robinson QC, the jury eventually decided it wasn't likely to deprave and corrupt and the case was thrown out. The book was little more than an excuse to detail Linda's lurid sexual experimentation and was published to cash in on the success of *Deep Throat* (which of course couldn't be shown legally in the UK). It gave no indication of the storm that was to come a few years later, when Lovelace took a sledgehammer to the adult entertainment business.

*Ordeal* (1985) was Linda's response to the exploitation she felt she had suffered at the hands of the porn industry. With its radical anti-porn agenda and searing condemnation of the role of Chuck Trayner, she soon became a poster girl for feminist anti-obscenity campaigners. Linda may have occasionally been a vague historian and some of her recollections were treated with scepticism by almost everyone who read them, but the real suffering she experienced at the hands of Trayner makes for deeply disturbing reading.

*Out of Bondage* (1992) was her final book, dealing with her concerns regarding the way the sex industry was developing, documenting her fight against breast cancer and letting the world know how happy she was to have found a caring, supportive family. Linda continued campaigning against *Deep Throat* until her death, travelling to film

festival showings and protesting to the crowds who came to bear witness to her 'rape'.

**31** John Hubner, *Bottom Feeders: The Rise and Fall of Counterculture Heroes Jim and Artie Mitchell* (Double Day, 1993).

**32** *Dogorama* (1972) was one of the loop's many titles.

**33** *Bunny, The Real Story of Playboy*, Russell Miller (Henry Holt & Co, 1985).

**34** Marilyn Chambers also undertook a number of mainstream acting roles. Most effectively as the carrier of the viral disease in David Cronenberg's *Rabid* (1978).

**35** Butchers also need to apply for a council licence to operate.

**36** David Sullivan and three co-defendants were found guilty of living off immoral earnings following a trial at the Old Bailey which started in February 1981. He was sentenced to nine months imprisonment and received a £10,000 fine. The charges resulted from his interests in a number of saunas in the South East. Sullivan was known as an enthusiastic punter, often visiting the sites for an 'assisted bath' before picking up the weeks takings.

**37** The Private name was 'borrowed' from the Spanish based Private Corporation, the European giant that is a global market leader in the pornography trade. They are the first ever adult entertainment concern to be listed in the NASDAQ ratings, and are famous for producing quality high end product. They were understandably outraged by the breach of their copyright, especially as Sullivan was ruining their UK reputation by selling his softcore slap and tickle using their established trademark. This was not an isolated case. The Danish Rodox Corporation sought legal advice regarding Sullivan's abuse of their Color Climax branding, but were advised that as pornography was illegal in the UK at the time, they were unable to sue for breach of copyright. These episodes prove if nothing else that Sullivan was equally happy scamming his business peers as he was his sex shop punters.

**38** The Ann Summers chain of sex shops are run by Jacqueline Gold, daughter of Ralph and niece of Philip Gold. The Gold brothers have major interests in a number of top shelf magazines, own a distribution company (Gold Star) that carries smut titles, and own a fifty per cent share in David Sullivan's *Sport* newspaper. Jacqueline took control over the Ann Summers retail and mail order business in the late 1990s and has made a spectacular success of the company, vastly increasing profits, market share and the firm's public profile. In di-

rect contrast to the Private Shops, Ann Summers always aimed at the female demographic through their tactic of organising lingerie parties in people's homes.

**39** It seems that Beyer and his mortal enemy David Sullivan do have something in common, despite the obvious loathing Mediawatch-UK reserves for Sullivan's publishing empire. Chris Morris once set up Sullivan in an episode of *Brass Eye*. When the businessman stated that he "runs a little adult channel" in the interview, Morris replied, "What, a channel for little adults?' Sullivan showed a marked sense of confusion at the time but was eventually so outraged at the spoof he published Morris' phone number in the *Sunday Sport*, encouraging his readers to ring and vocalise their outrage at the satirist.

**40** All quotes in bold type are taken from *Hope and Recovery: A Twelve Step Guide for Healing from Compulsive Sexual Behaviour*, Mic Hunter (Hazelden, 1994).

**41** BBFC Annual Report 2002.

**42** 'Sex Sells,' *The Observer* (October 2002).

## ABOUT THE AUTHOR

Bruce Barnard now lives alone in Cornwall. He previously edited Subnet, a website devoted to the margins of pop culture and continues to write doomed comedy projects for radio and television. The author welcomes all feedback, marriage proposals, death threats and offers of sordid sexual encounters via his email address [e] bruce@phatbeats.freeserve.co.uk